GROUND

*A Reprise of Photographs from the
Farm Security Administration*

Bill McDowell

Daylight

Cofounders: Taj Forer and Michael Itkoff
Designer: Ursula Damm
Copy editor: Elizabeth Bell

Ground: A Reprise of Photographs from the Farm Security Administration
© 2016 Daylight Community Arts Foundation

www.billmcdowellphoto.com

"The Sunken Lands" written by Rosanne Cash & John Leventhal.
Copyright 2014. Published by Chelcait Music (BMI) admin by
Measurable Music LLC, a Notable Music Co./ Downtown Music
Publishing & Lev-A-Tunes (ASCAP) admin by Downtown Music
Publishing. Used by permission.

The Current© 2012 by Wendell Berry, from New Collected Poems.
Reprinted by permission of Counterpoint.

ISBN 978-1-942084-12-9

Printed in Turkey, by OFSET YAPIMEVI

Daylight Books
E-mail: info@daylightbooks.org
Web: www.daylightbooks.org

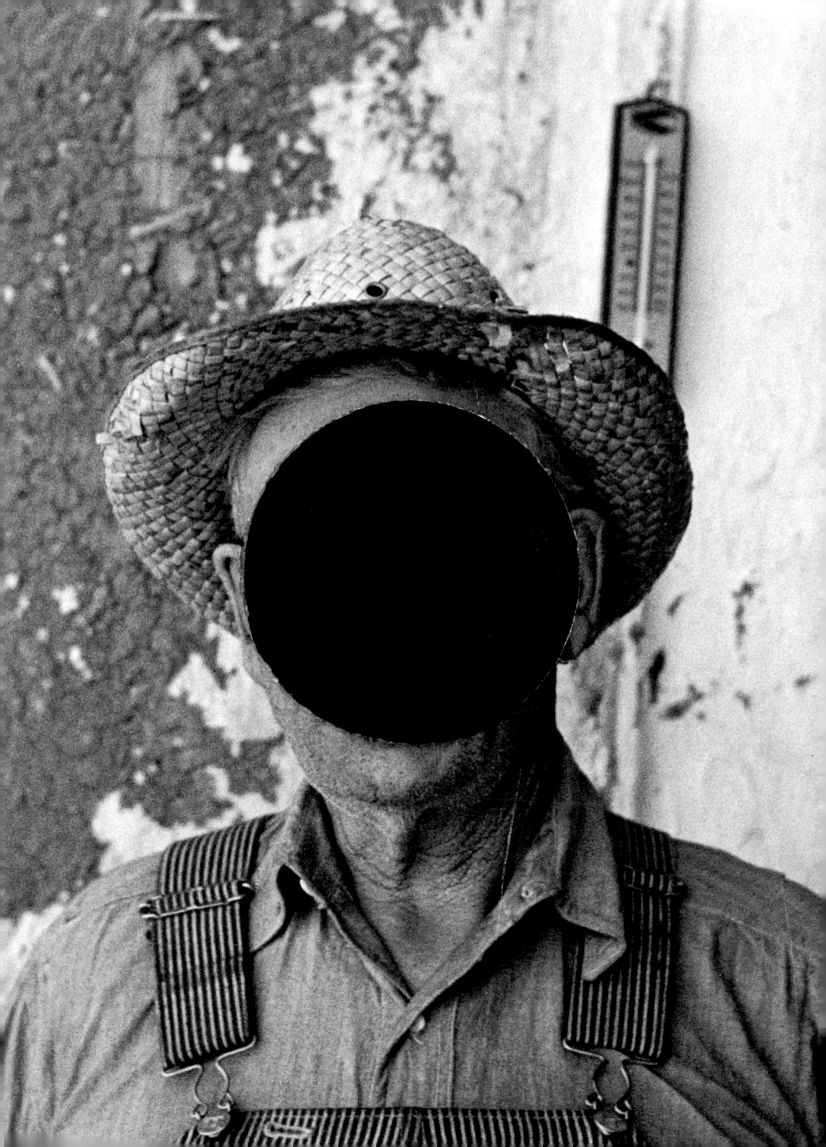

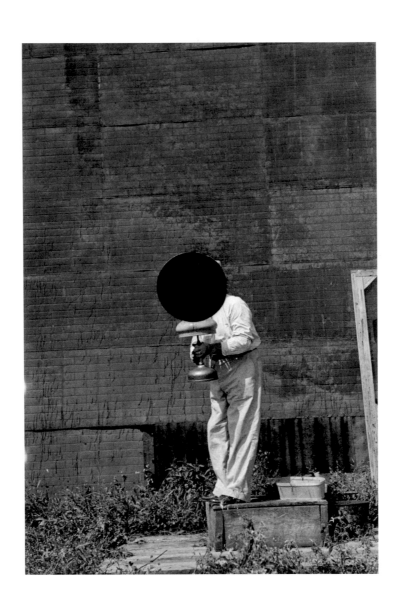

To Britt, Nina, Sam, and Olivia.
Always.

COMMON GROUND

The cover of Bill McDowell's *Ground* bears a classic image of a farmer working 40 acres and a mule in the American South. It was taken in 1938 by John Vachon, one of a legion of talented photographers then employed by Roy Stryker of the Farm Security Administration (FSA), who at the time had commissioned and was personally directing a vast visual survey of our land and its people during the Great Depression. But this particular image is noticeably different from the 145,000 or so fully intact FSA negatives and photographs that now reside in our Library of Congress, many of which have been broadly published from the era of FDR's New Deal to the present time. Something else has entered into this particular picture and all the others in this book. Hovering just above the tree line in this landscape appears a jet black orb, one that upon a quick glimpse might be mistaken for an eclipse of the moon. But that it is not. Instead, this image was recently printed by McDowell from a "killed" negative, one Stryker deemed to have no value and had rendered useless, along with many others, with a manual hole punch. But now, some 77 years later, this image and some of the many others he cast aside, often to the dismay of the artists who produced them, have been given new meaning and life in this artist's book.

Much as many families who lived through the Great Depression sought to make use of every scrap of food, clothing, or other material resource, McDowell has fashioned his contemporary creative endeavor from that which has been cast off, and in so doing has discovered a way to achieve common ground between images others created in the past and the ones he has printed for the first time in the present. His first image, the frontispiece that directly follows upon opening the cover of his book, shows a man whose face has been almost entirely obscured by the hole that was punched in one of Russell Lee's notable FSA portraits. The cropped enlargement of this image, seen again in its entirety deeper in the book, also intensifies the recognition that the faces of the poor have often been hard to see in America, even in the present era, and only at certain times have they been brought emphatically to the fore as a focus of serious political concern and social action, as is the case again today.

The newly printed and well-sequenced FSA images also take on a visual rhythm as one peruses them in McDowell's thoughtful curation, replete with rich, abstract figure-to-ground relationships in which possible readings and

narratives arise from both the chance delivery and the specific placement of each hole that was punched within the killed negatives he printed, much as a bullet might pierce a paper target. These jet-black circular voids strongly focus a reader's attention in different ways, in some instances calling attention to concrete issues such as the fact that wide swaths of farmland have been overpastured, exhausted from lack of crop rotation, eroded by floods and poor water drainage, or have gone fallow from drought, and the way verdant forests have been subjected to clear-cutting.

As more and more people begin to appear deeper in the book's pages, they are for the most part locked in dire poverty, living in the humblest of shacks and circumstances, often as sharecroppers pictured performing backbreaking labor picking crops, planting trees, and building levees. In a few instances those who are struggling mightily are juxtaposed with other men and women dressed more comfortably and living in far more prosperous circumstances. And sometimes the dark negative voids within McDowell's images punctuate his readers' attention by focusing on the particular stoop of working backs, calloused hands plunging into soil or picking berries, the hanging of just-washed clothes, and views of tired feet moving along and through dusty furrows. This is hard work, pictured from the past and recalled for us again today in yet another way, making it clear what it once meant and still means to be "dirt poor."

By the time Woody Guthrie wrote the lyrics to "This Land Is Your Land" in 1940, he had already walked, rambled, and sung his way through the country from his home state of Oklahoma, observing for himself what many of the FSA photographers were also seeing and recording with their cameras. The great song he finally recorded in 1944, as World War II raged and Stryker's grand documentary endeavor concluded, has served ever since as our alternative national anthem and an invitation to all Americans to take more notice of the beauty and richness of our country's now increasingly fragile natural resources: its lands, waters, forests, and people. It may not be too much of a stretch to suggest that McDowell has issued this contemporary visual poem as a reprise to Guthrie's hopeful invitation, holding it up alongside the deep caring and insightful artistry of the poet Wendell Berry and that of singer-songwriter Rosanne Cash.

—*Jock Reynolds*, artist
 Henry J. Heinz II Director of the Yale University Art Gallery

The Sunken Lands

Five cans of paint
and the empty fields
and the dust reveals

The children cry
the work never ends
there's not a single friend

Who will hold her hand?
In The Sunken Lands

The mud and tears
melt the cotton bolls
it's a heavy toll

His words are cruel
and they sting like fire
like the devil's choir

Who will hold her hand?
In The Sunken Lands

The river rises
and she sails away
she could never stay

Now her work is done
in The Sunken Lands
There's five empty cans

—Rosanne Cash/John Leventhal

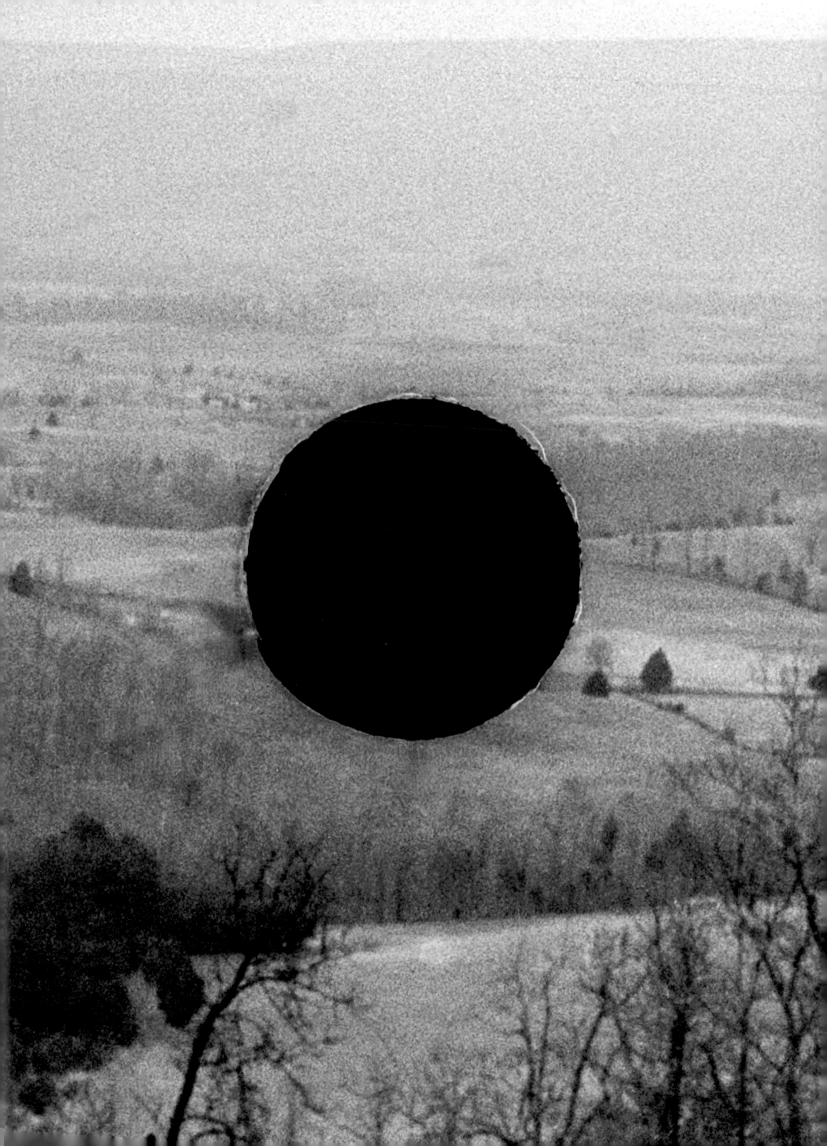

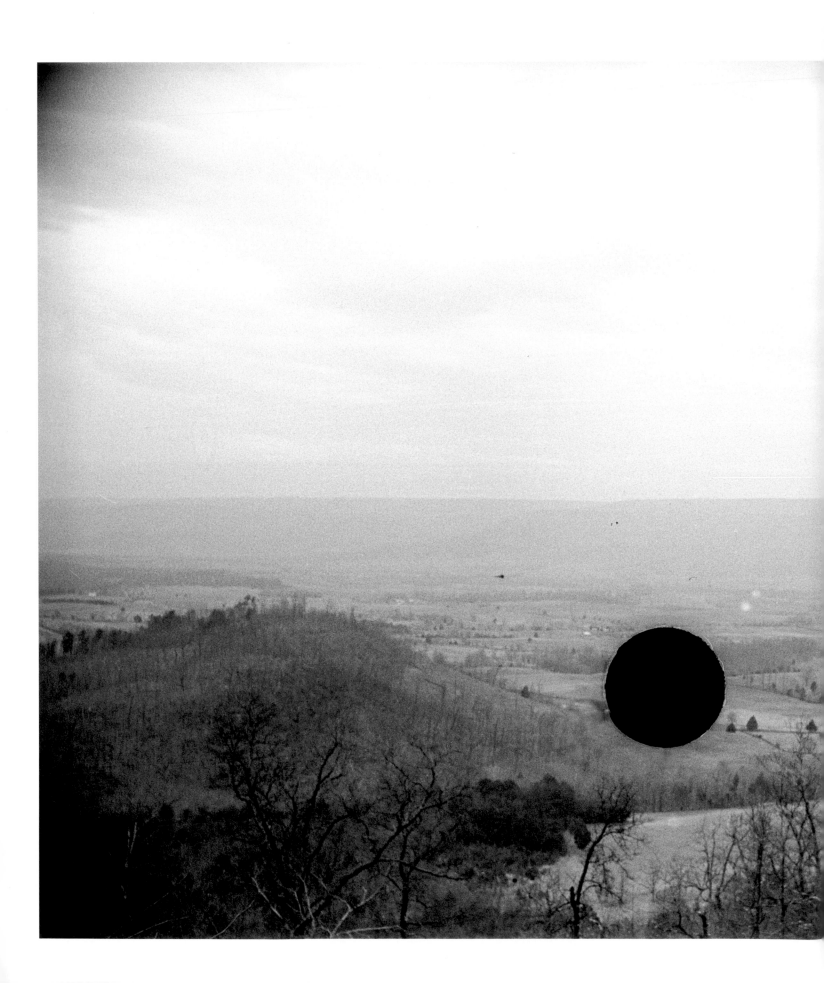

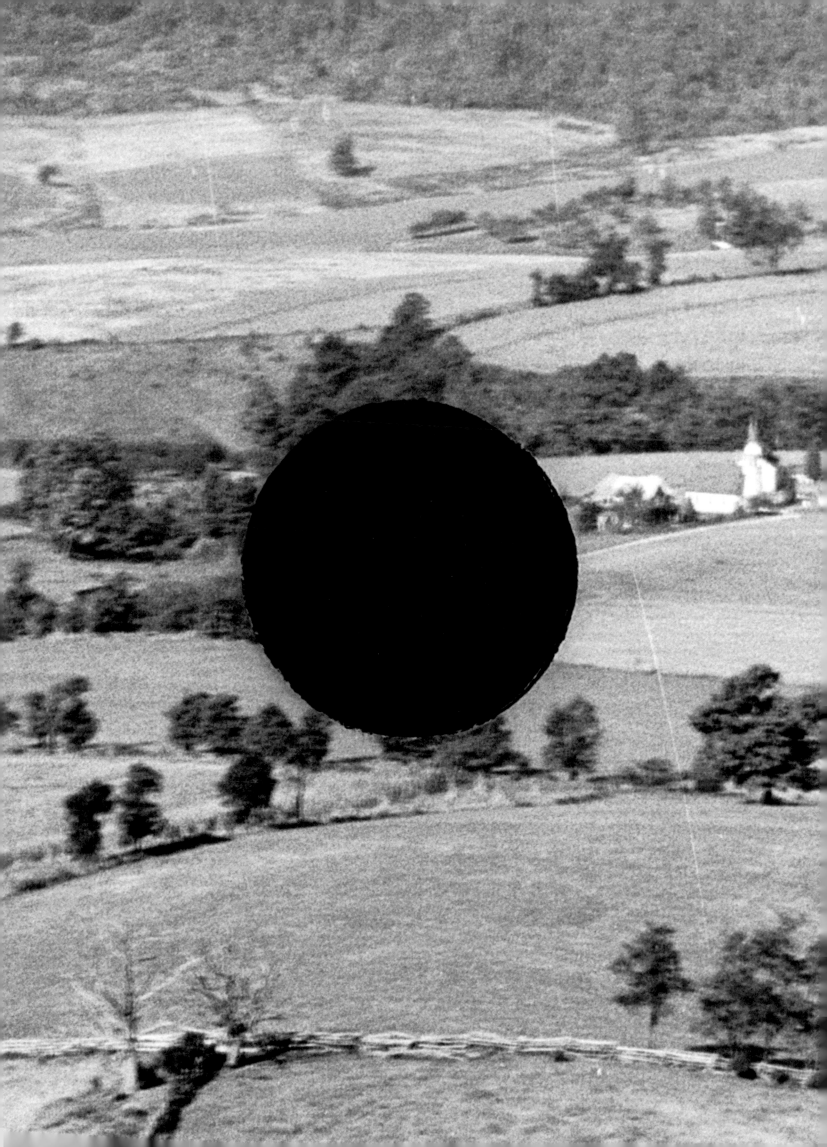

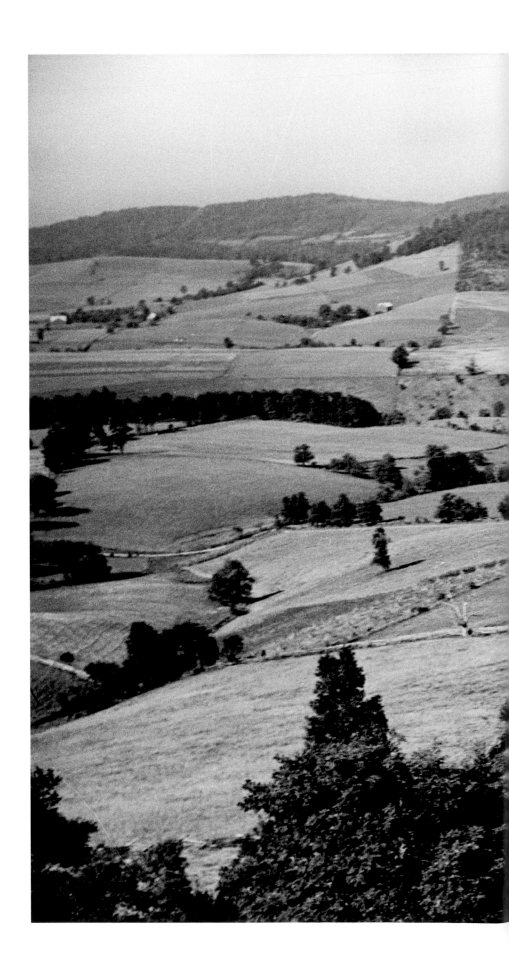

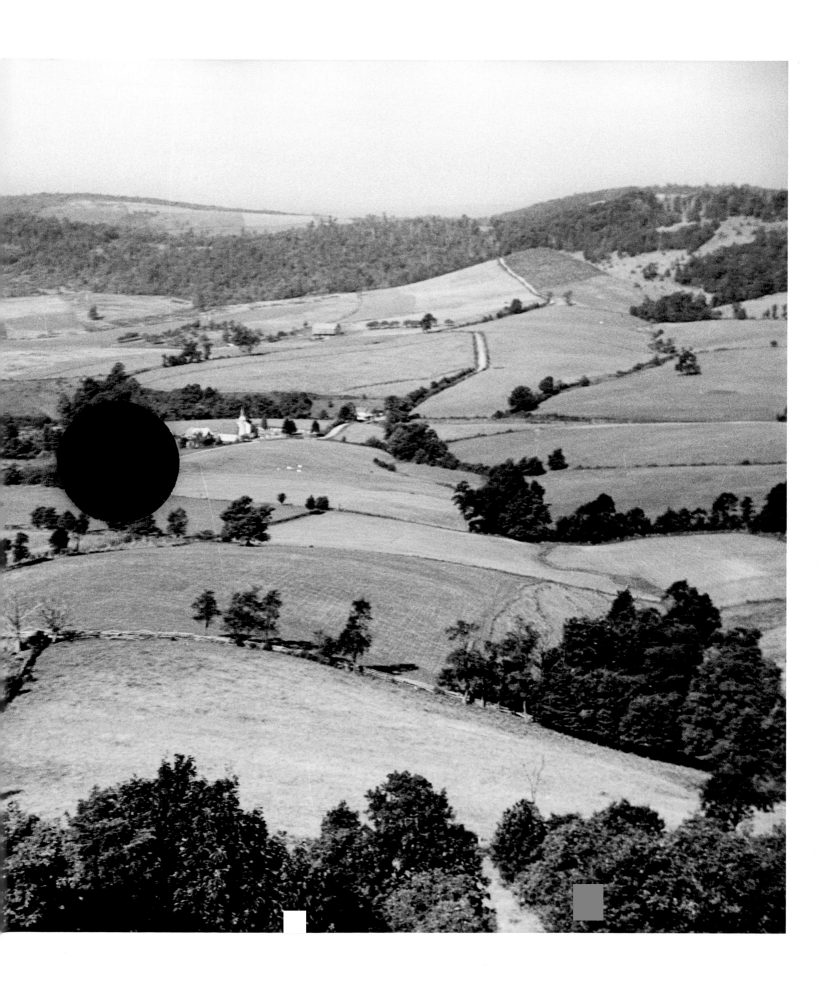

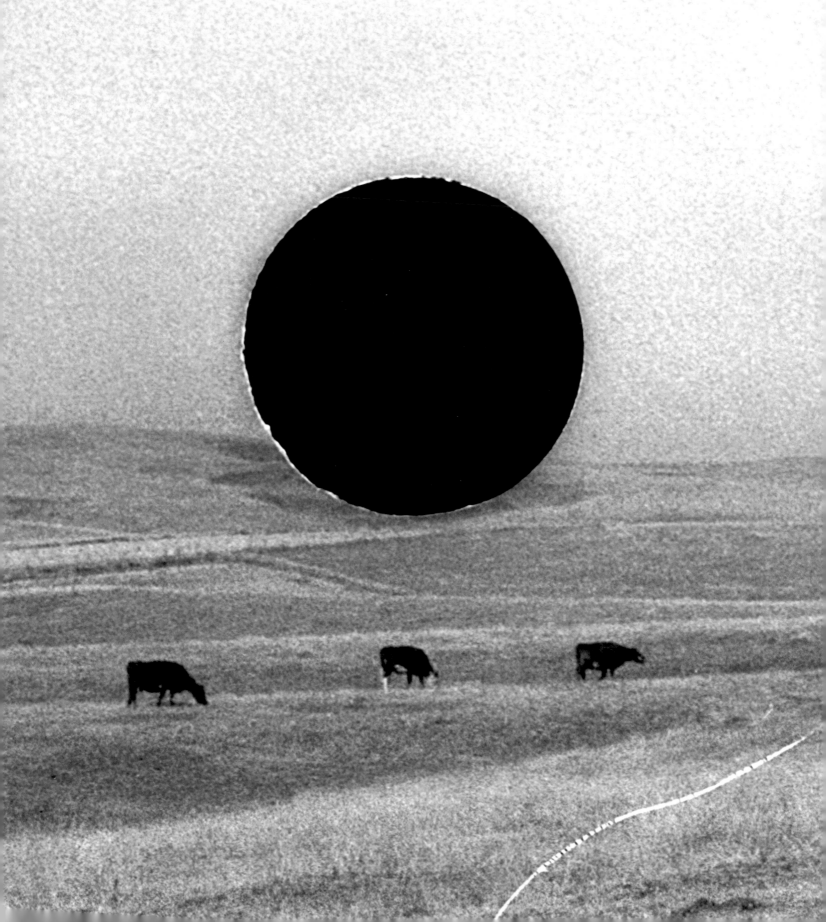

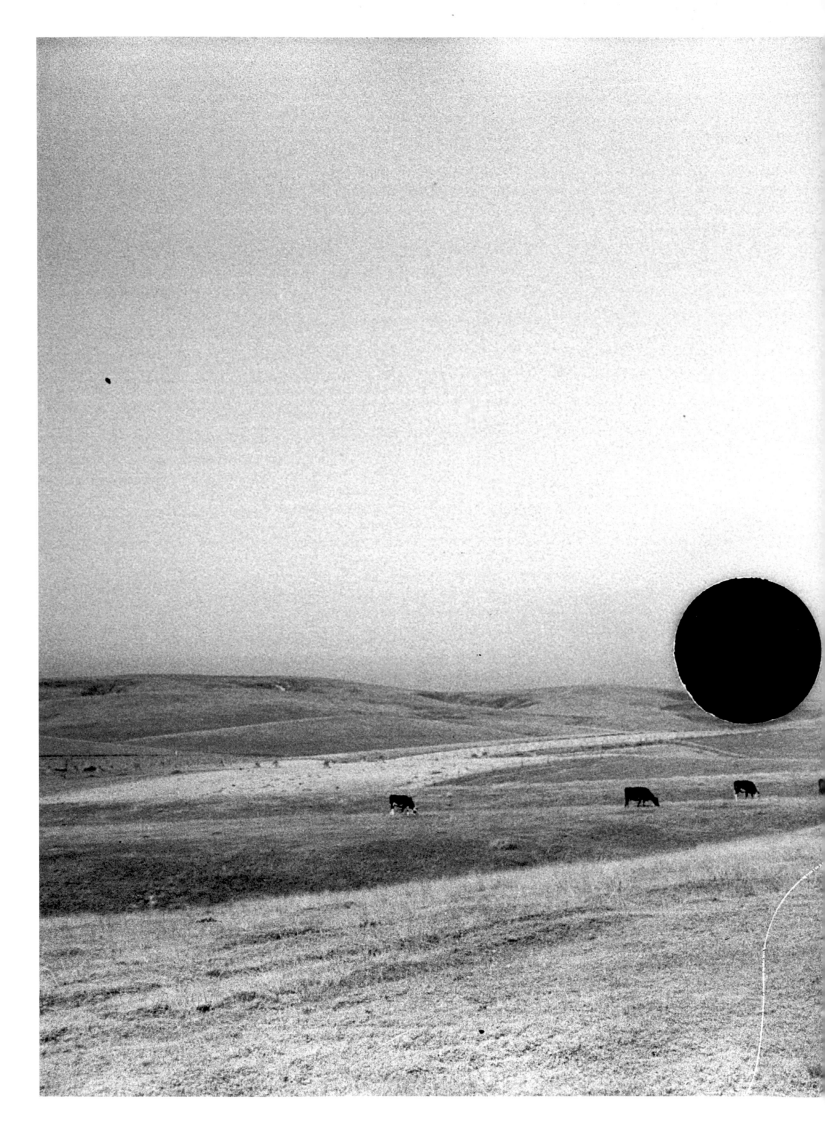

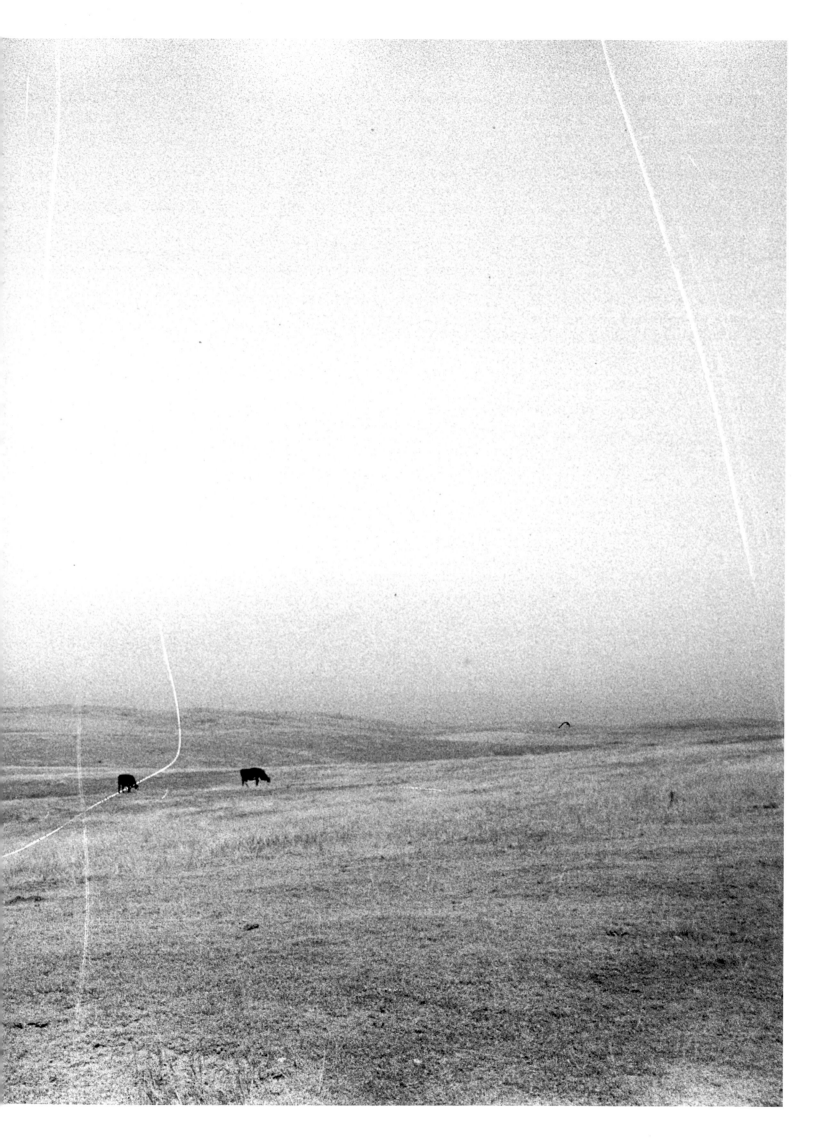

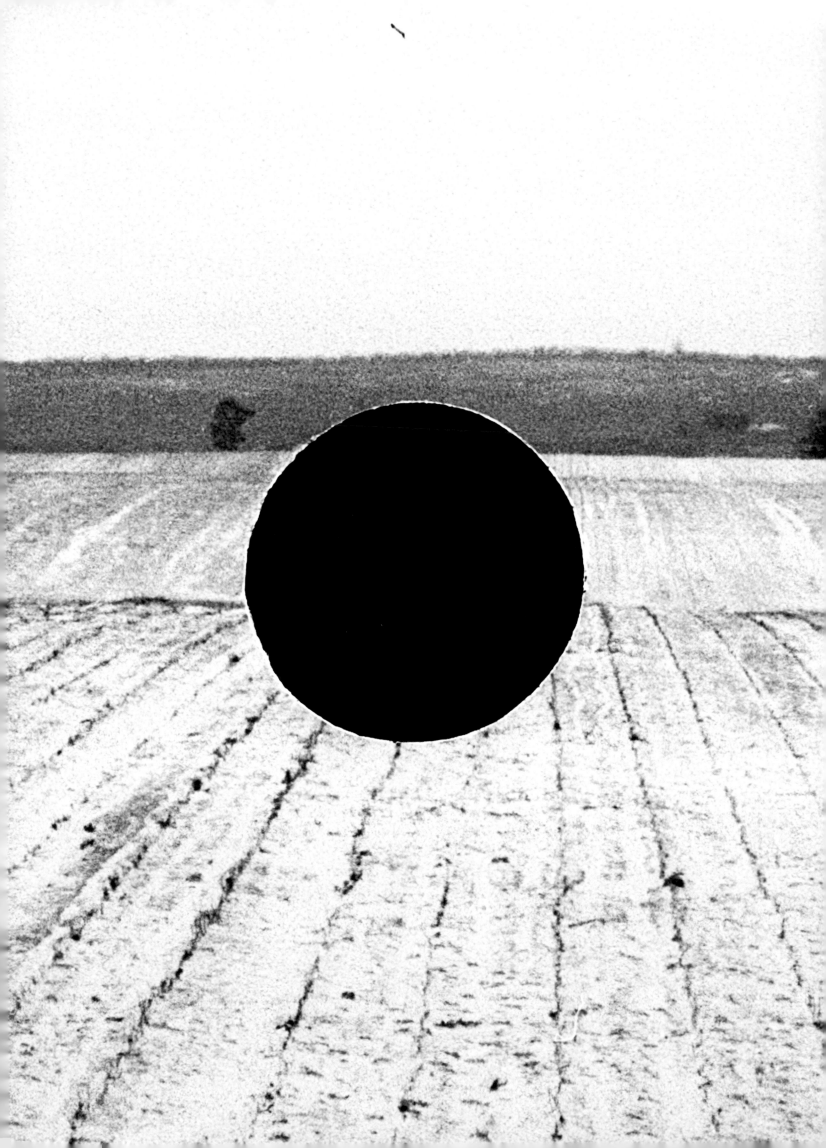

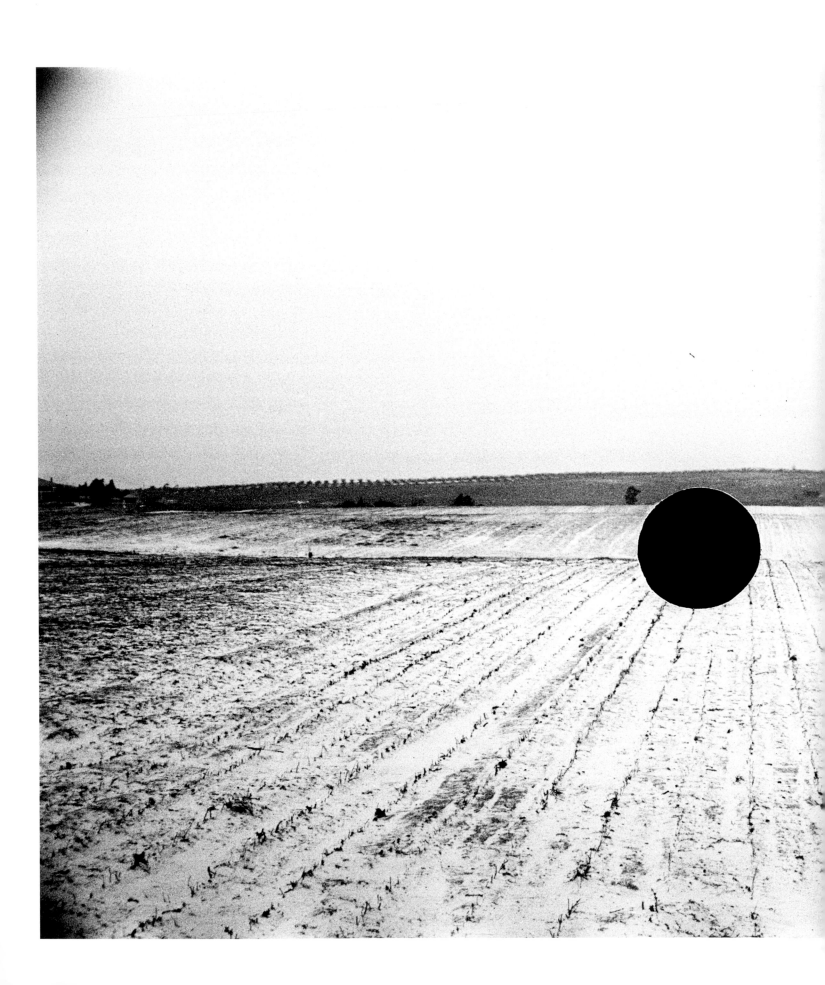

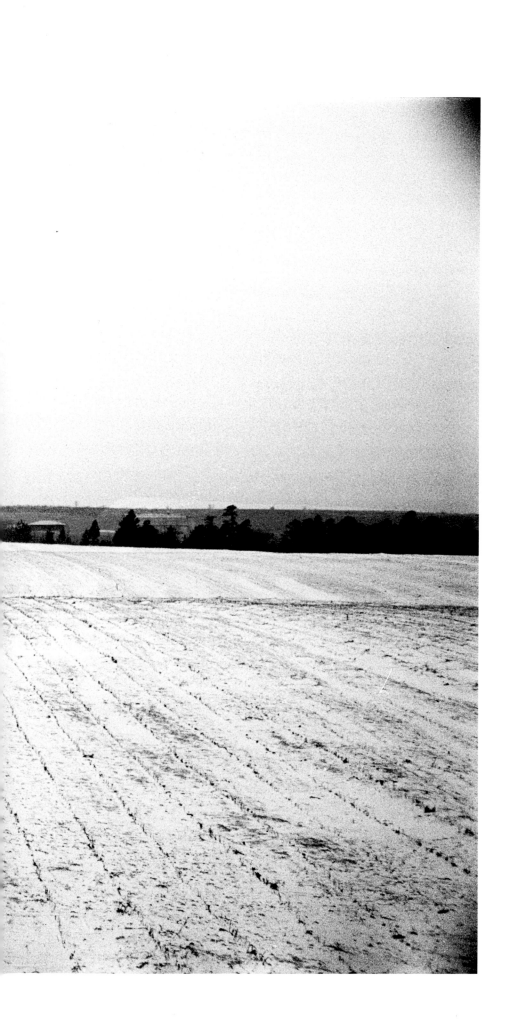

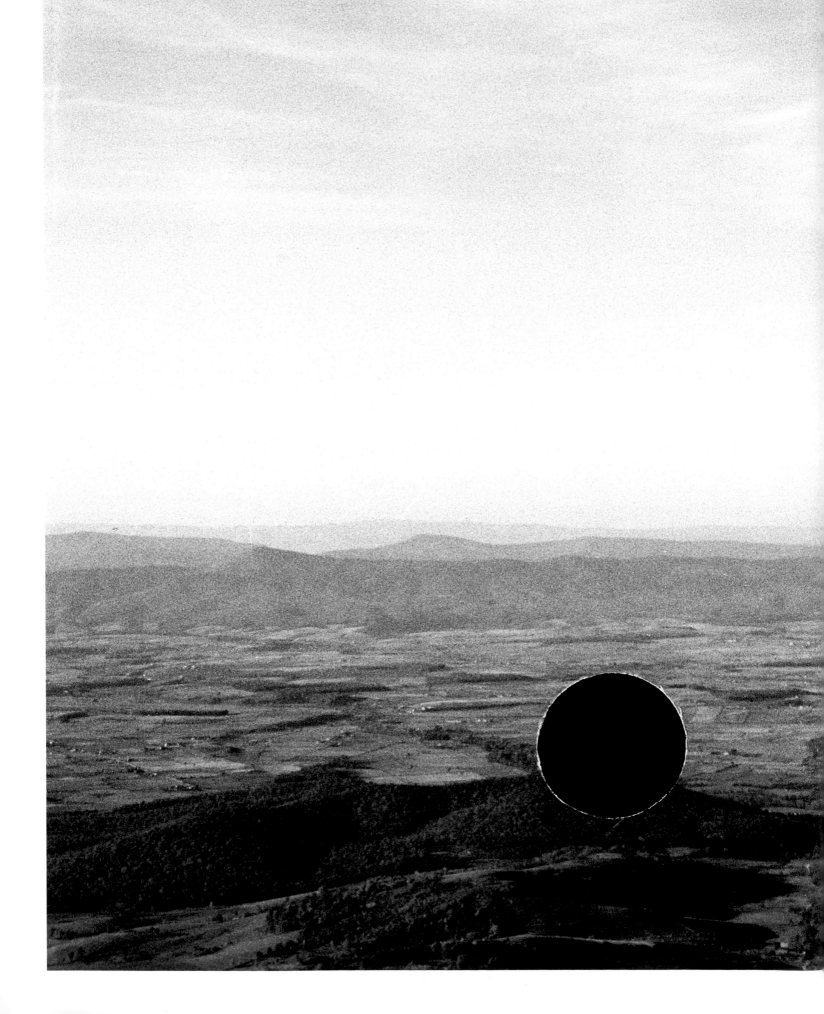

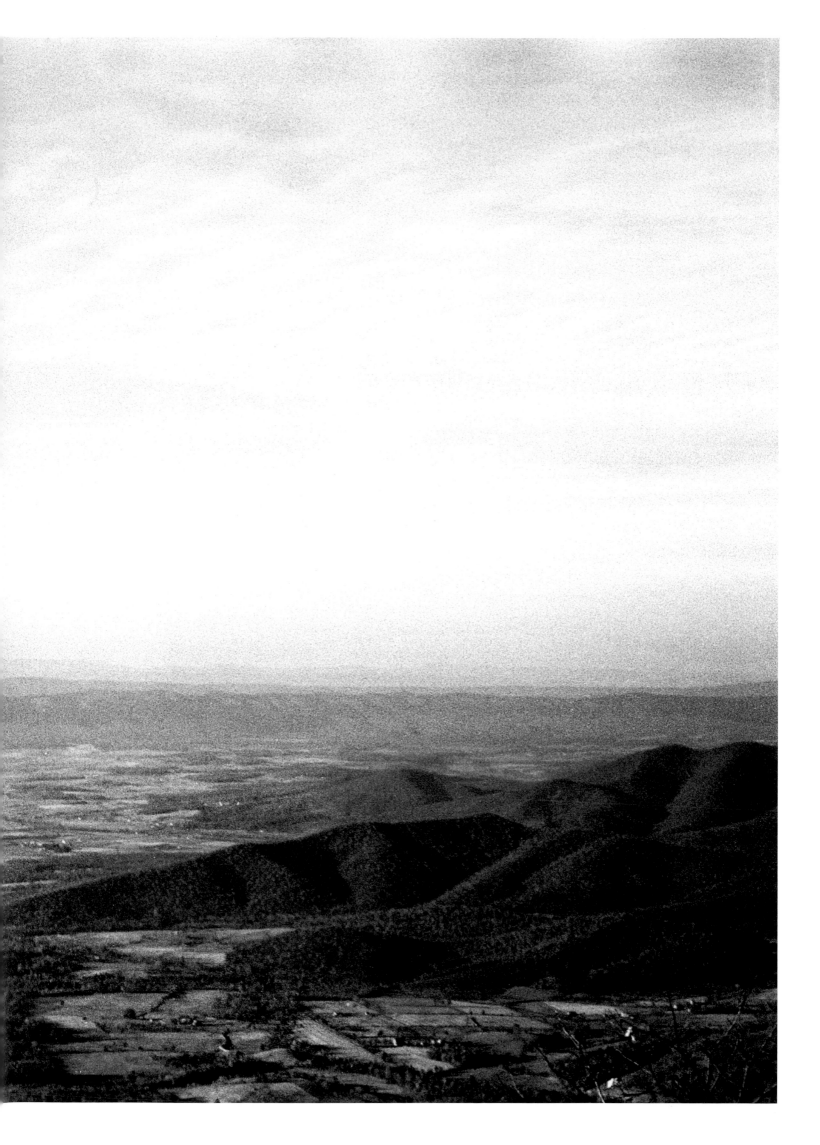

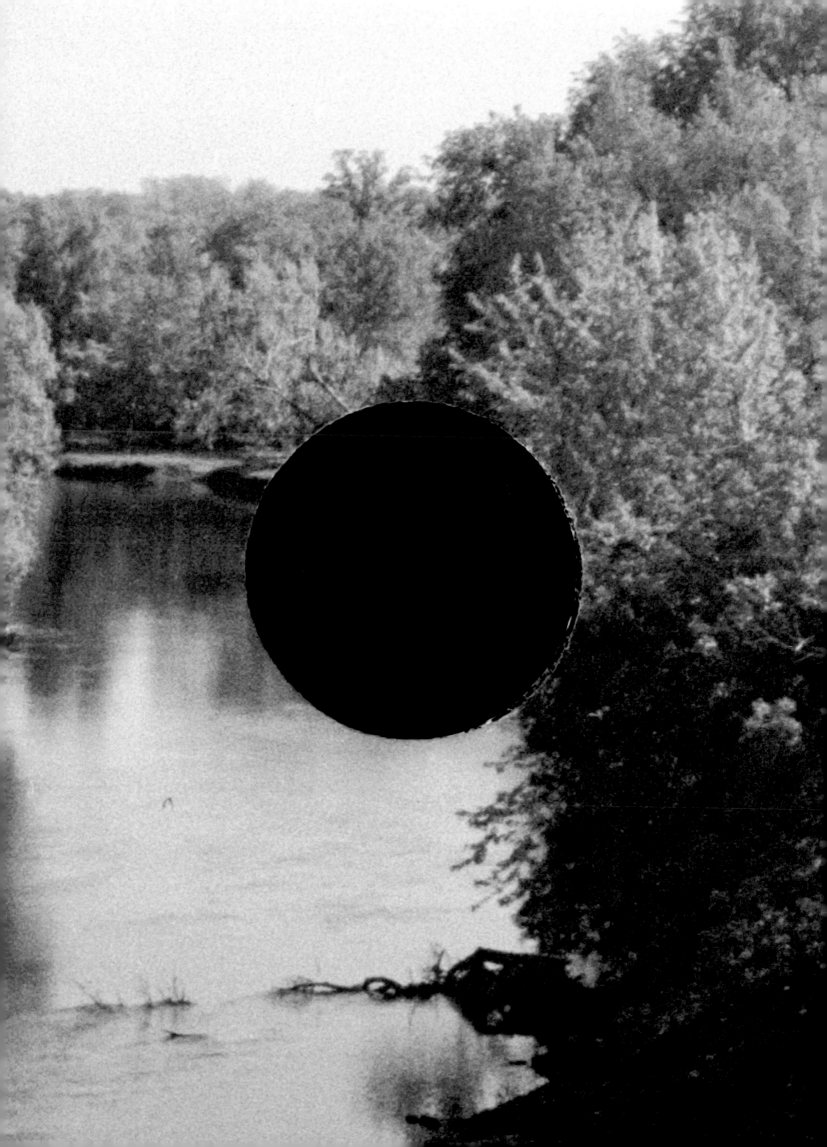

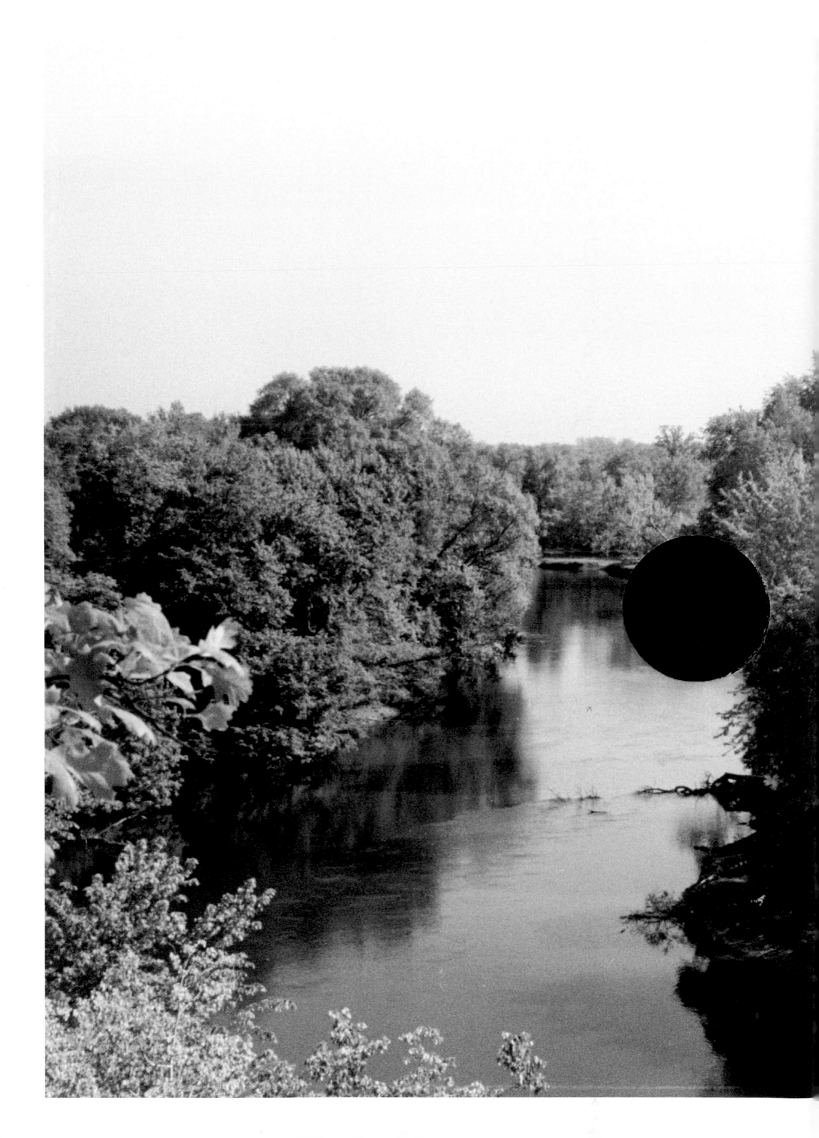

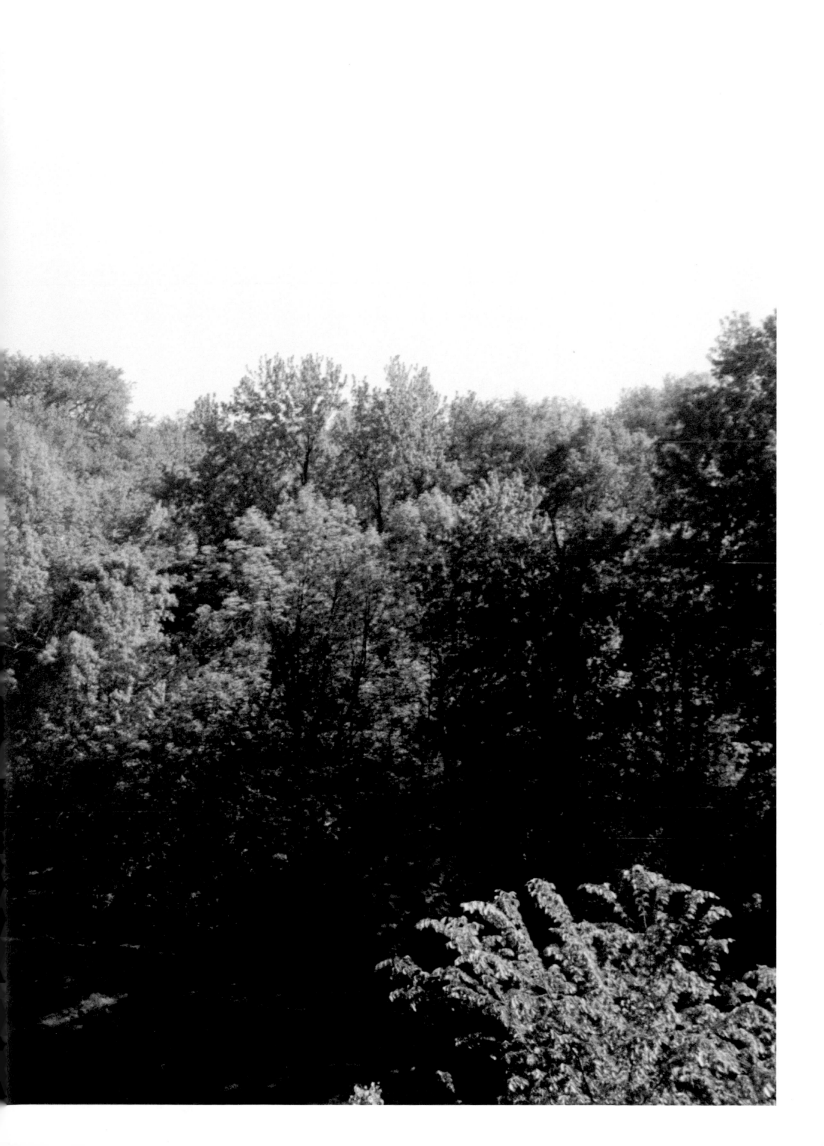

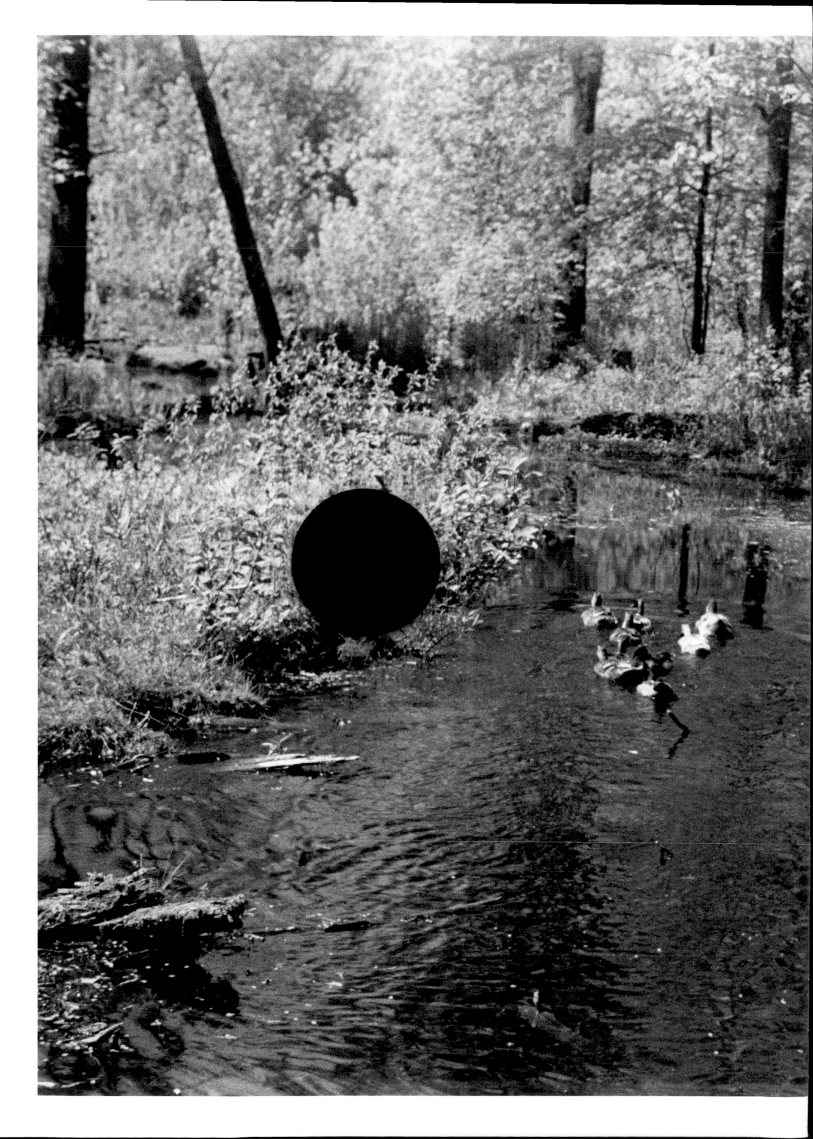

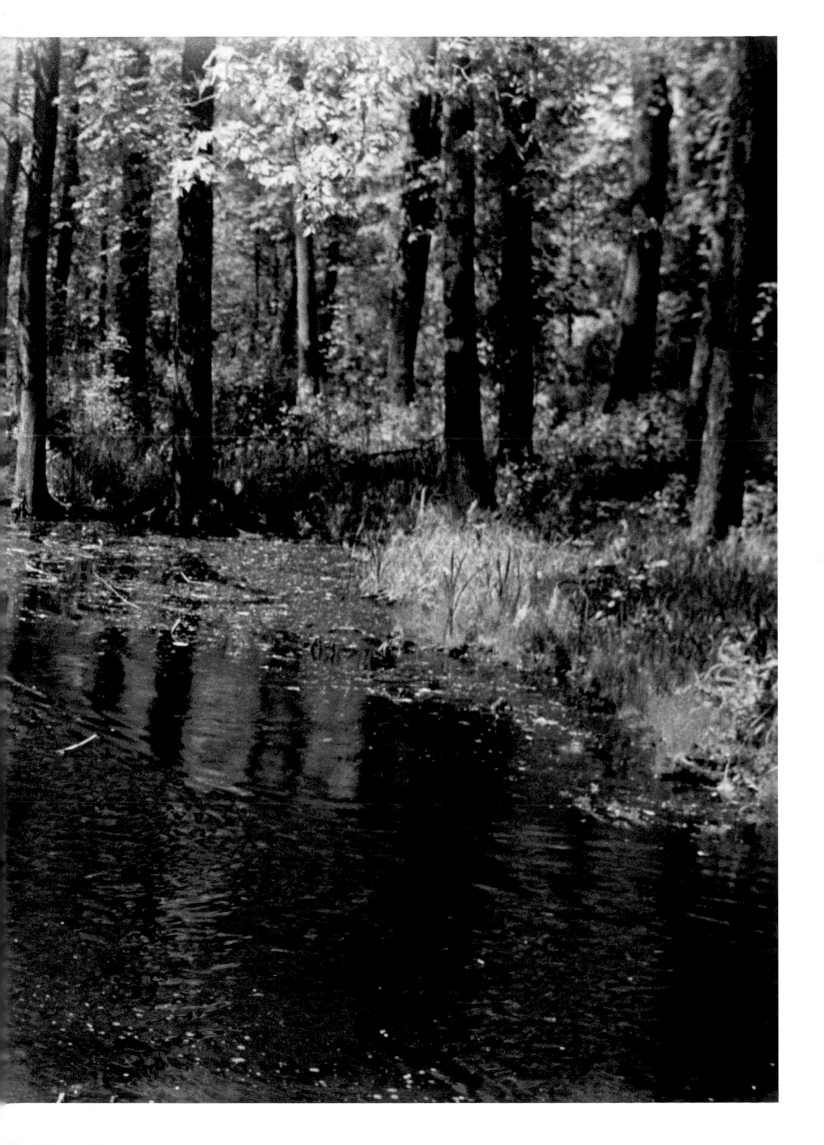

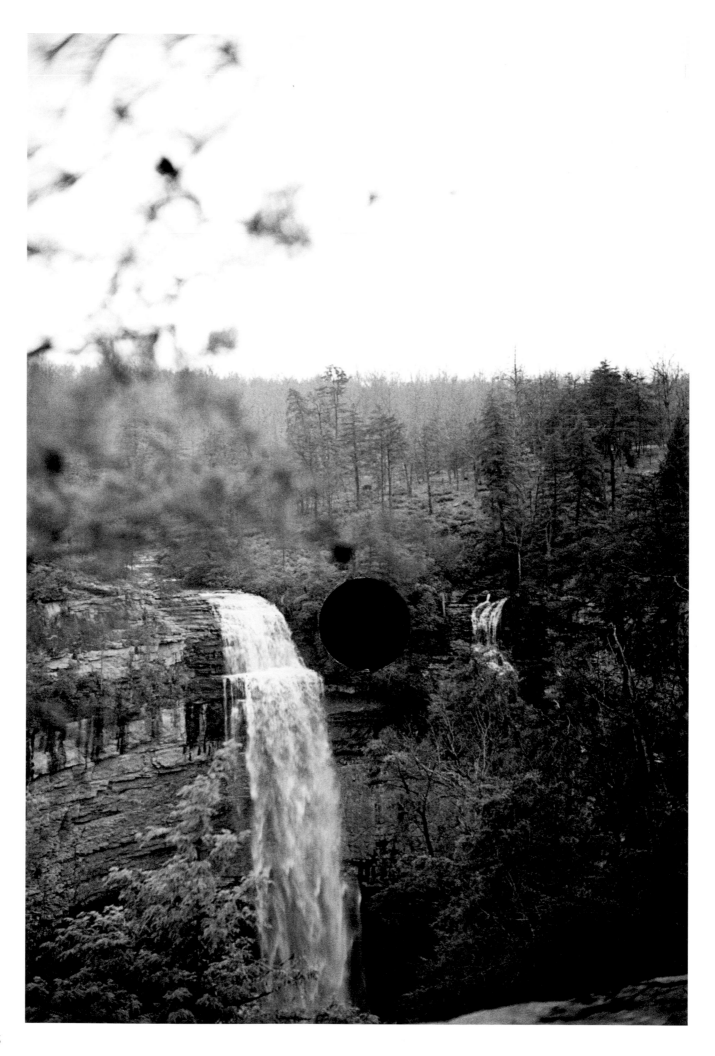

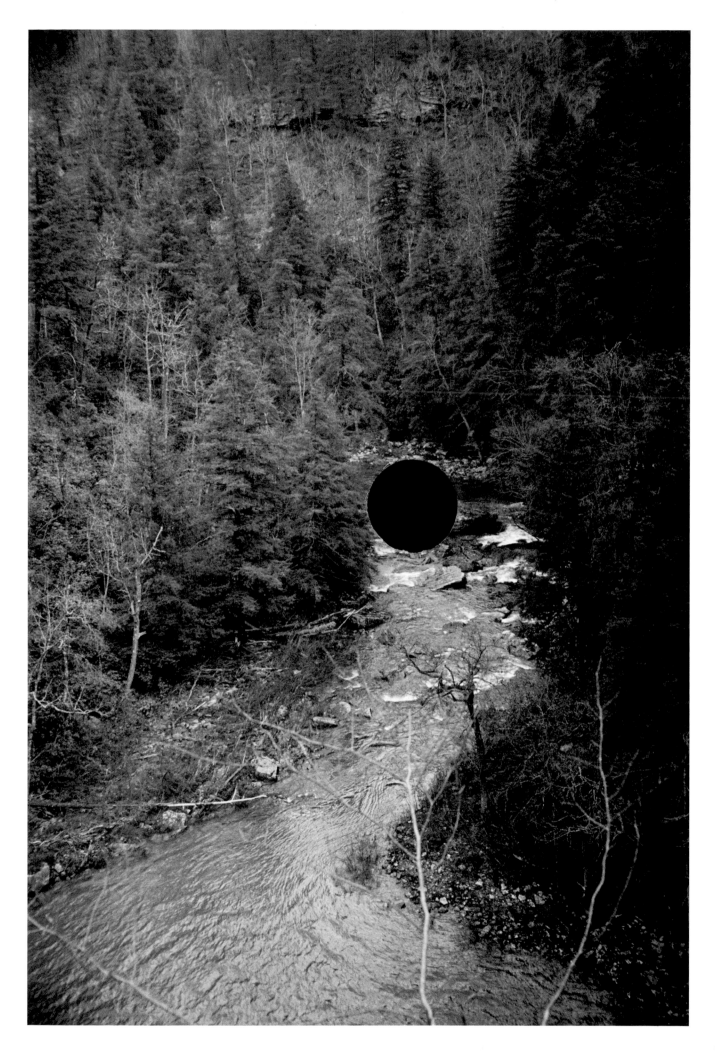

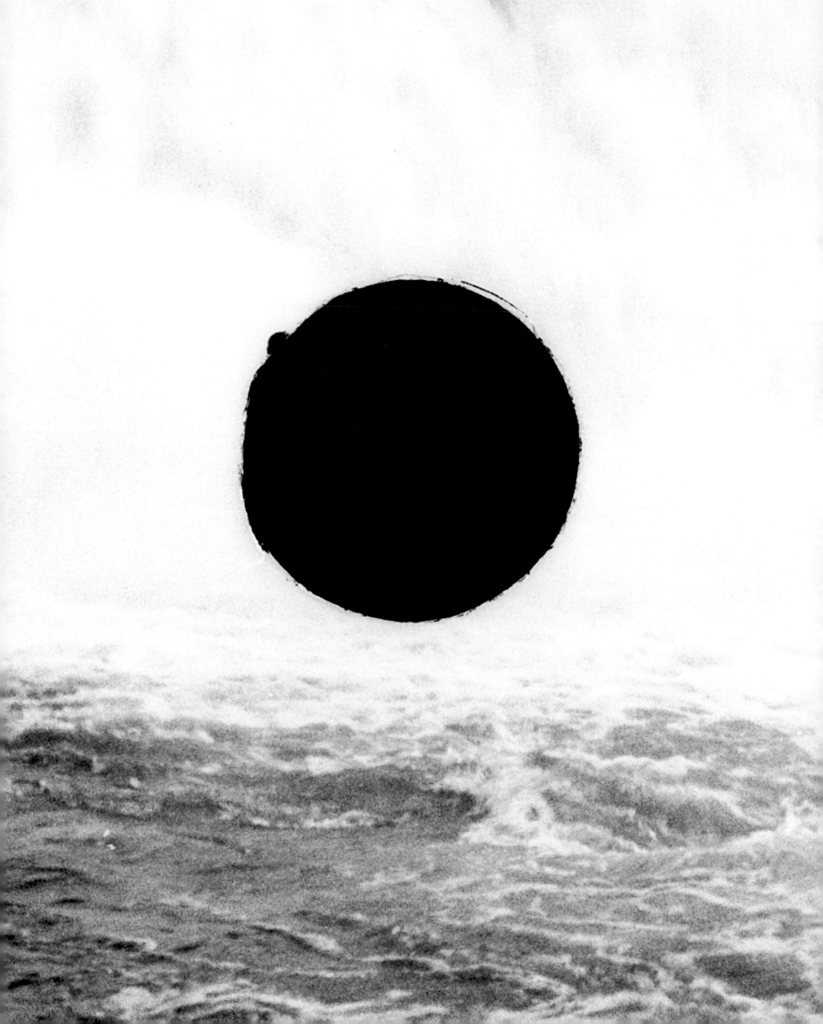

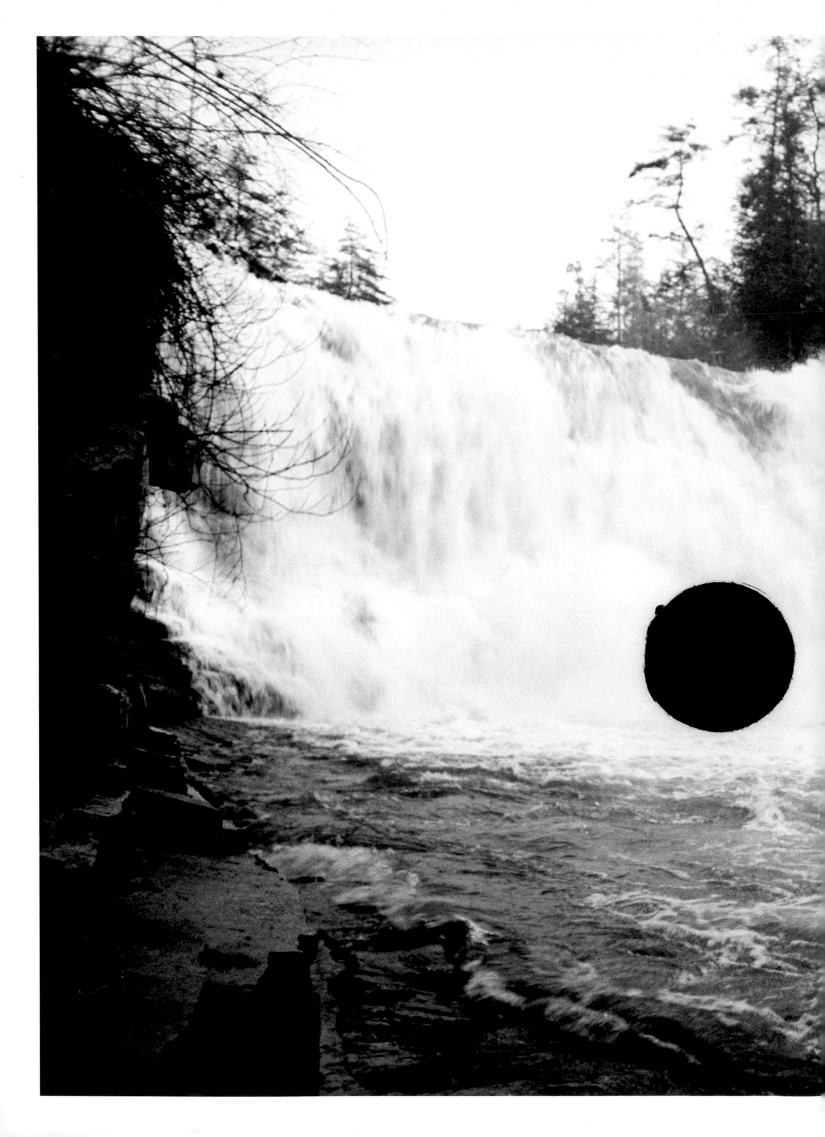

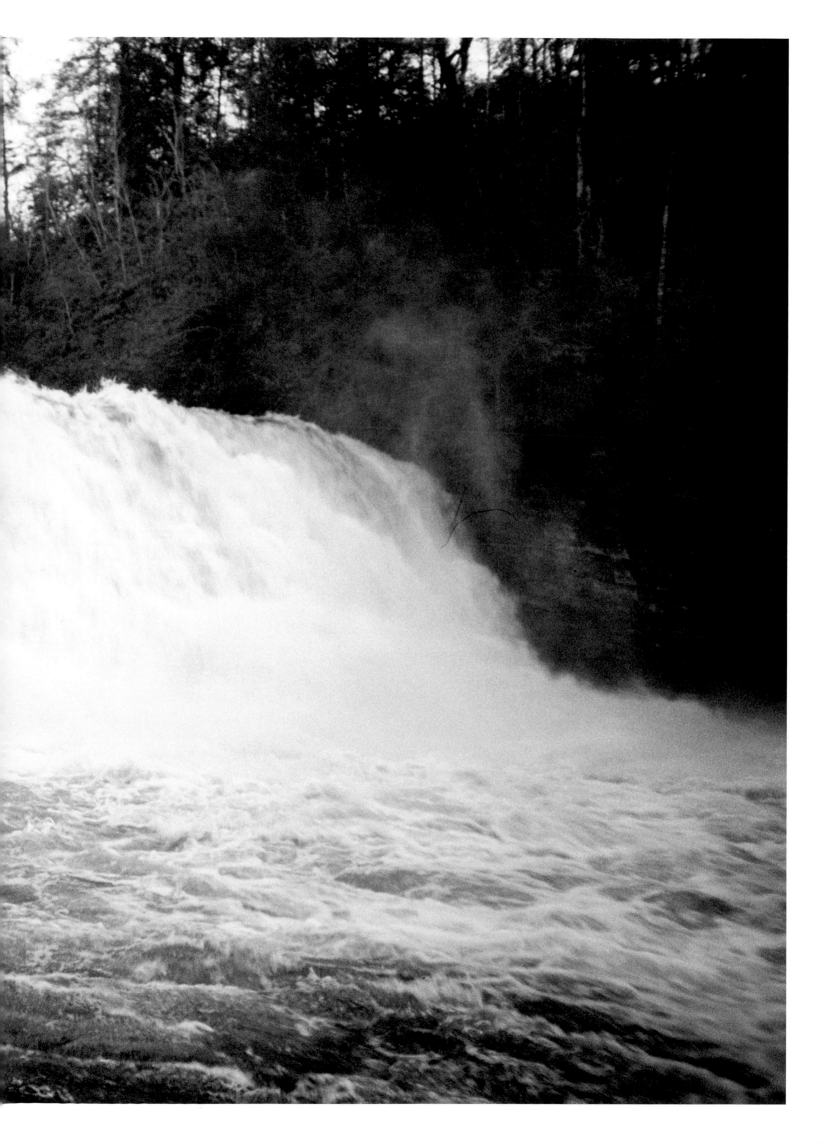

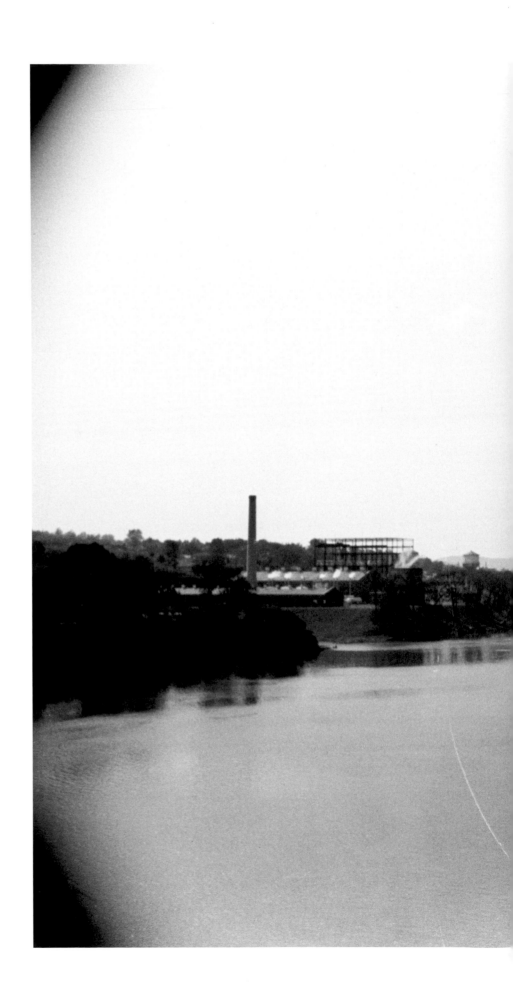

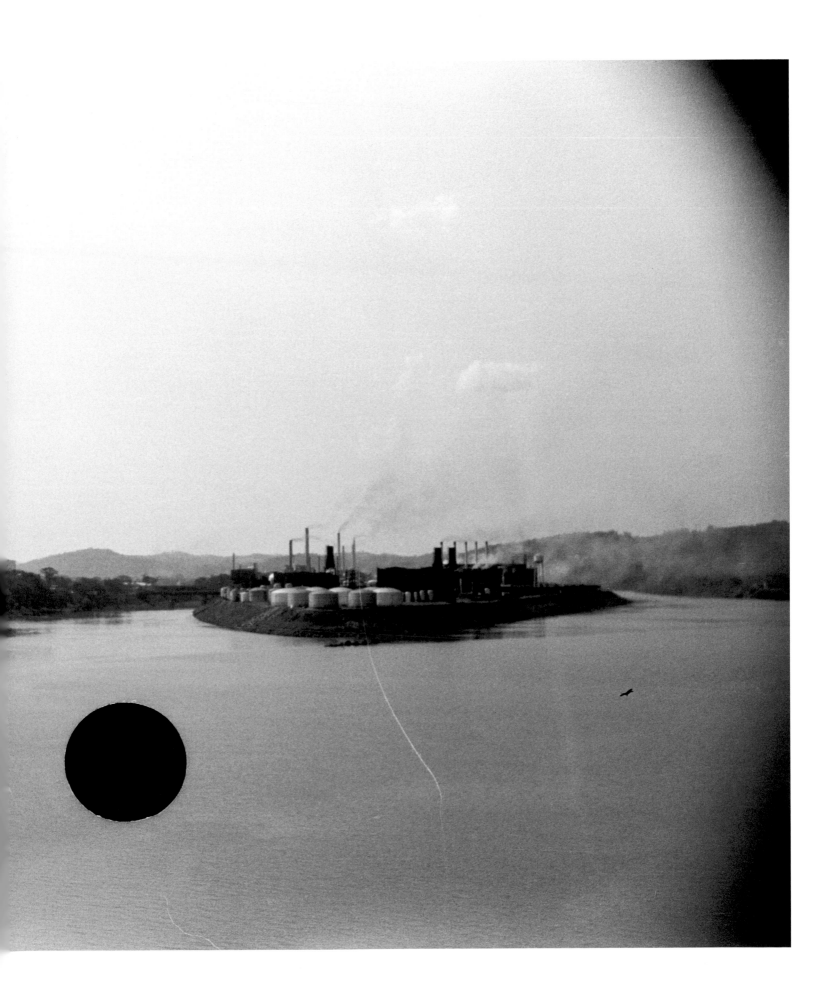

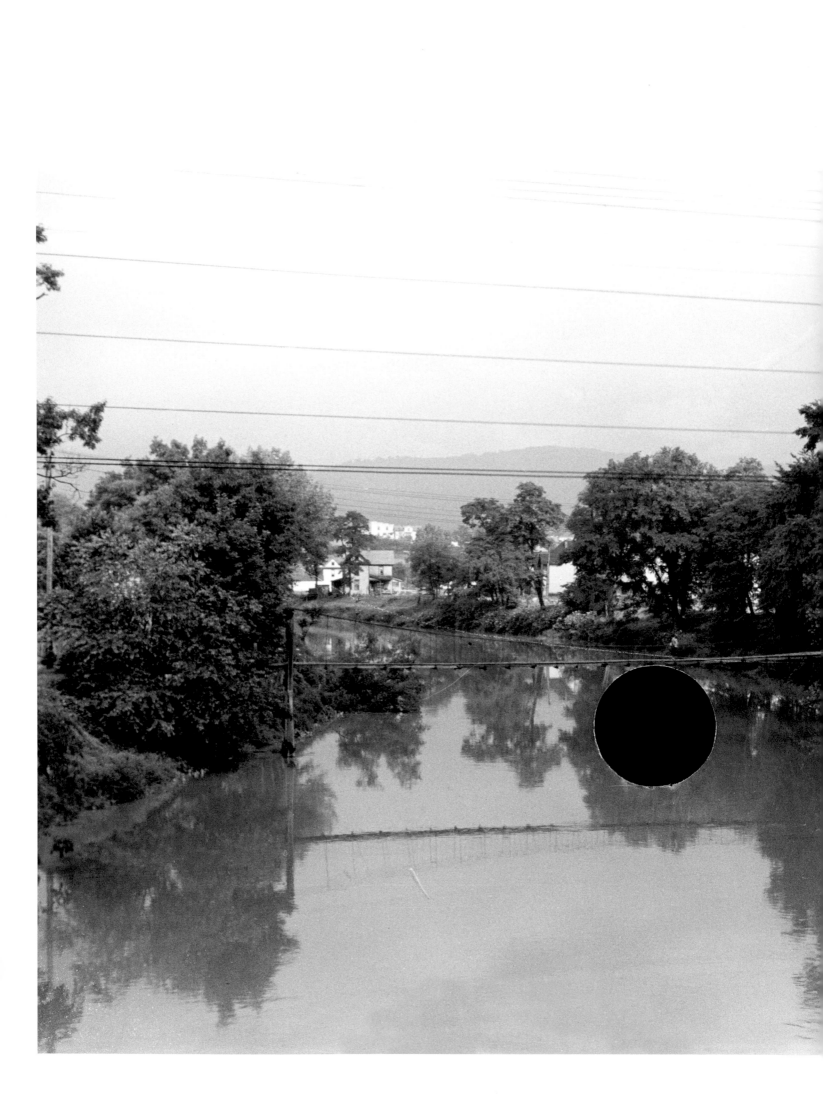

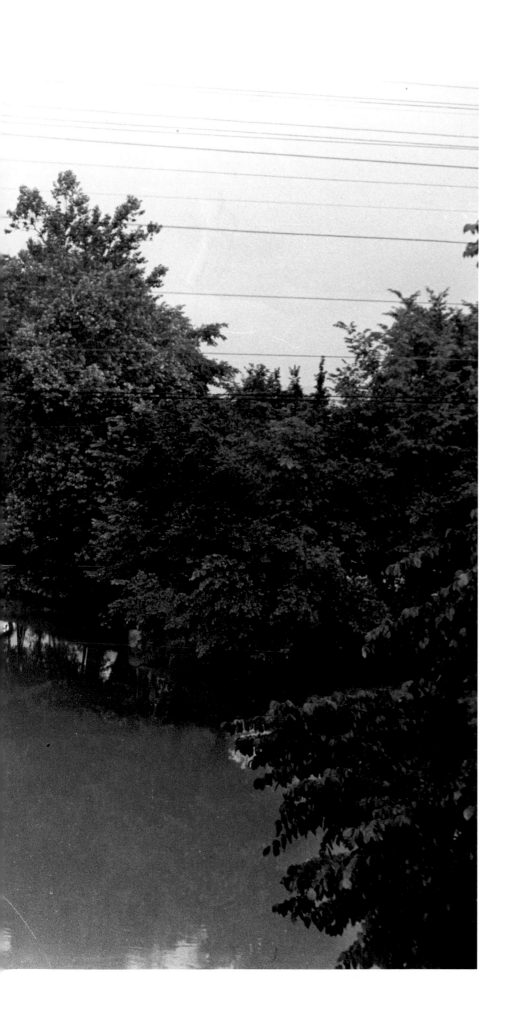

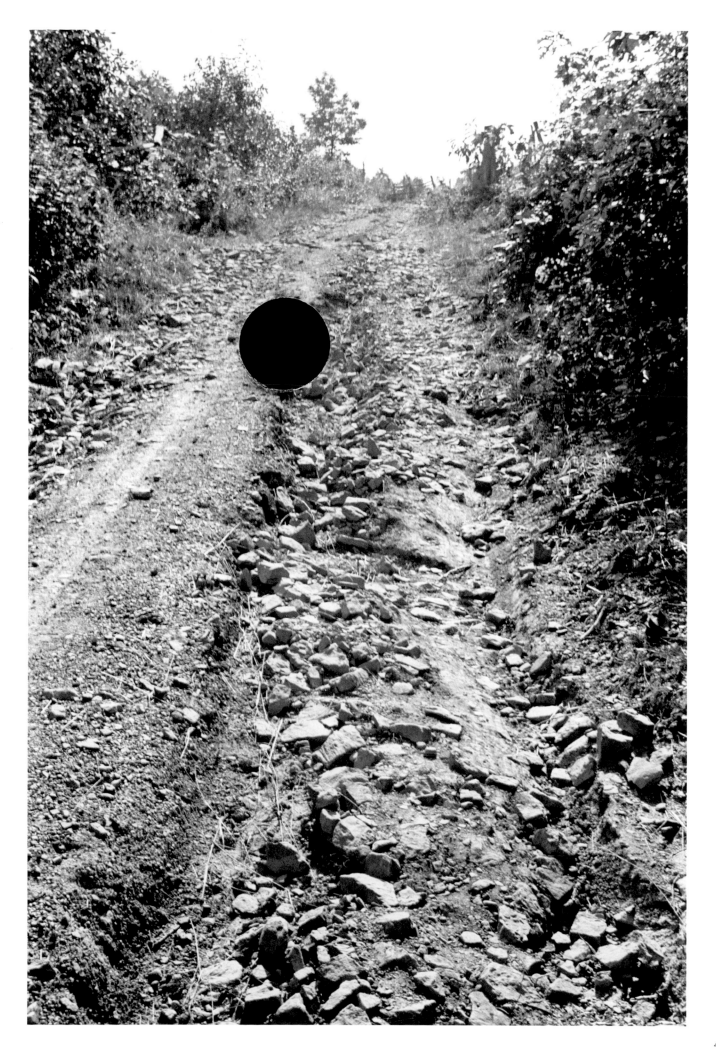

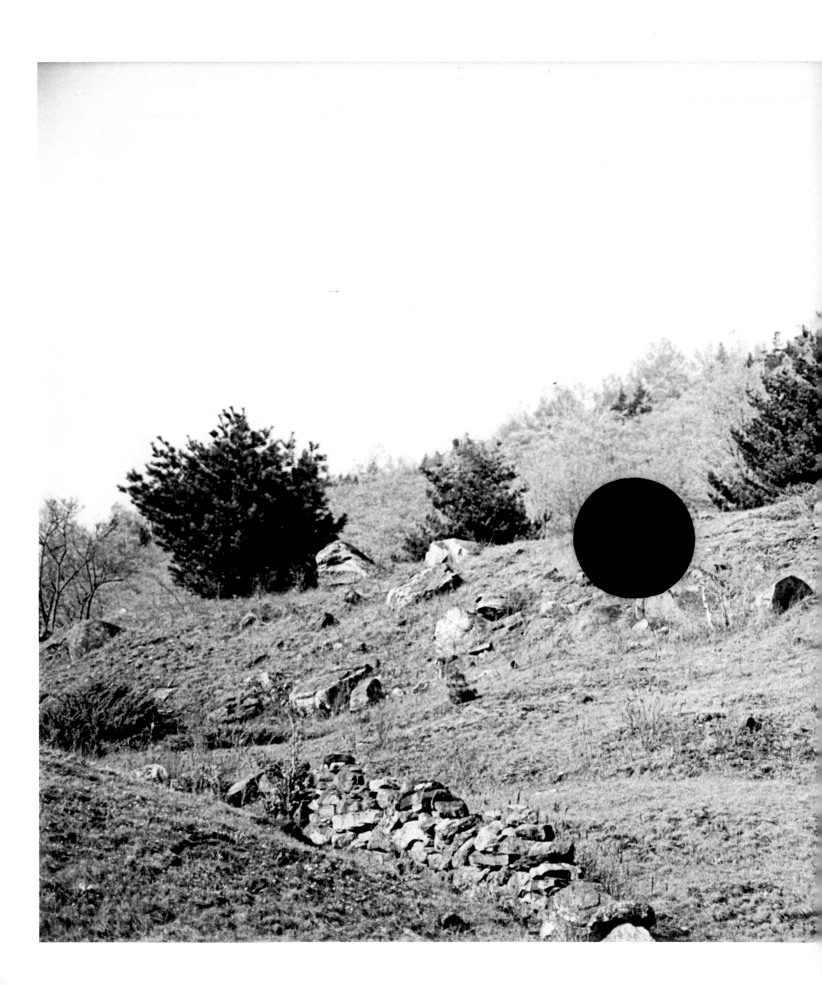

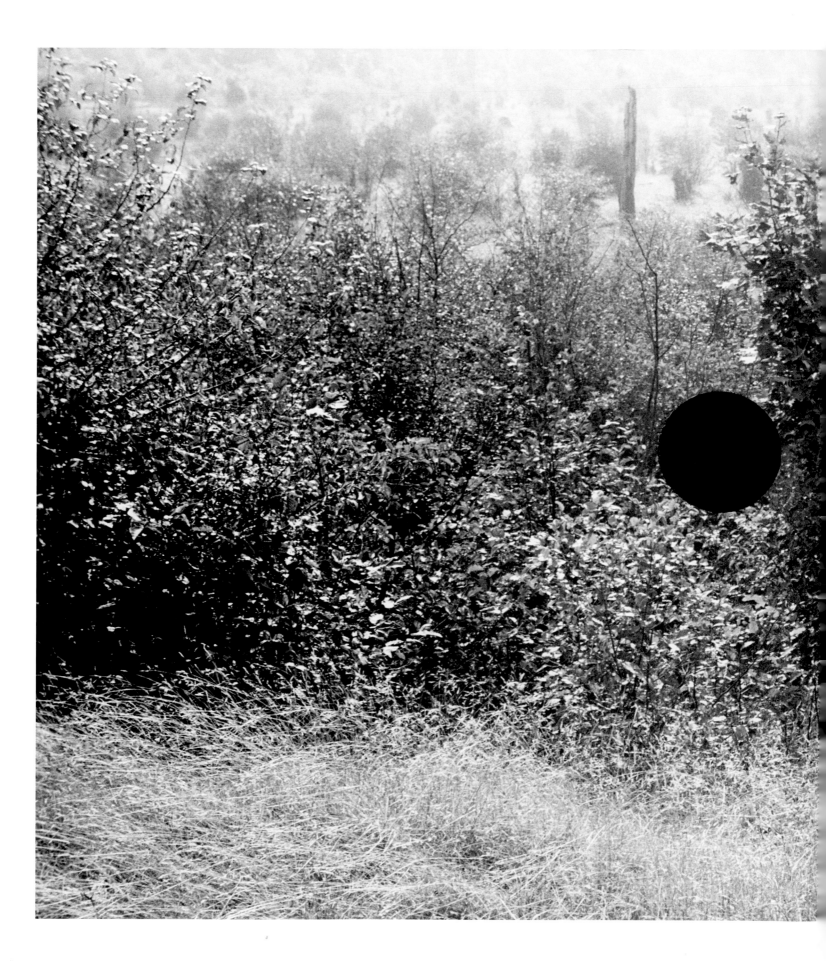

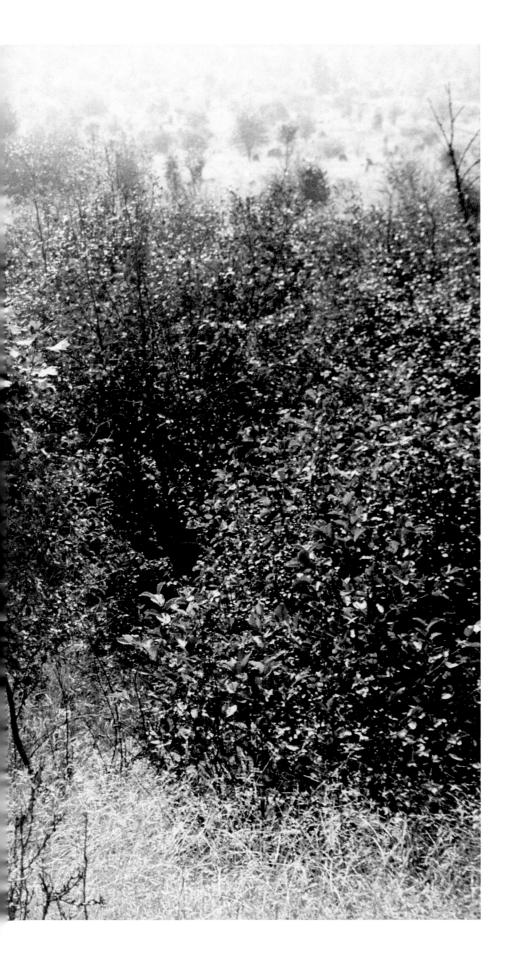

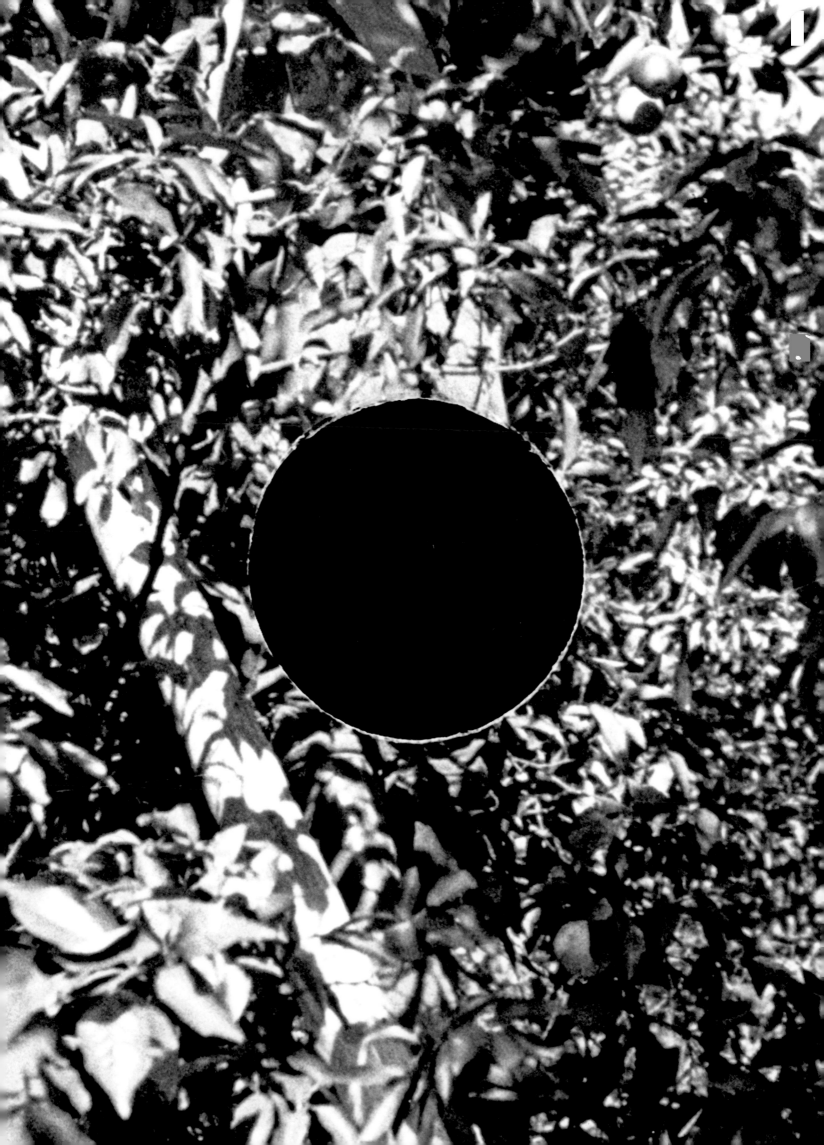

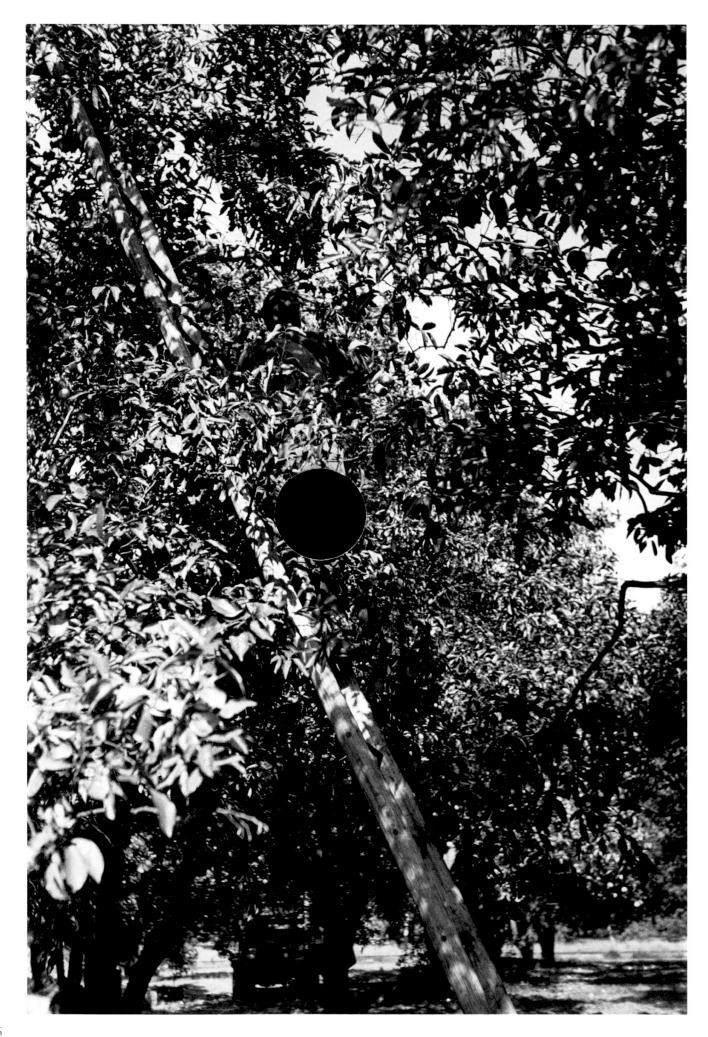

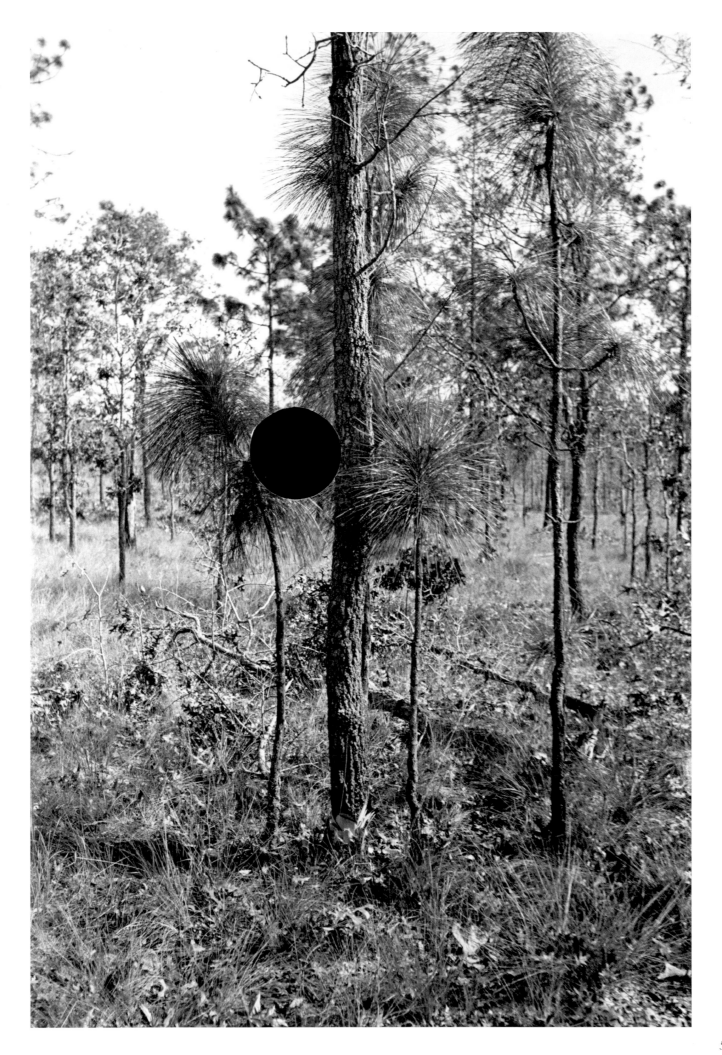

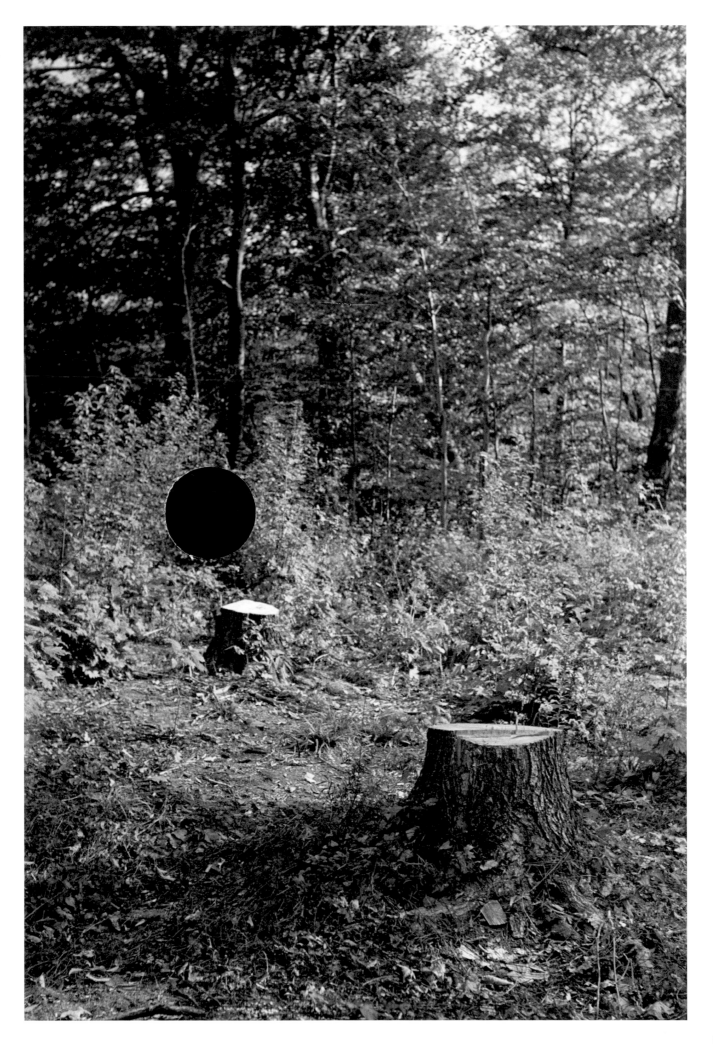

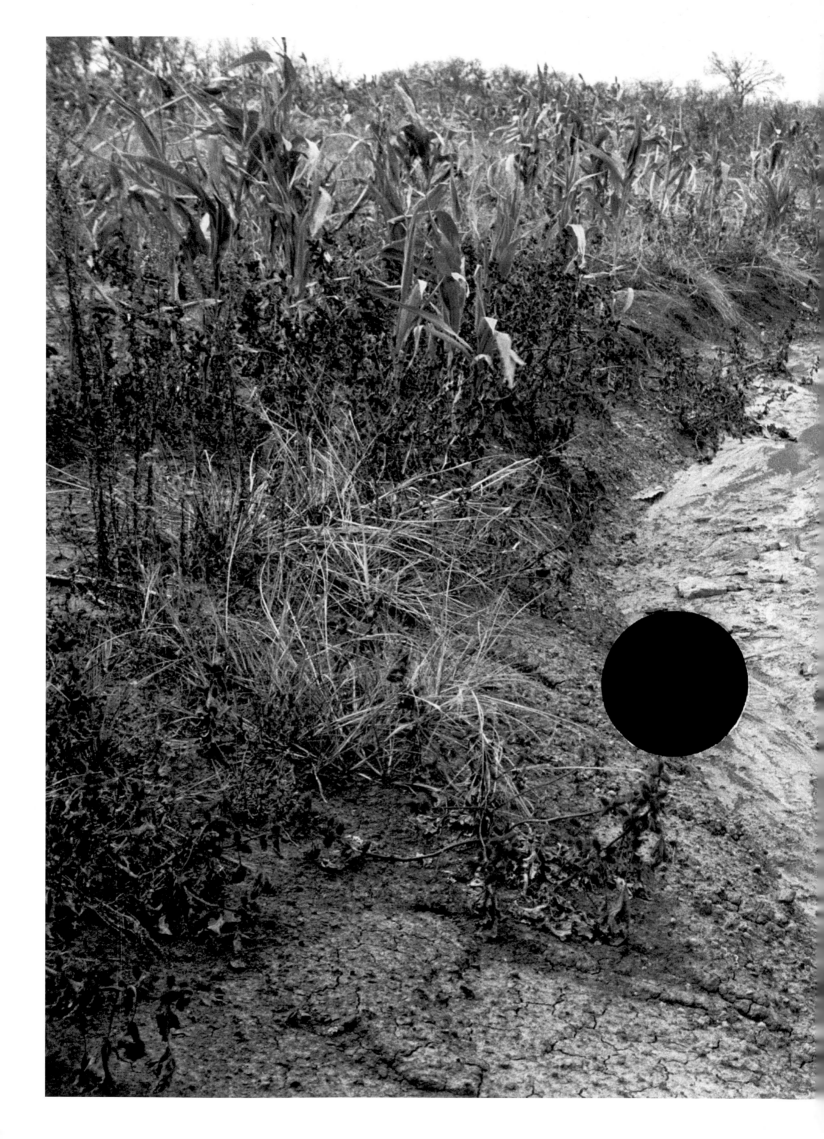

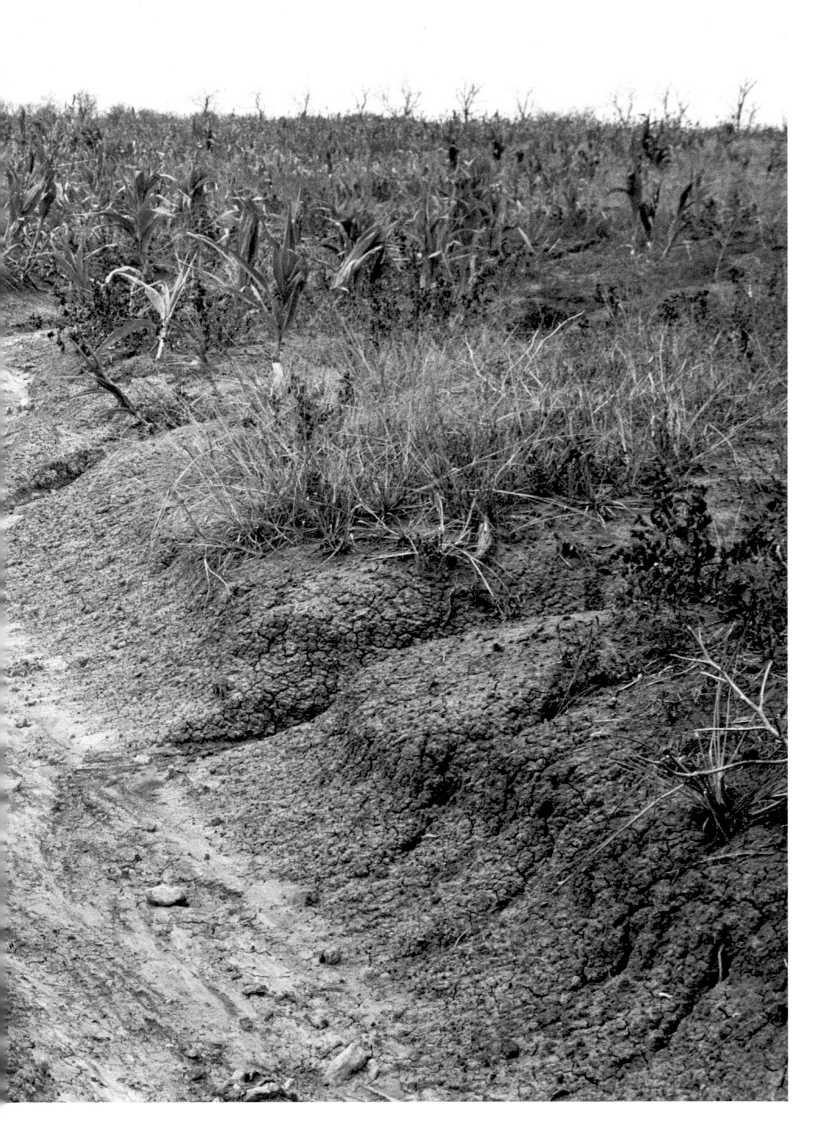

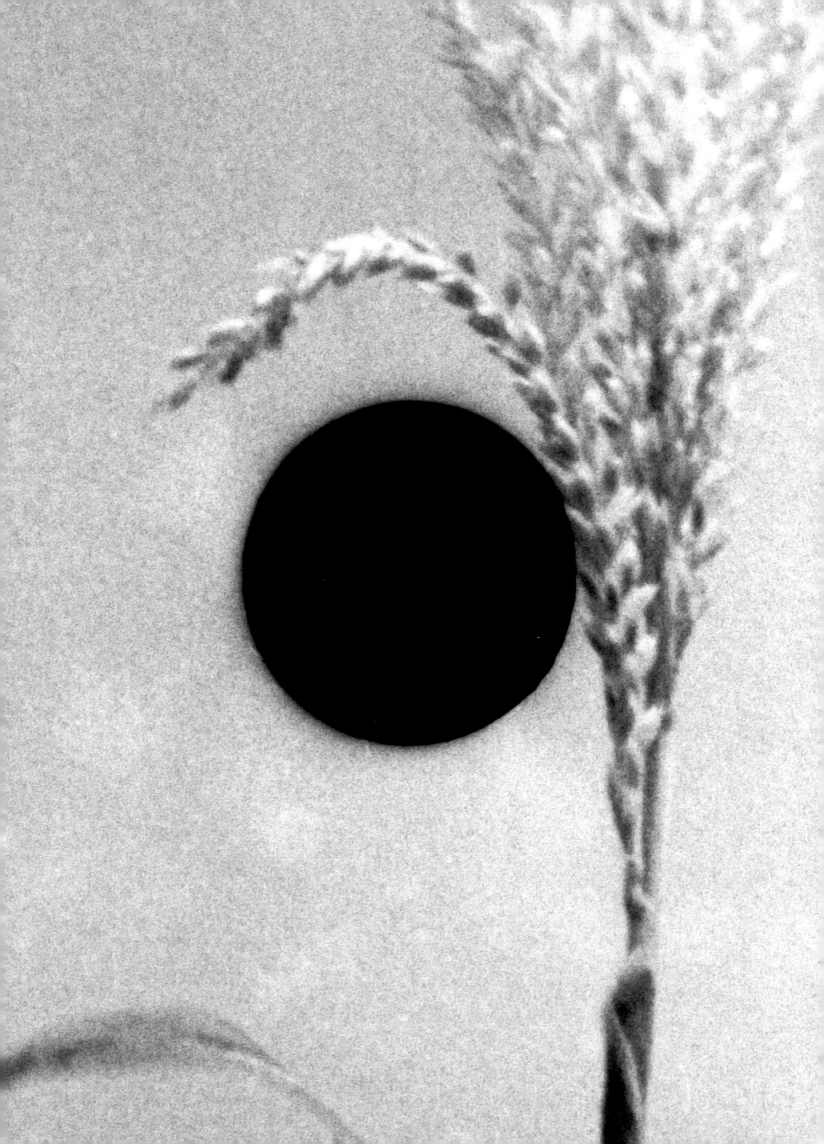

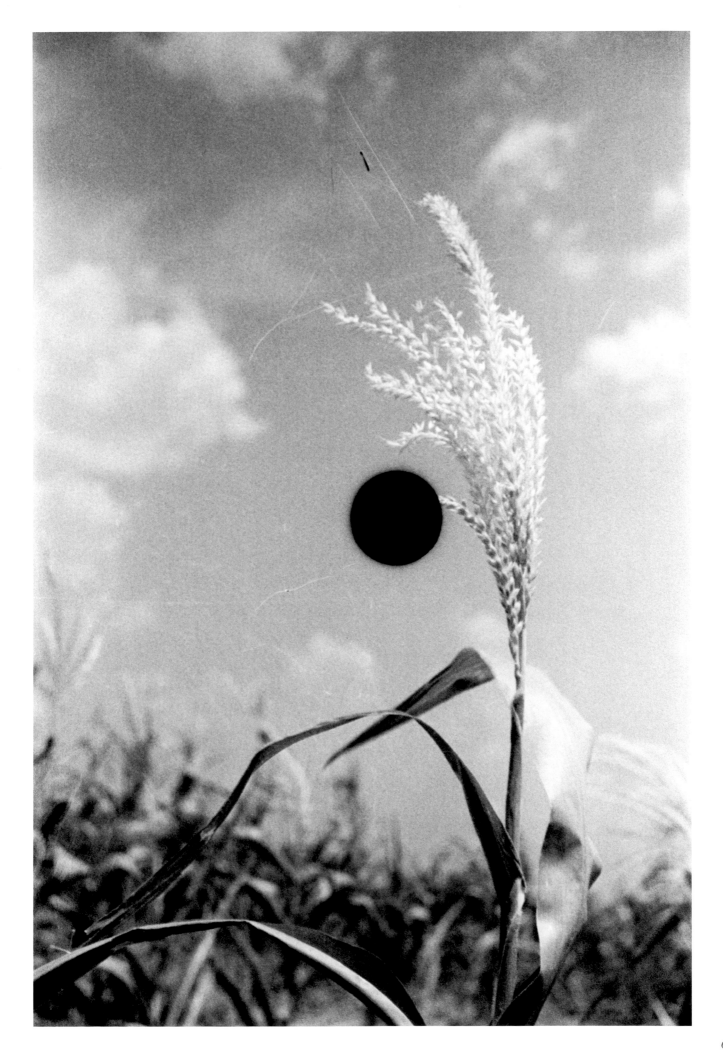

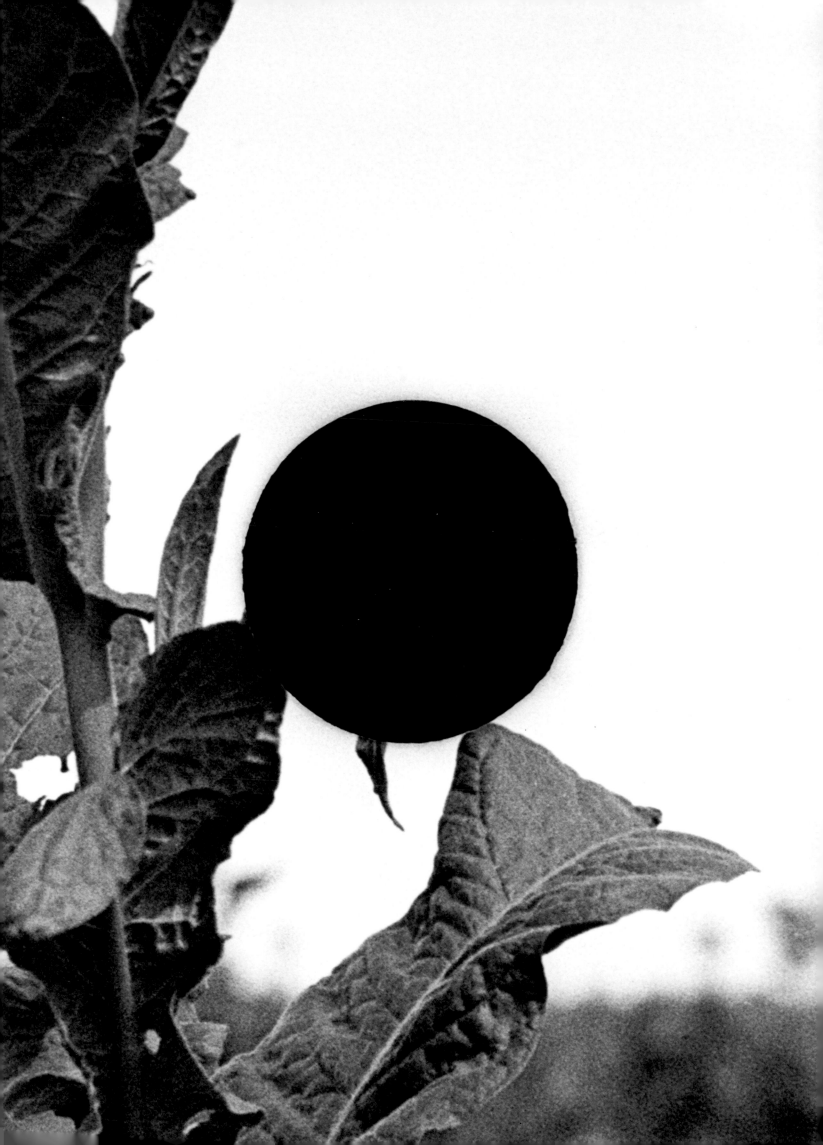

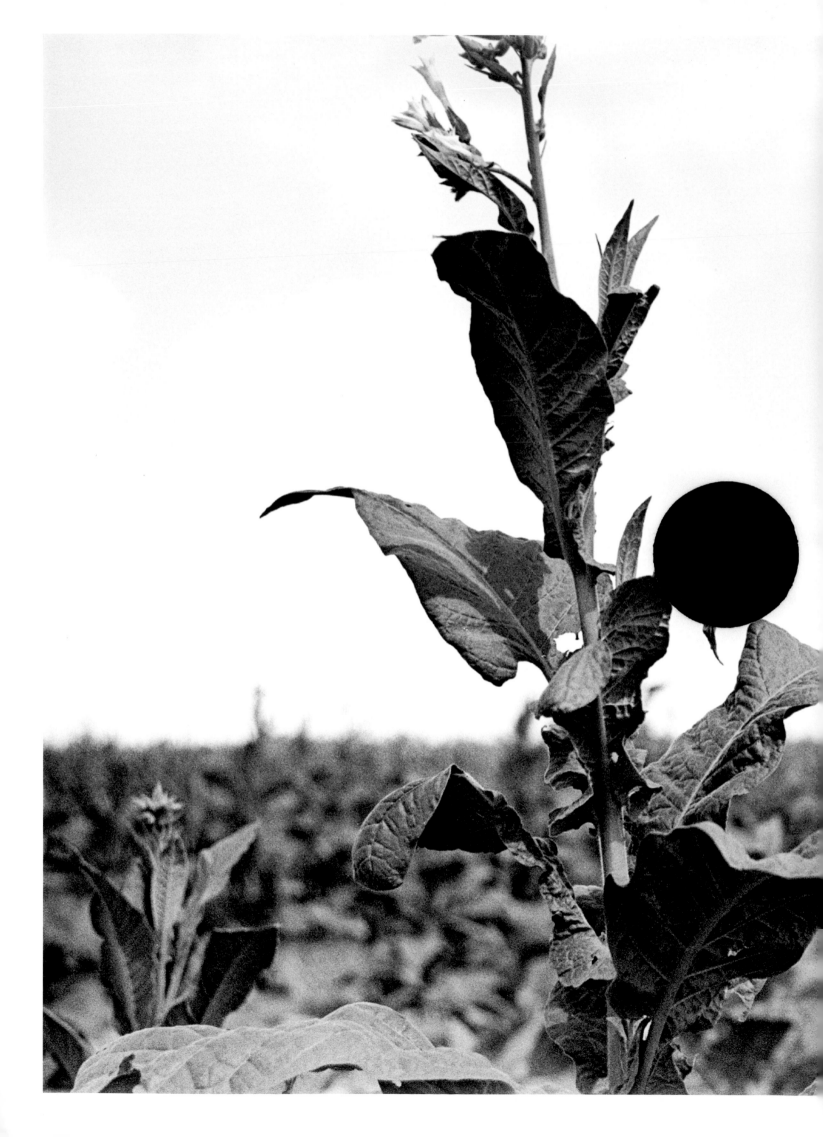

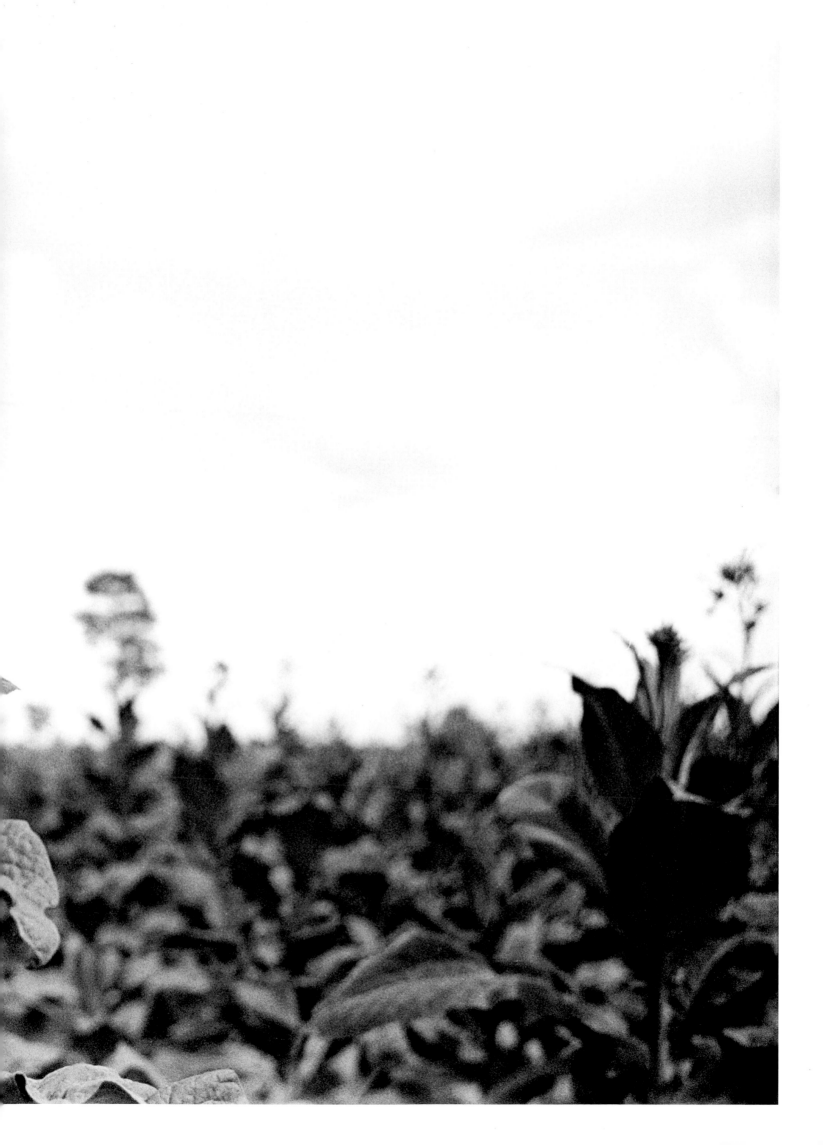

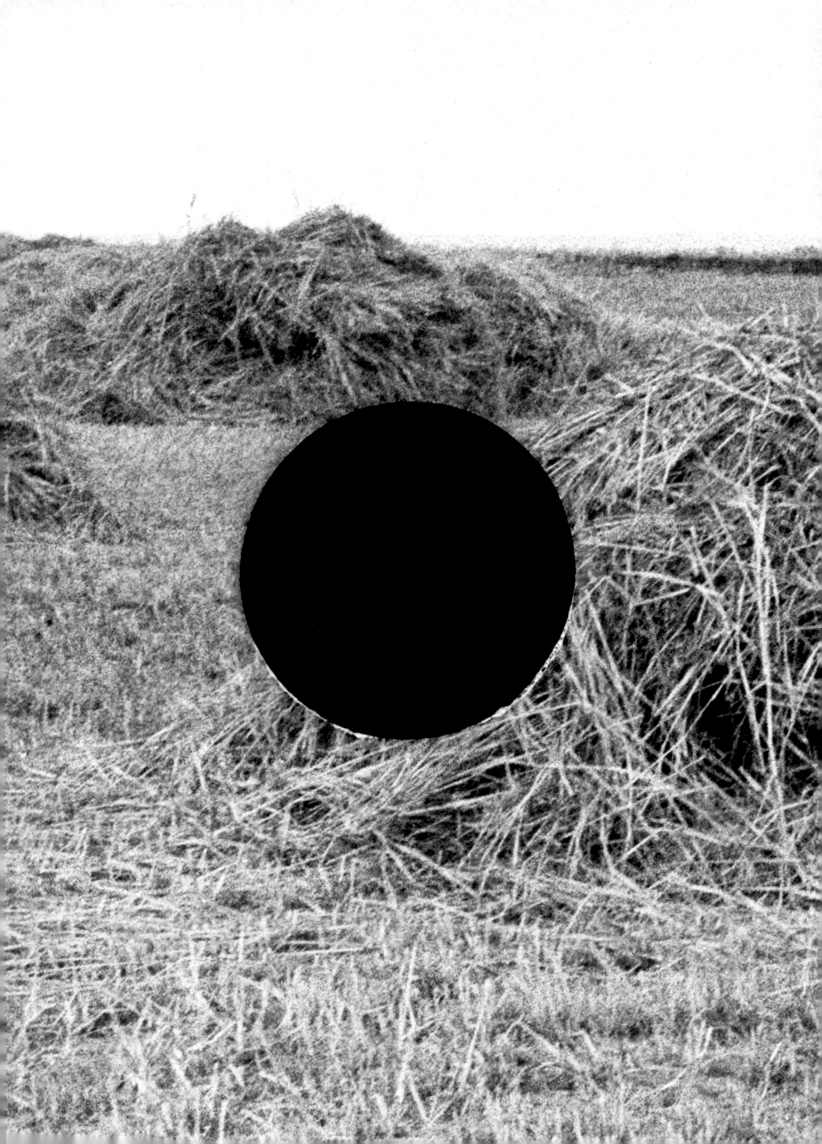

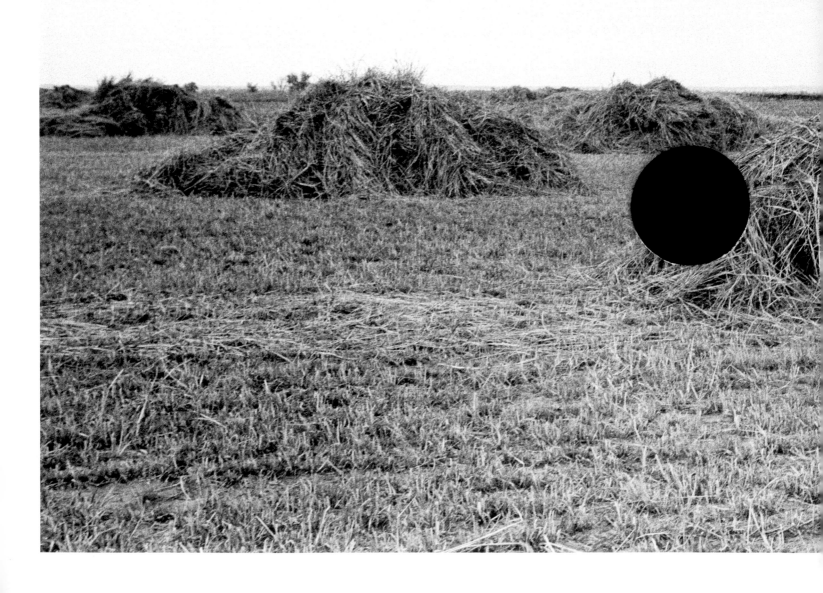

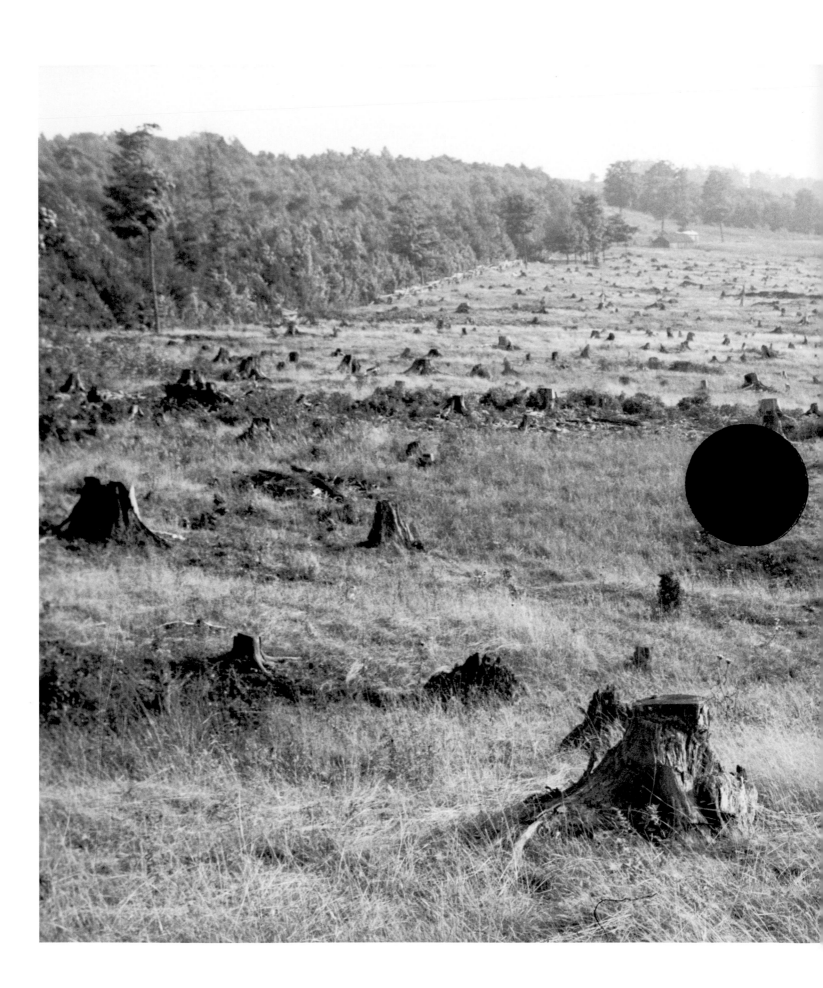

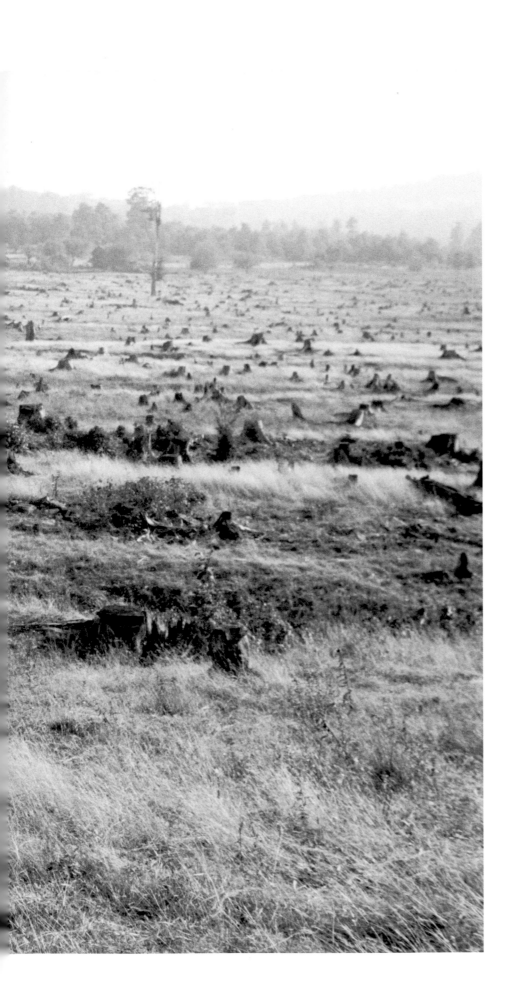

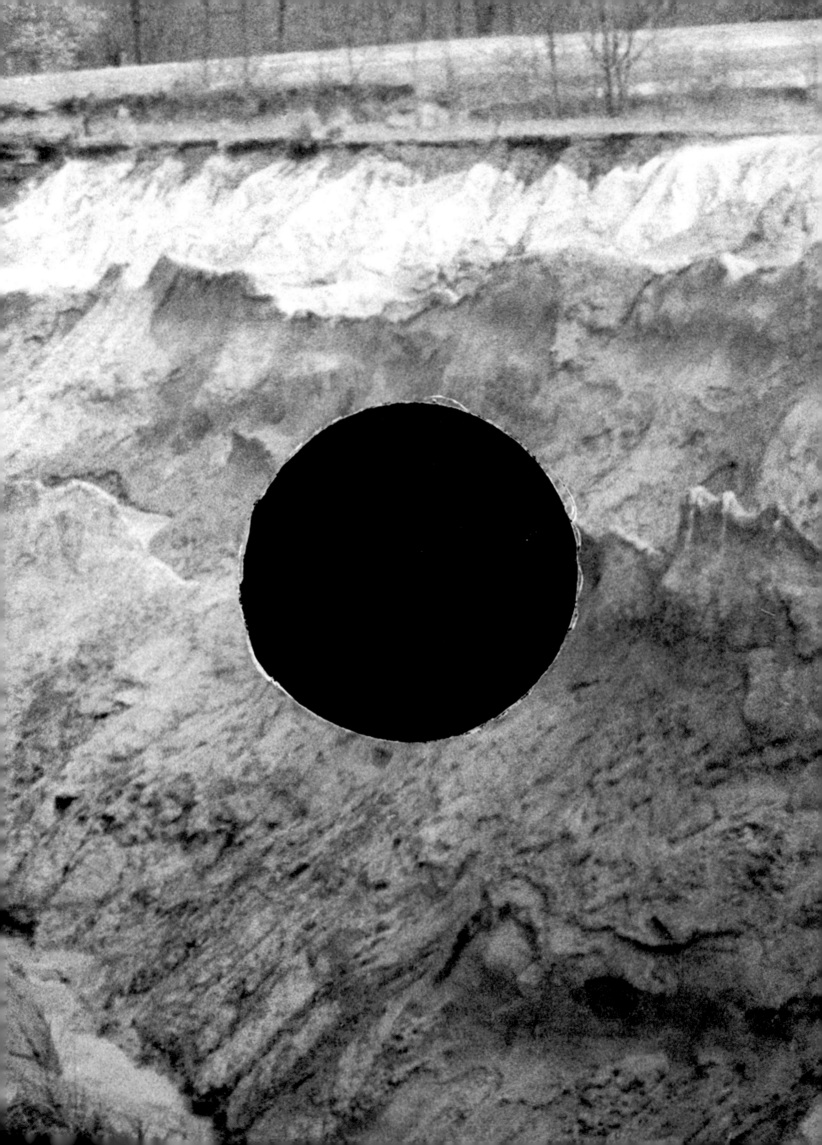

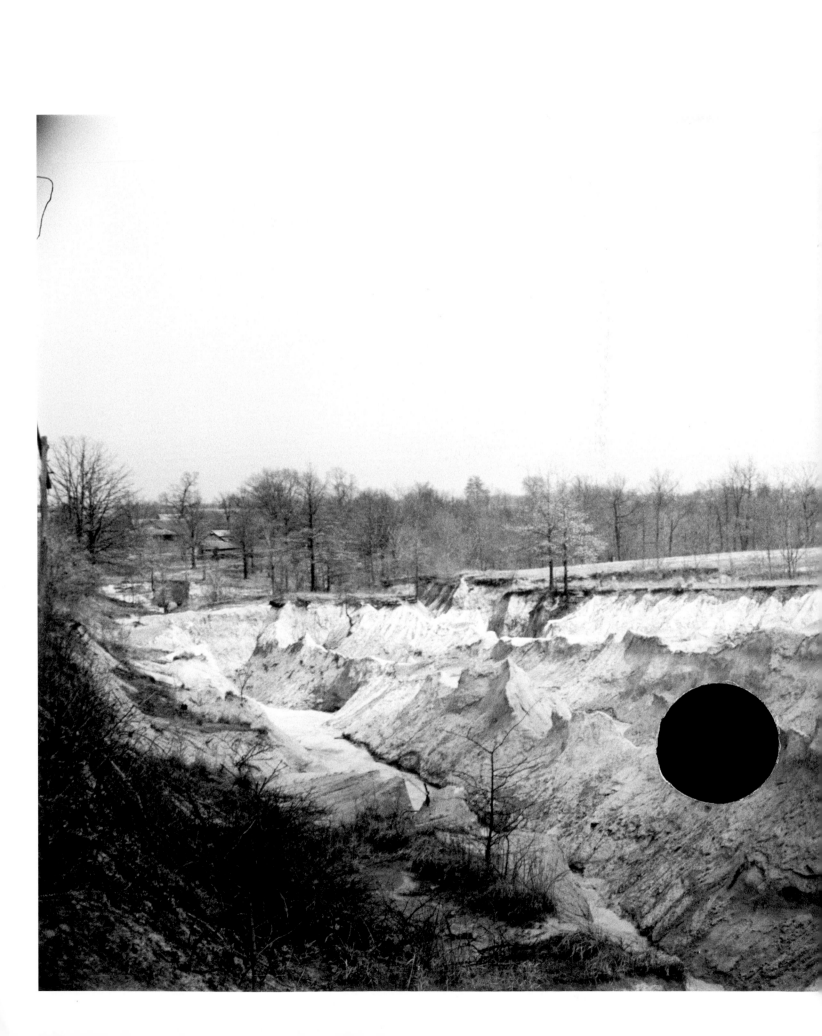

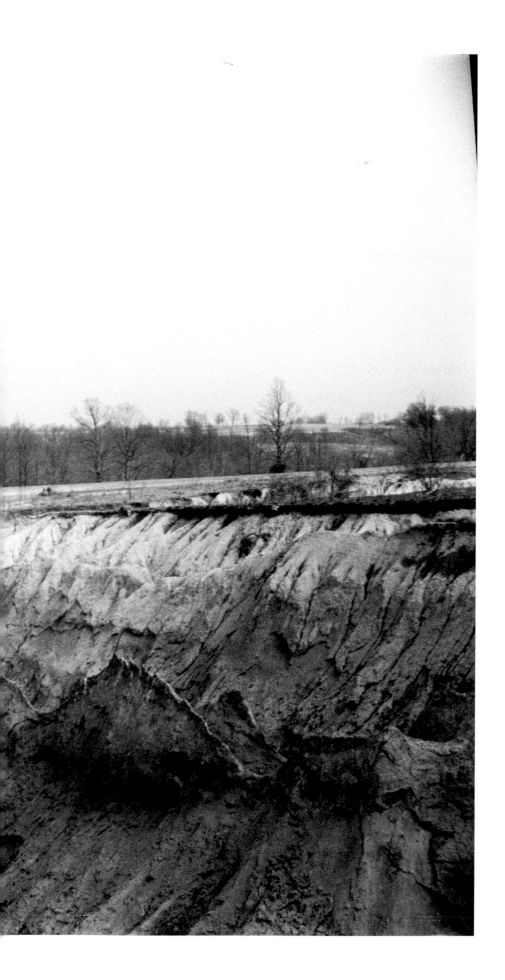

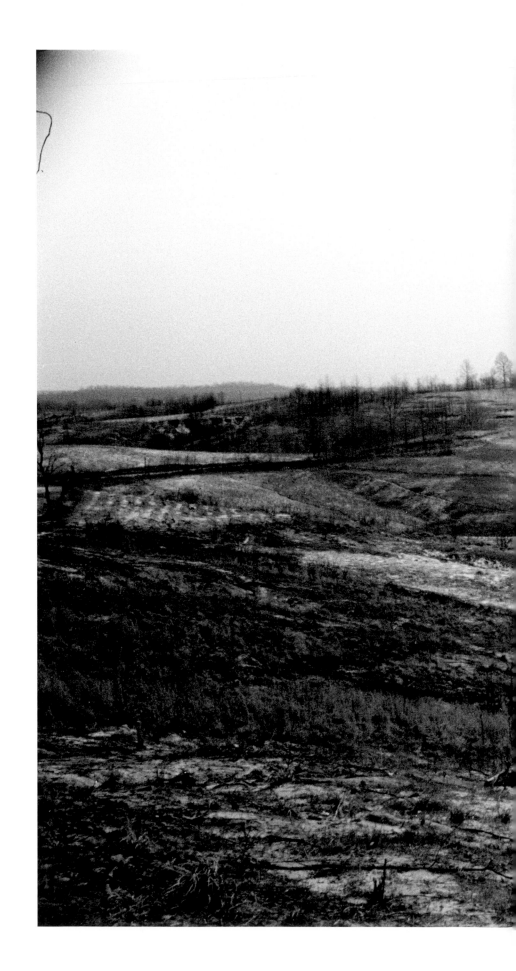

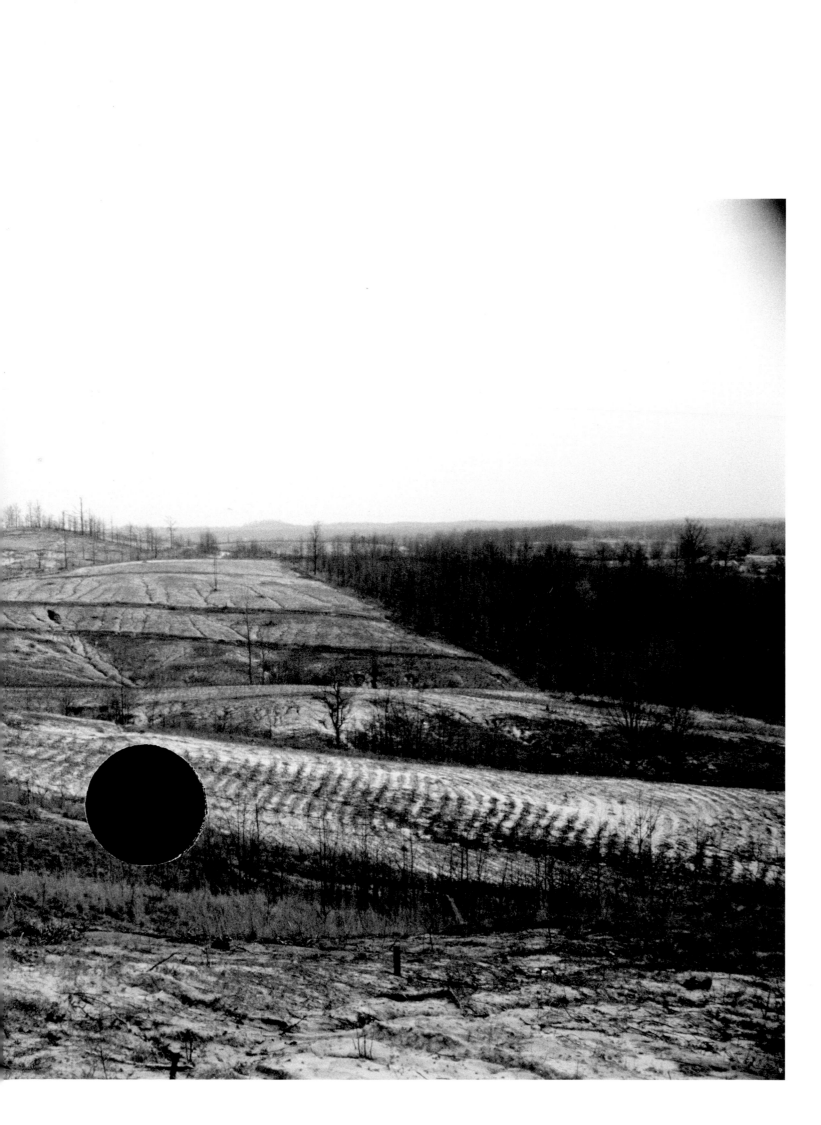

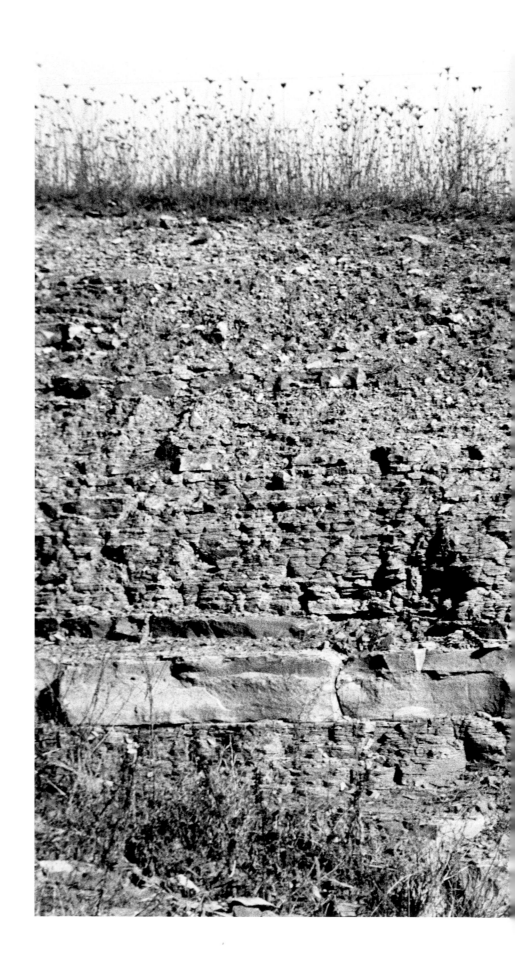

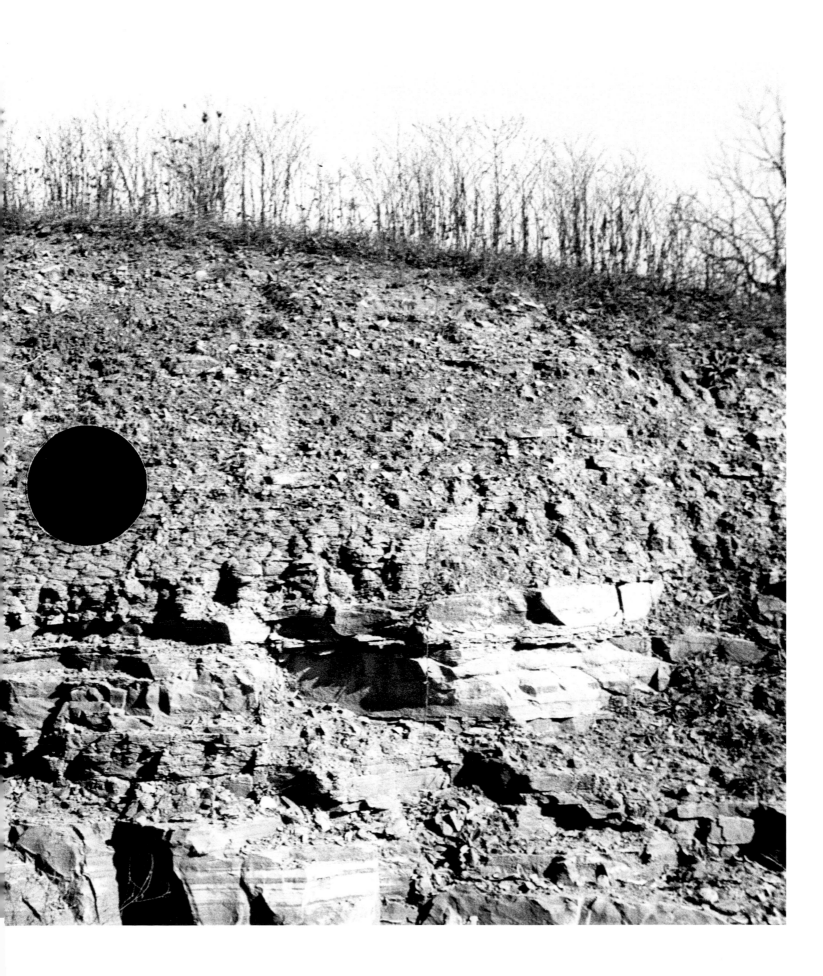

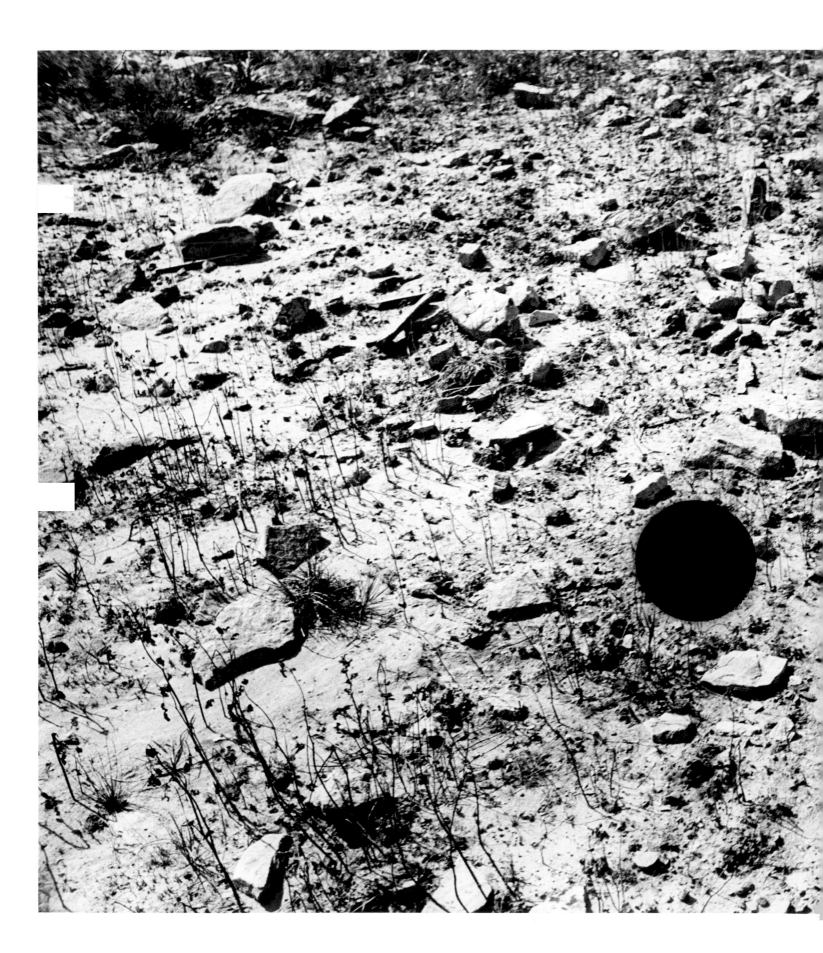

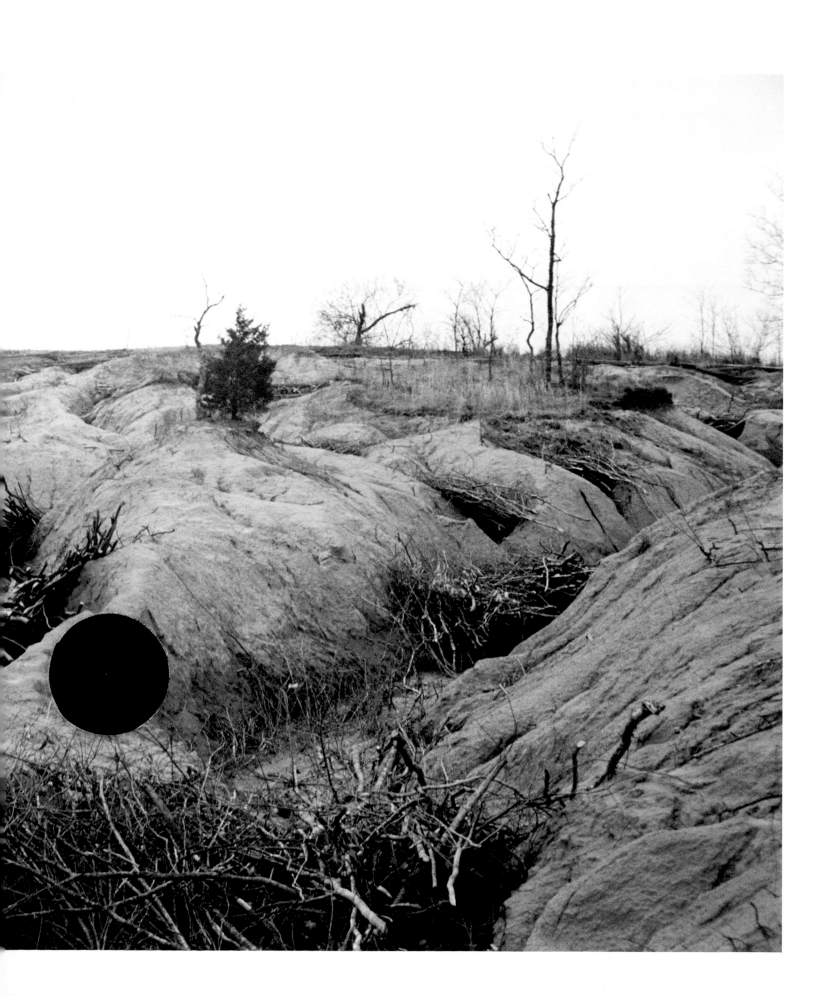

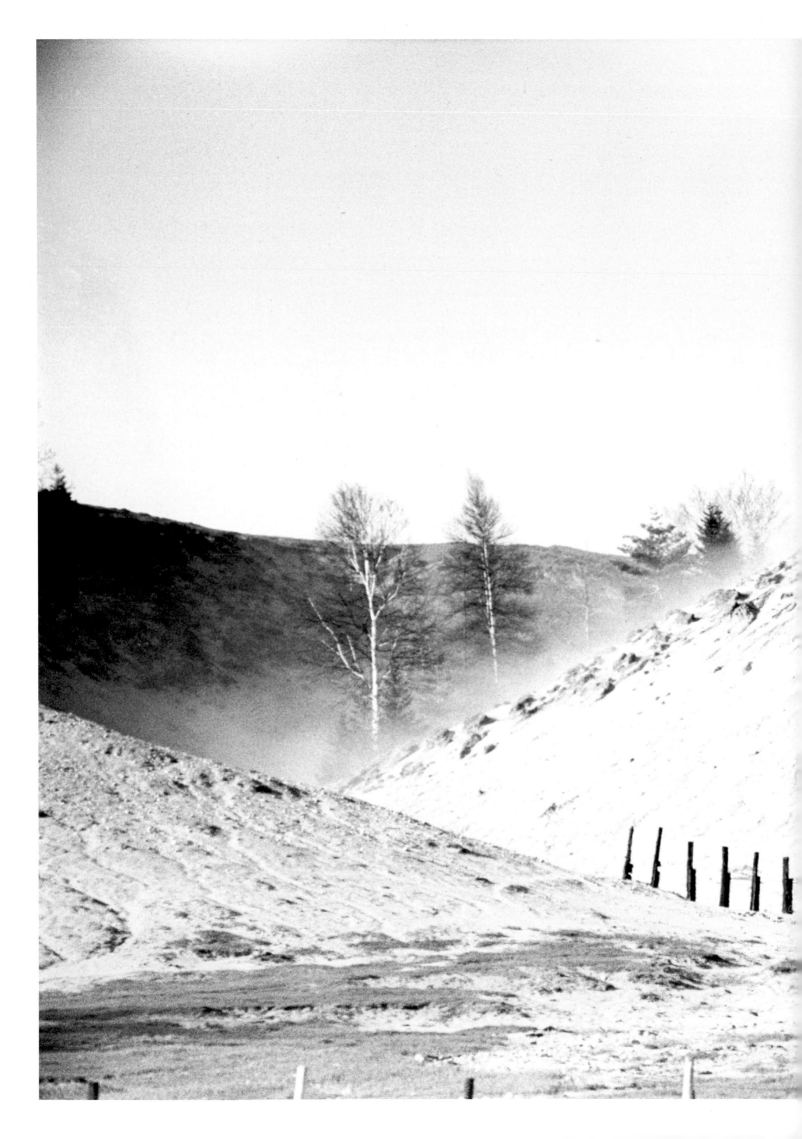

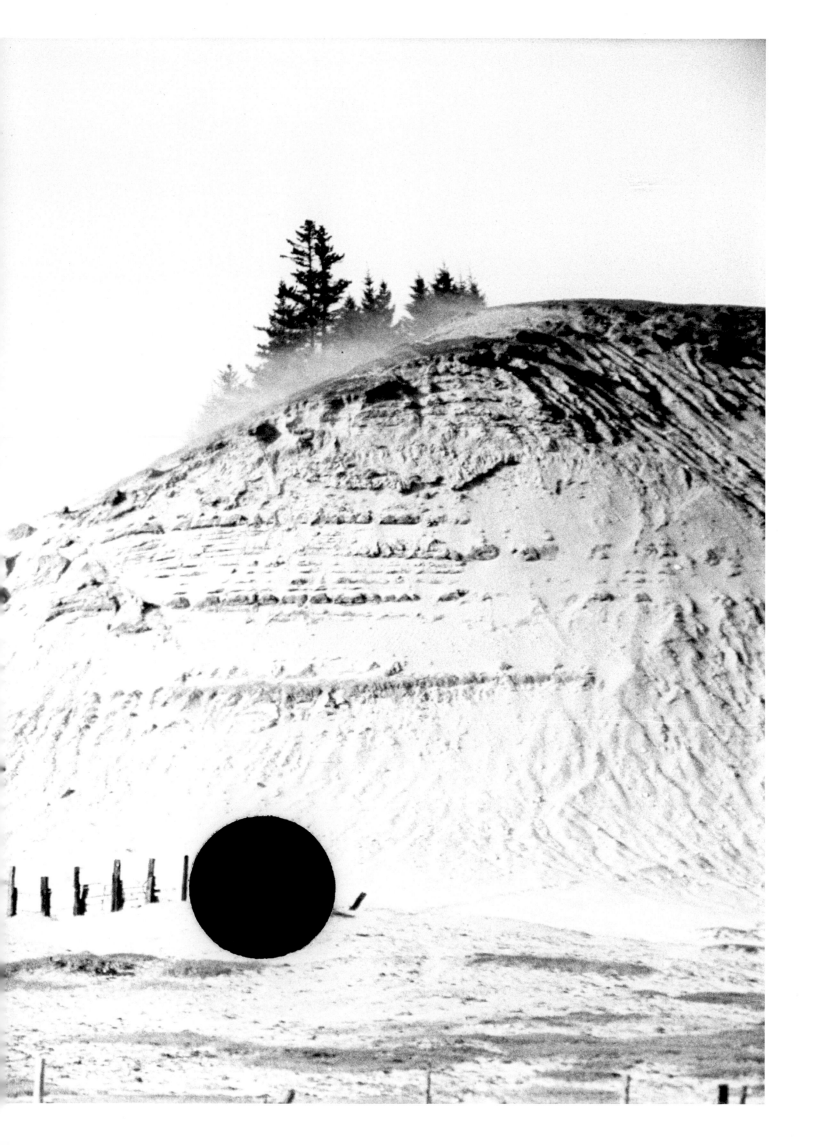

The Current

Having once put his hand into the ground,
seeding there what he hopes will outlast him,
a man has made a marriage with his place,
and if he leaves it his flesh will ache to go back.
His hand has given up its birdlife in the air.
It has reached into the dark like a root
and begun to wake, quick and mortal, in timelessness,
a flickering sap coursing upward into his head
so that he sees the old tribespeople bend
in the sun, digging with sticks, the forest opening
to receive their hills of corn, squash, and beans,
their lodges and graves, and closing again.
He is made their descendant, what they left
in the earth rising into him like a seasonal juice.
And he sees the bearers of his own blood arriving,
the forest burrowing into the earth as they come,
their hands gathering the stones up into walls,
and relaxing, the stones crawling back into the ground
to lie still under the black wheels of machines.
The current flowing to him through the earth
flows past him, and he sees one descended from him,
a young man who has reached into the ground,
his hand held in the dark as by a hand.

—*Wendell Berry*

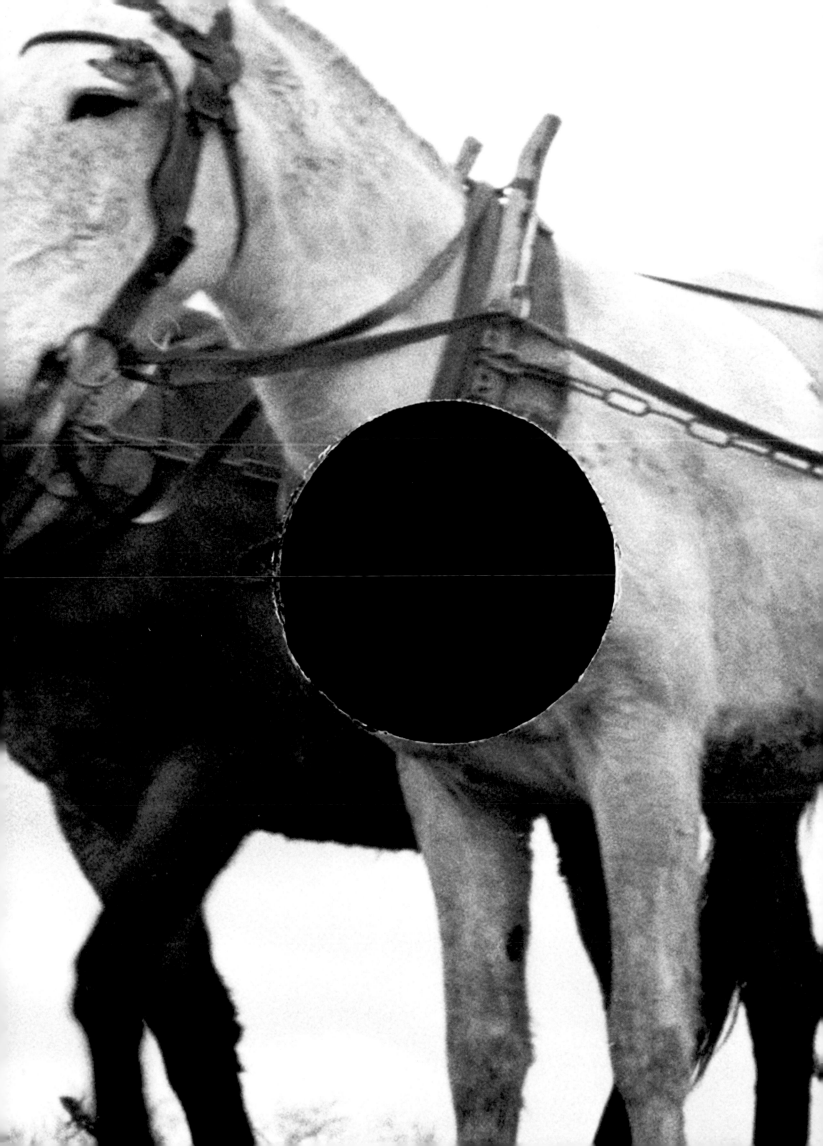

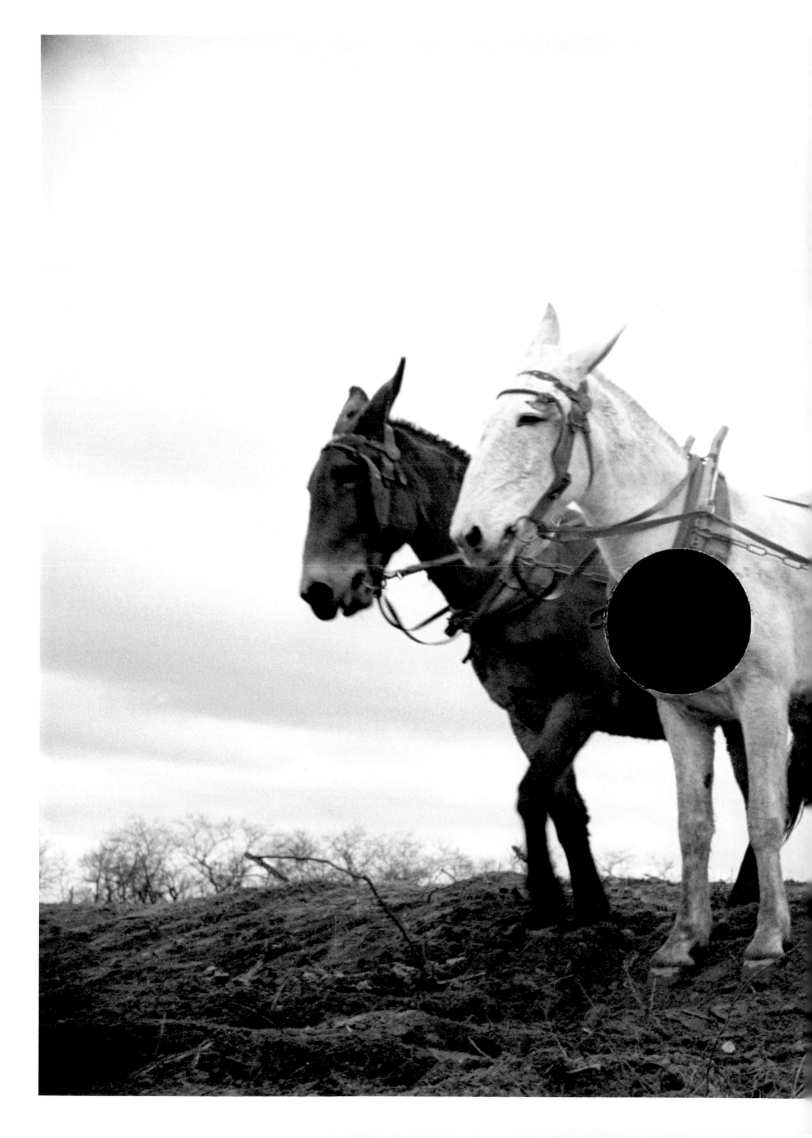

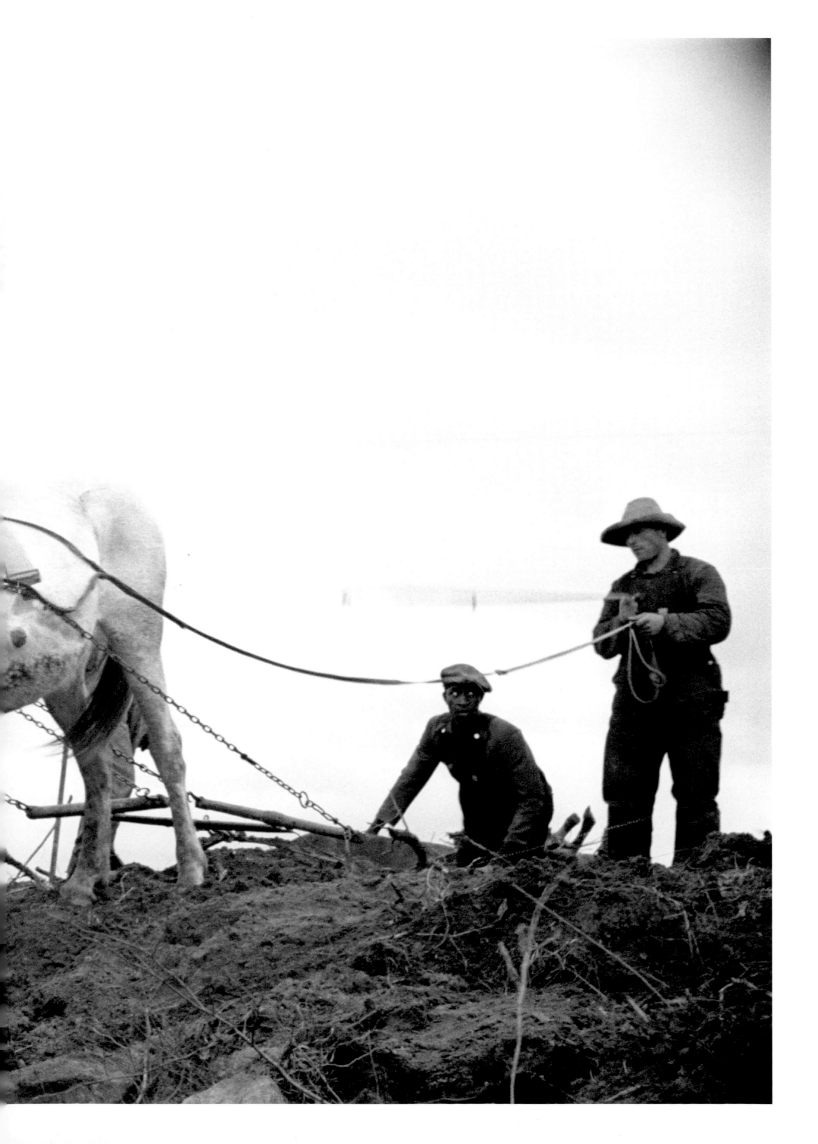

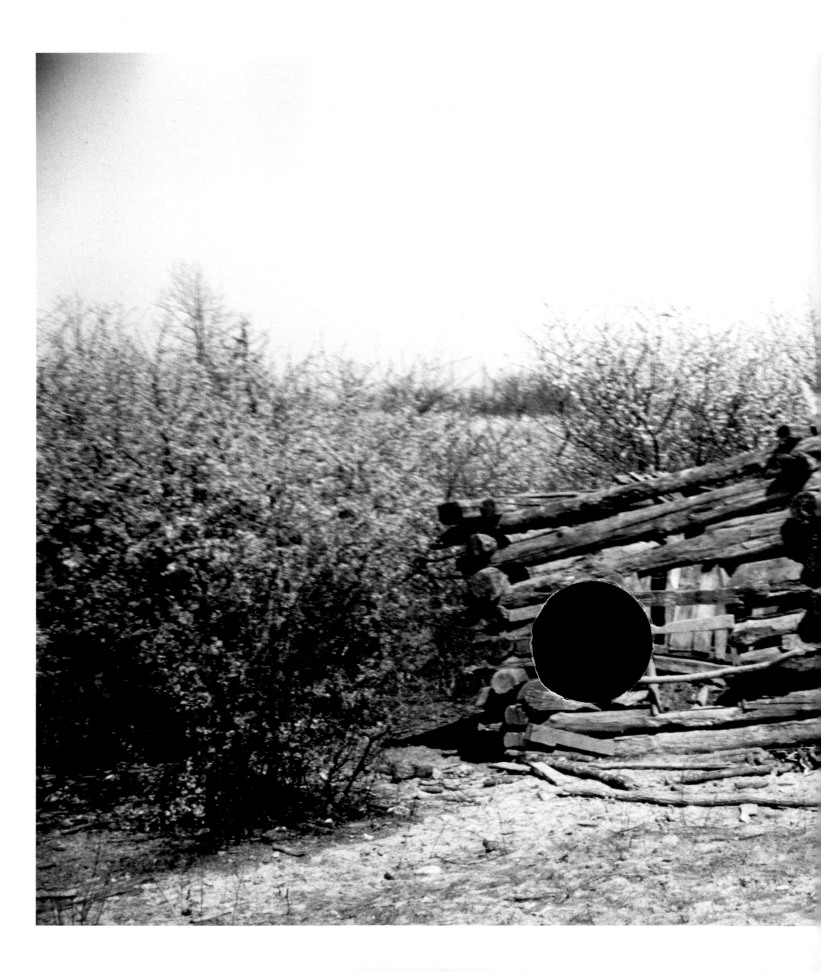

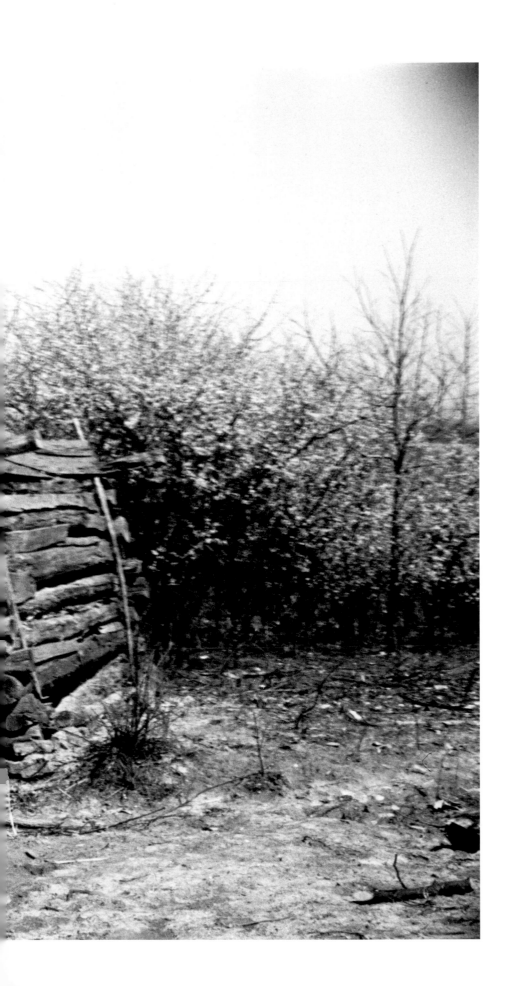

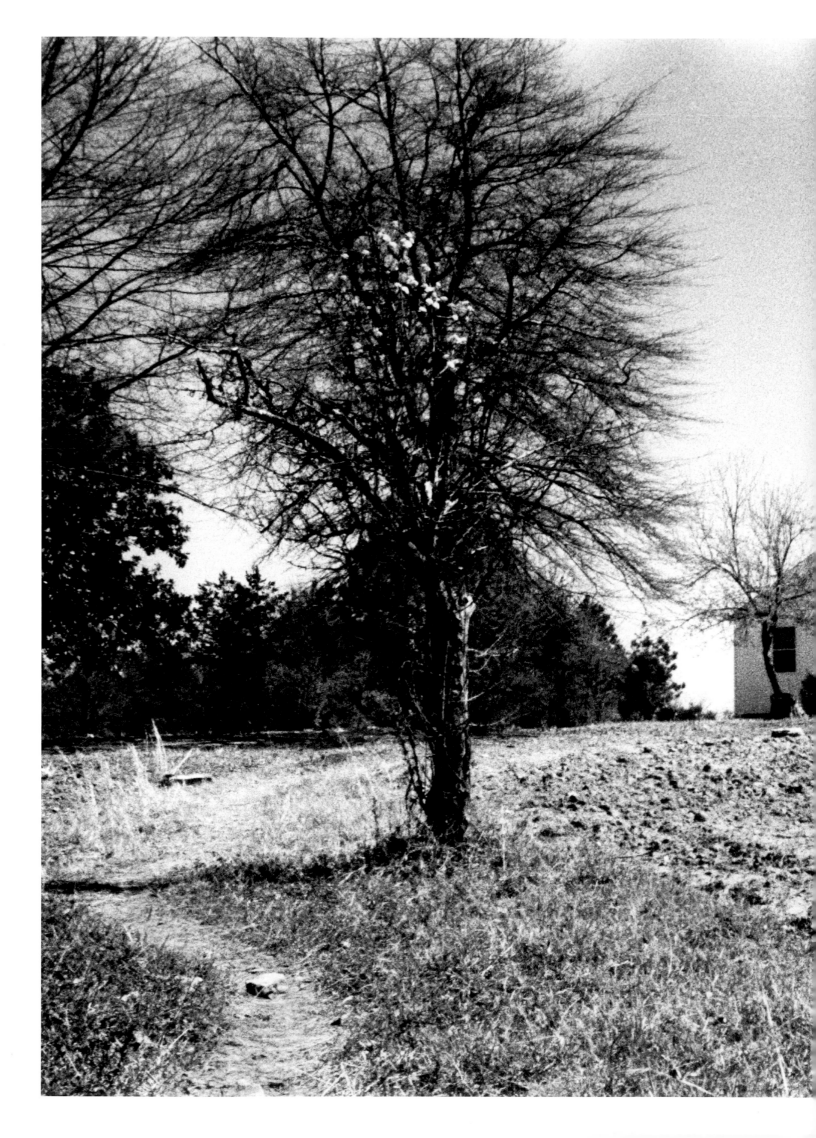

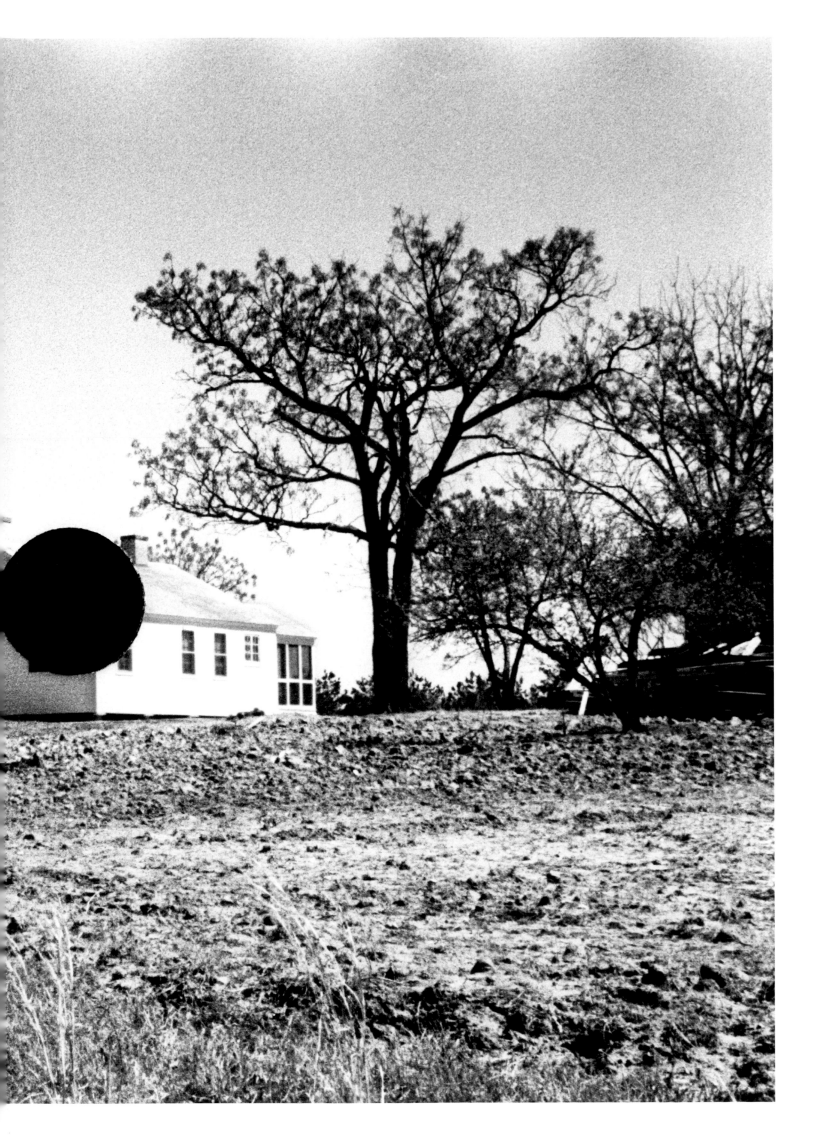

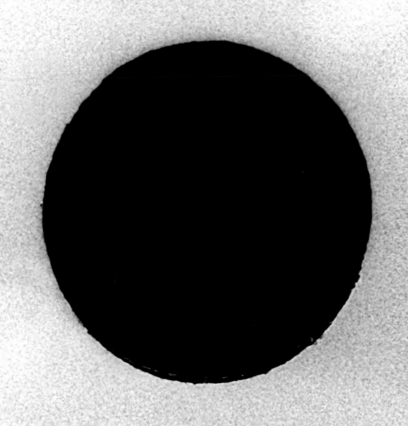

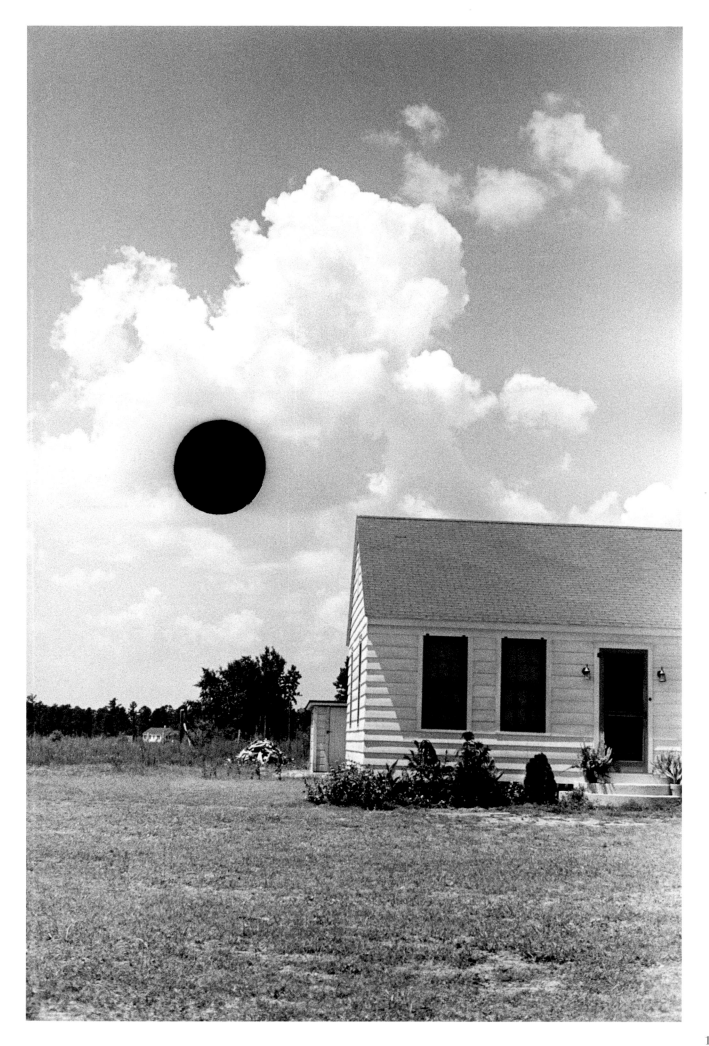

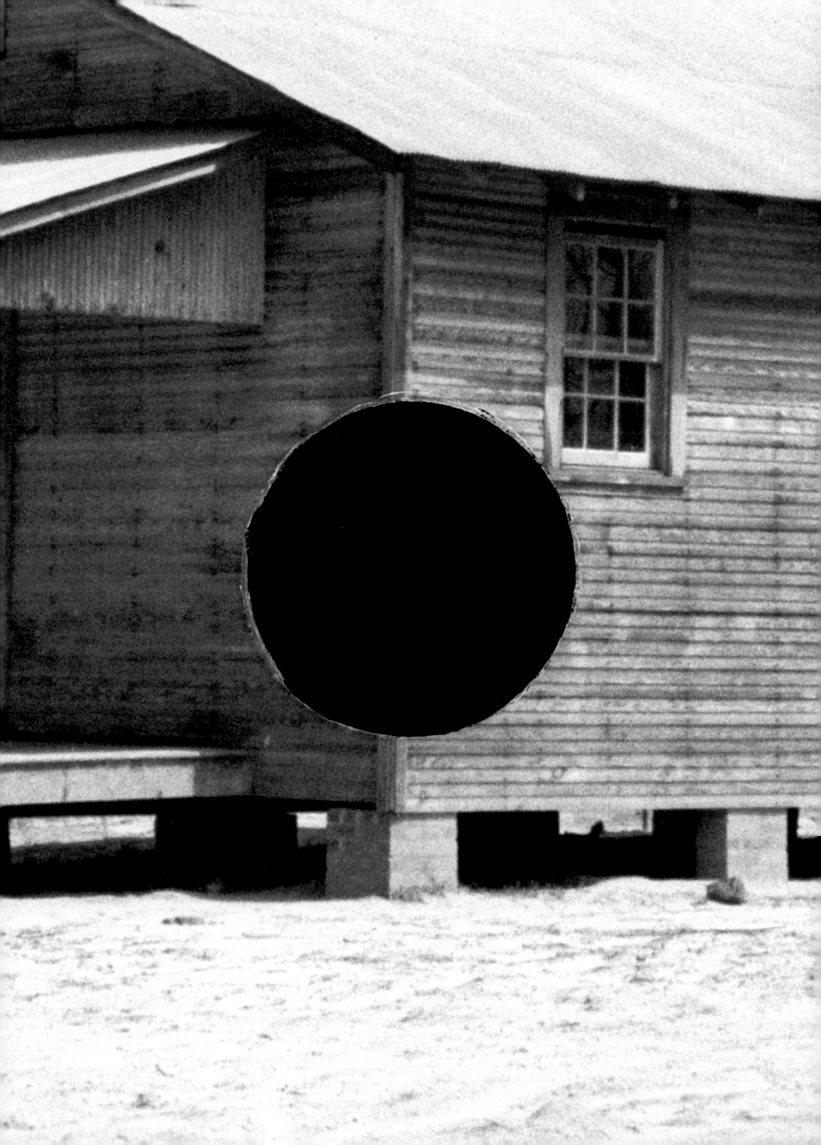

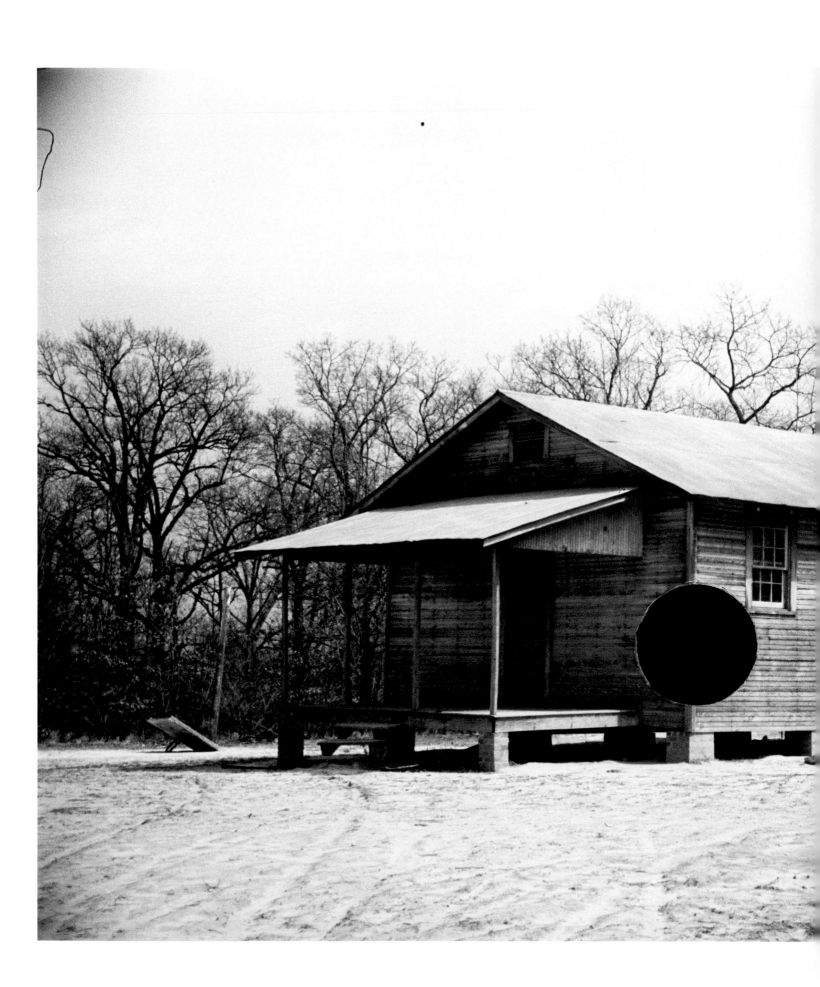

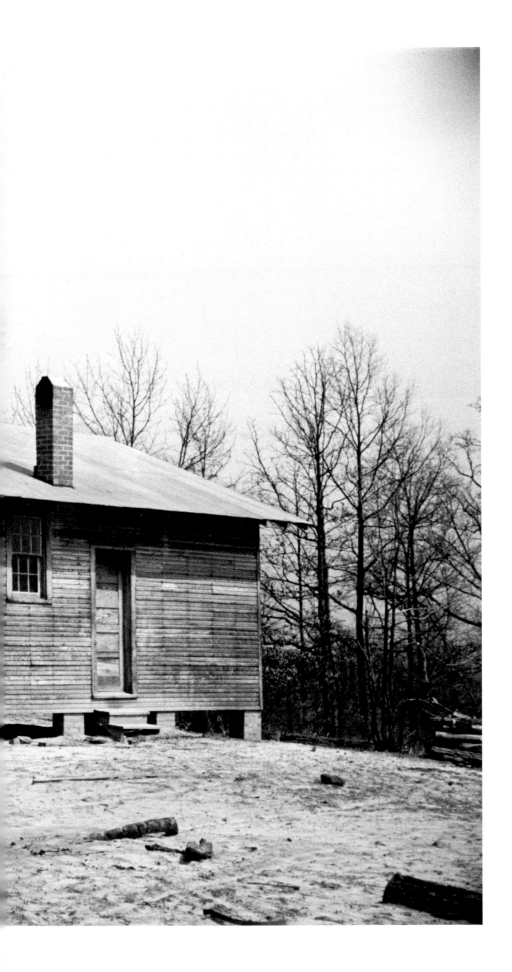

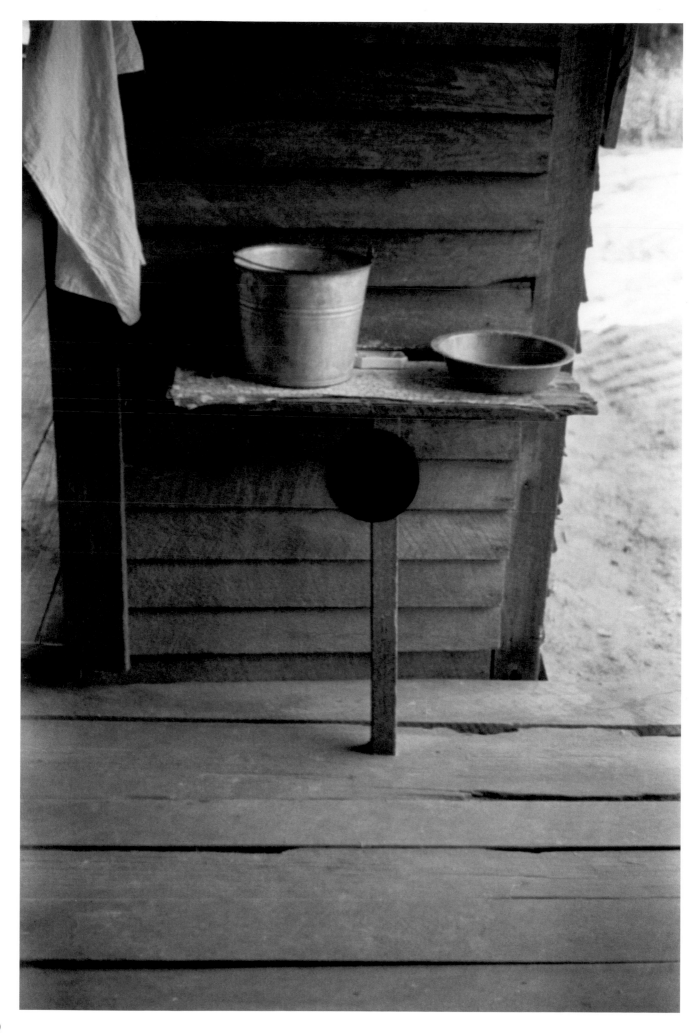

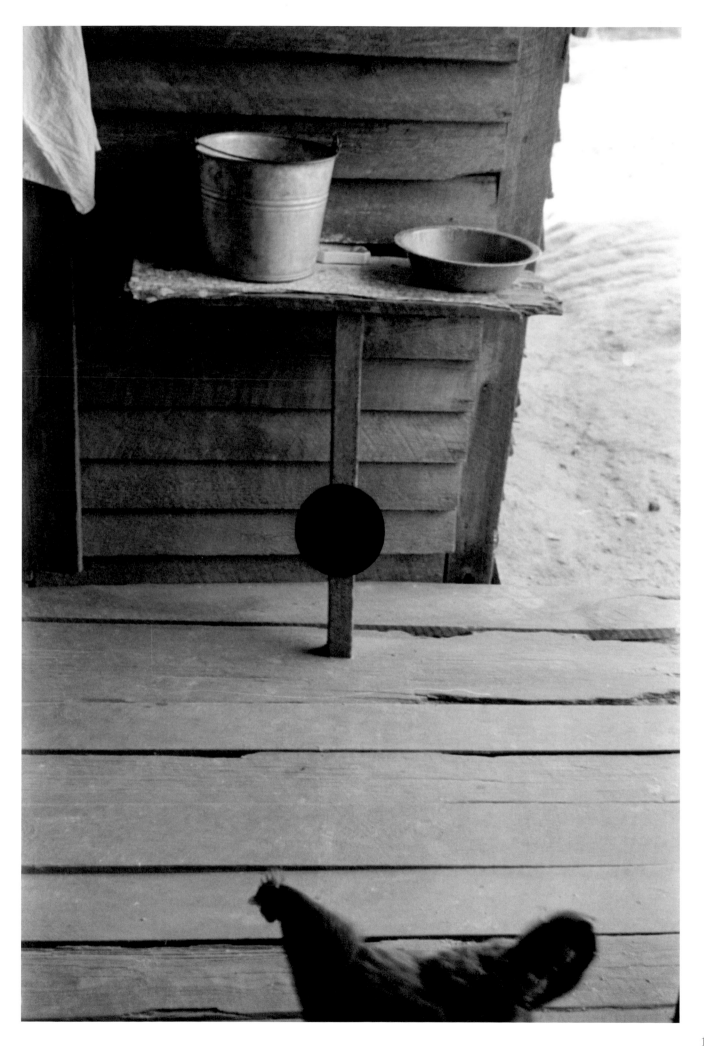

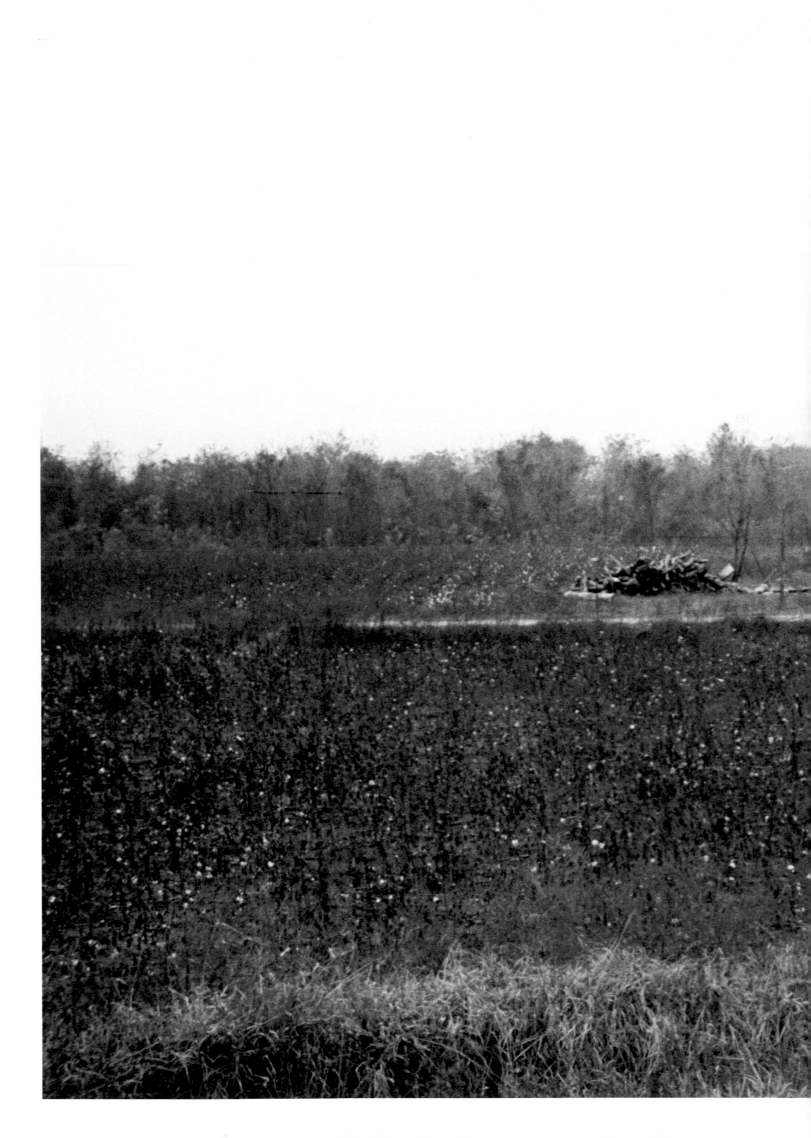

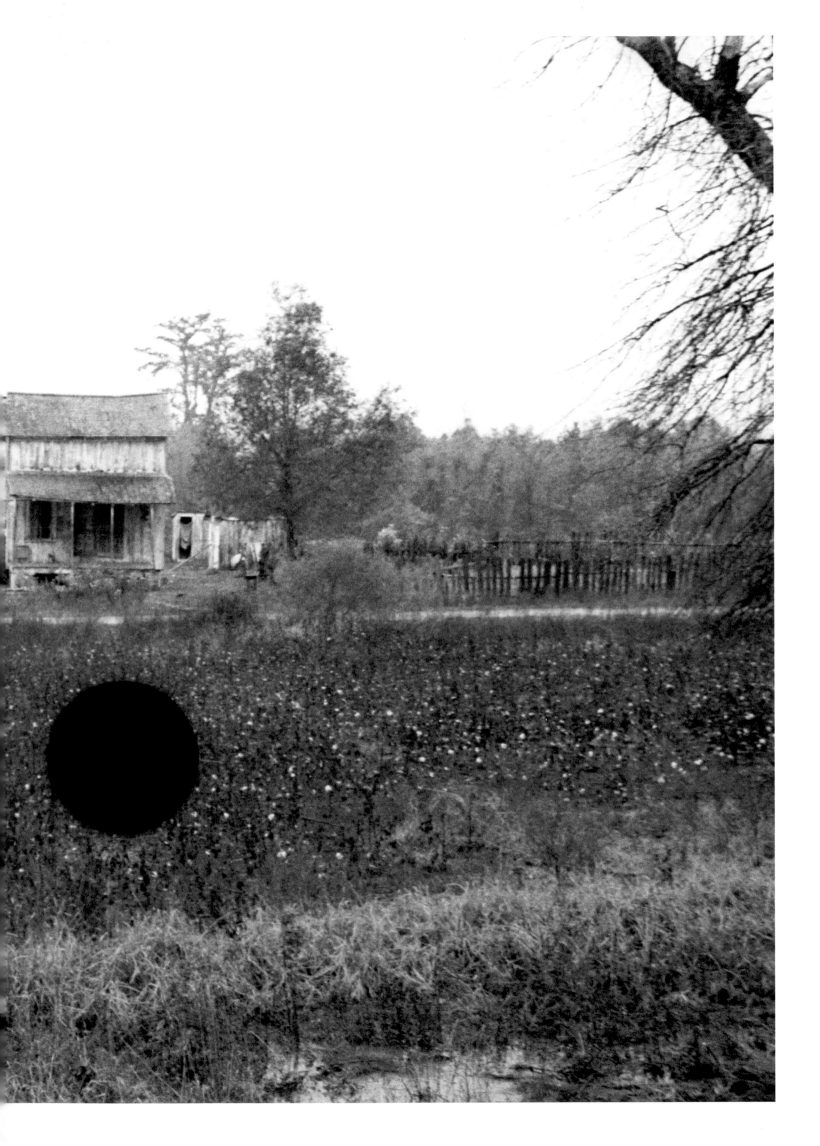

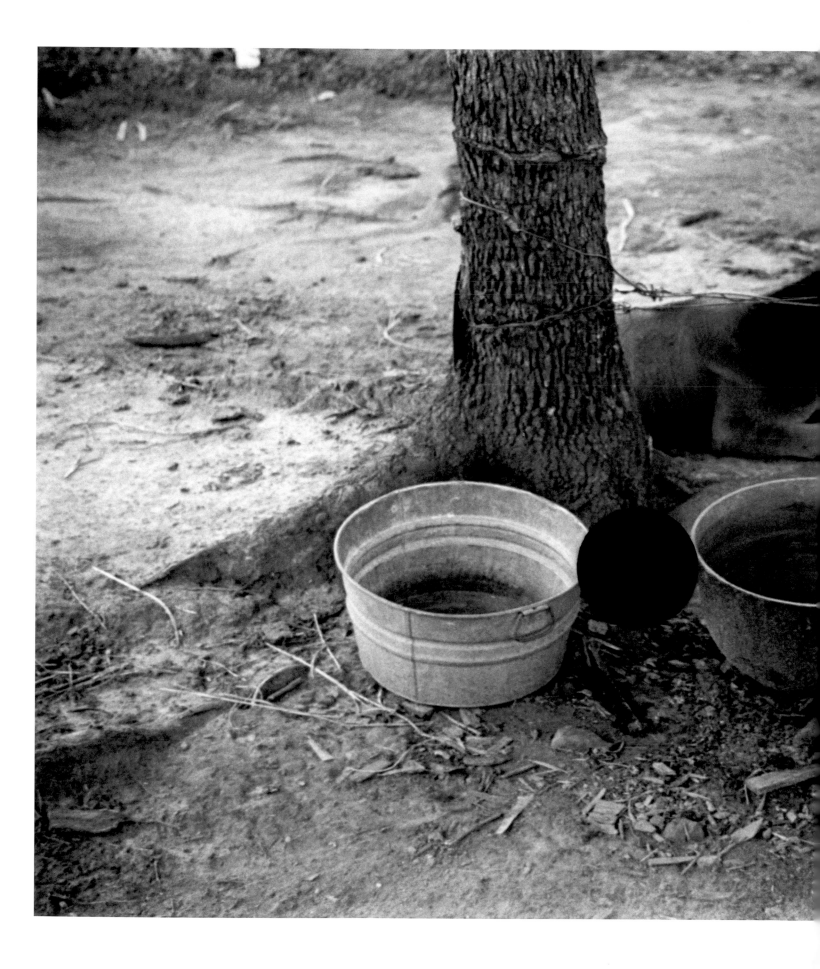

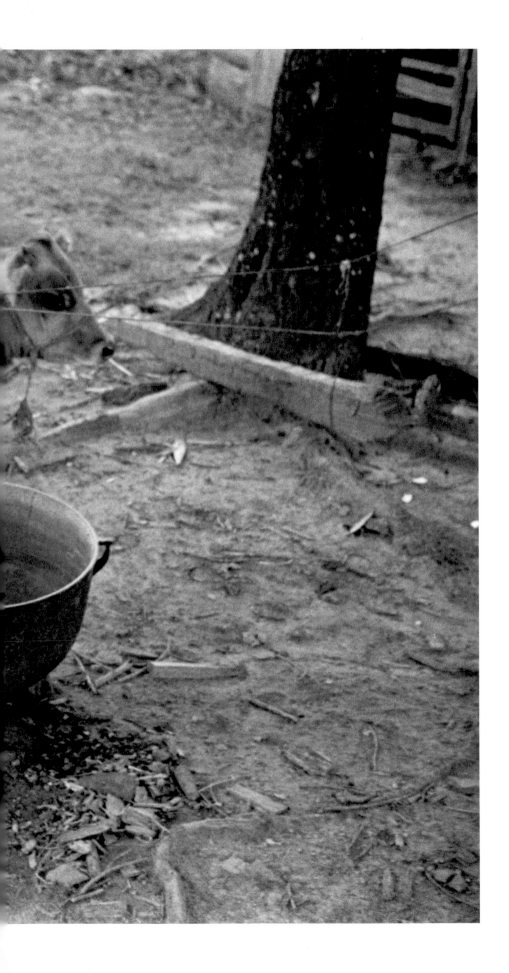

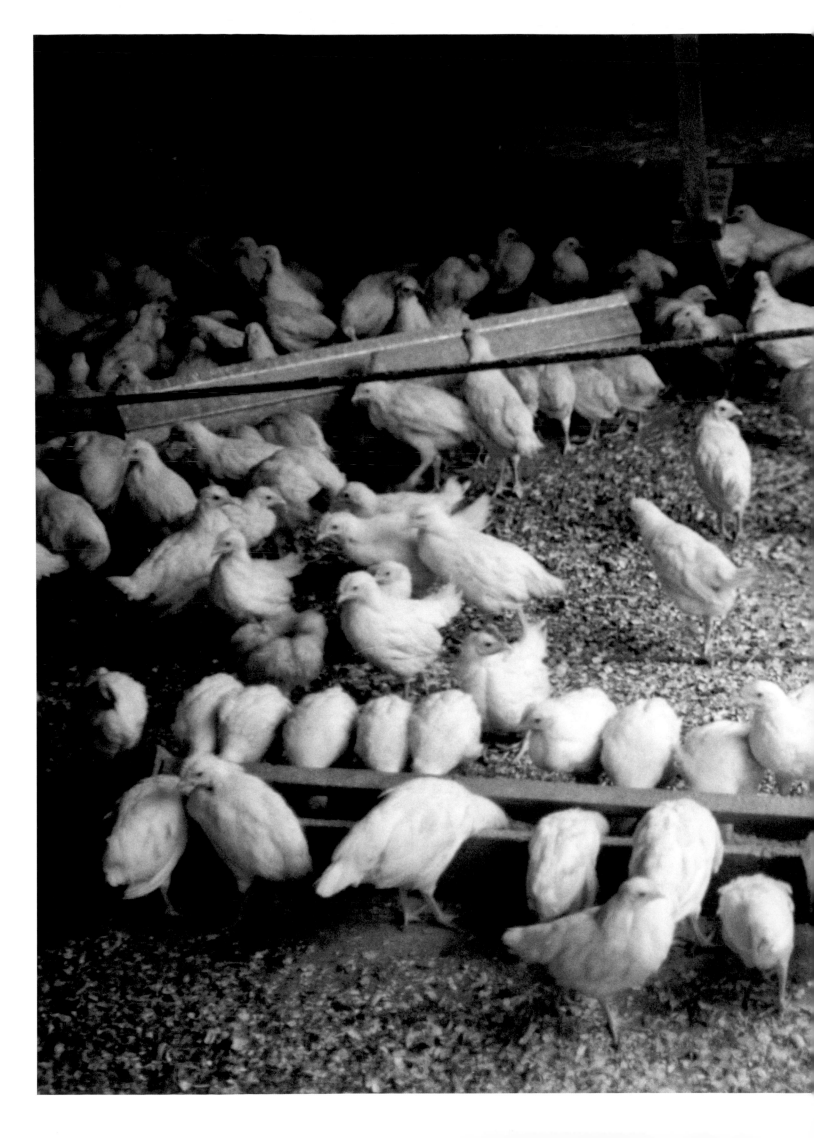

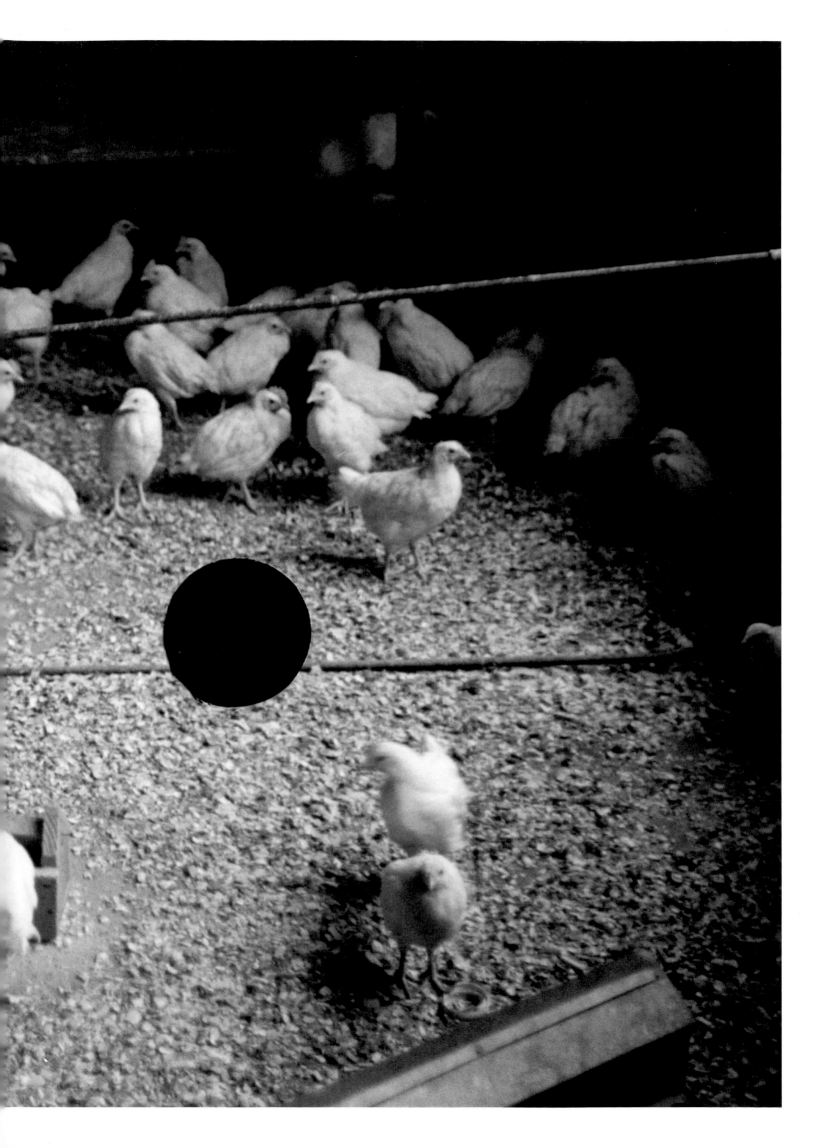

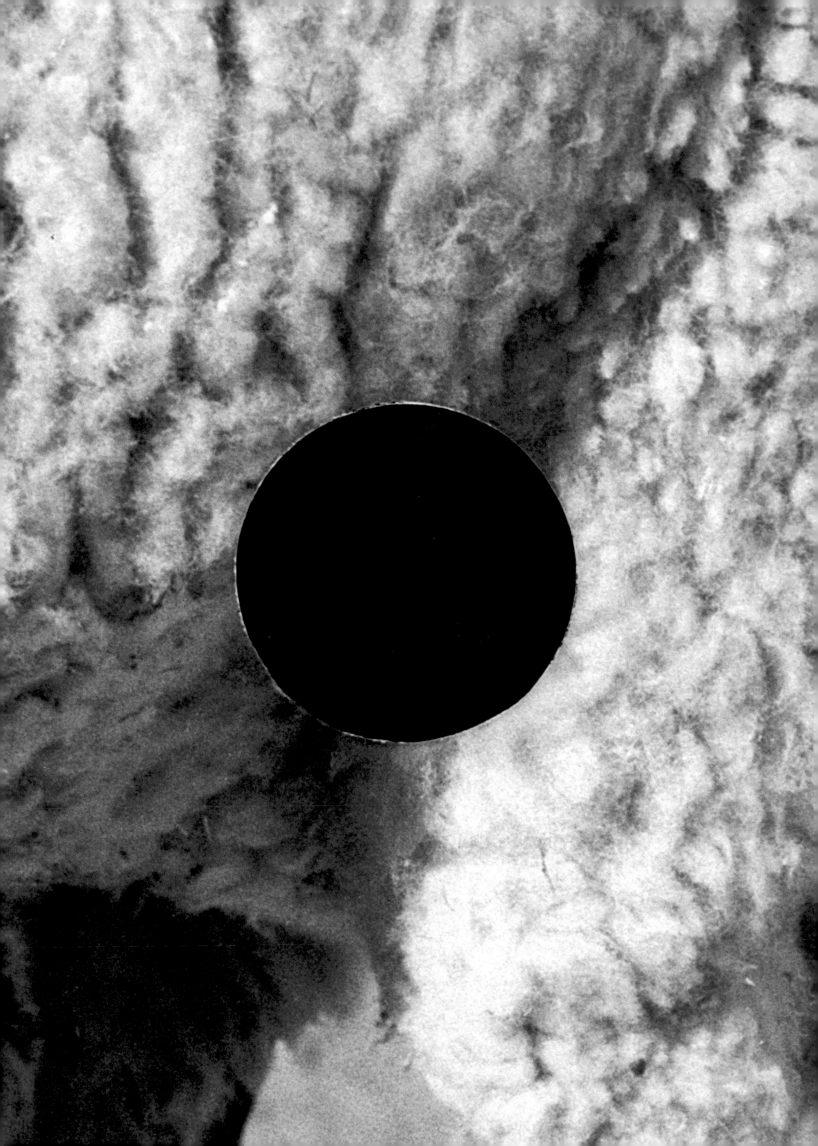

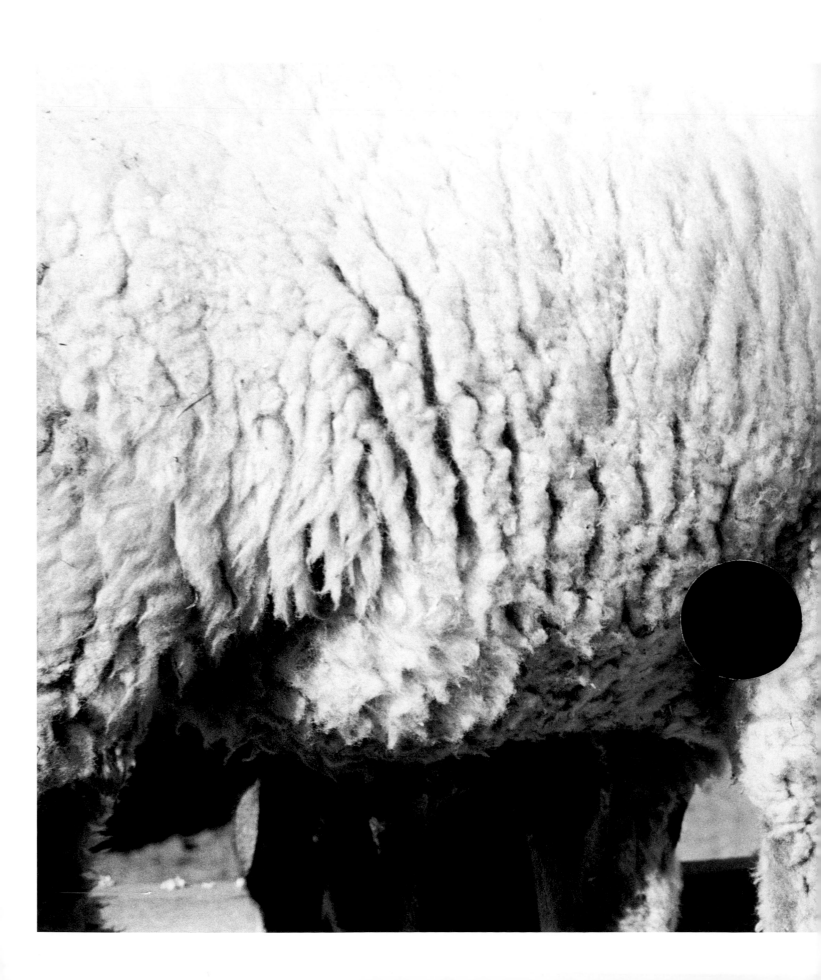

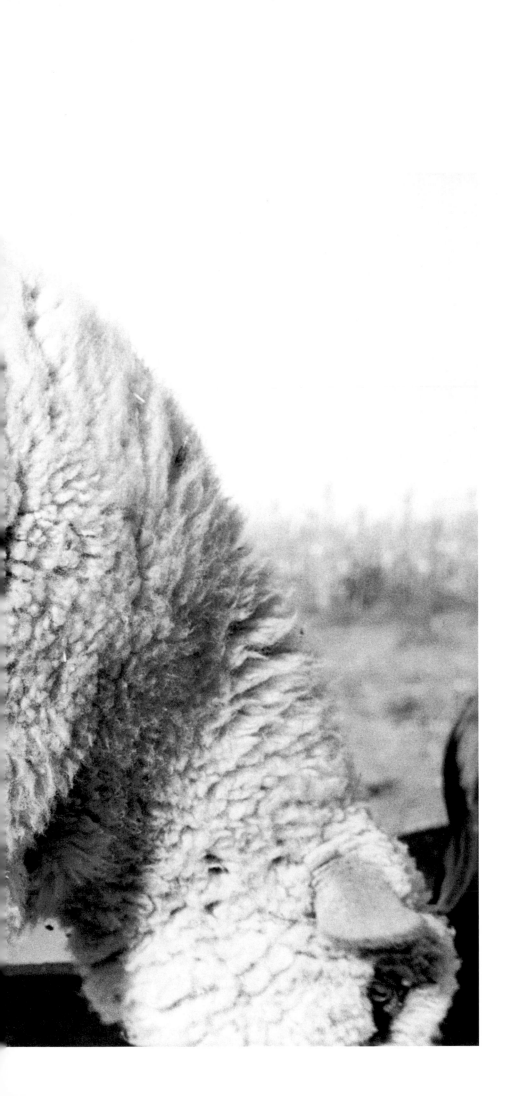

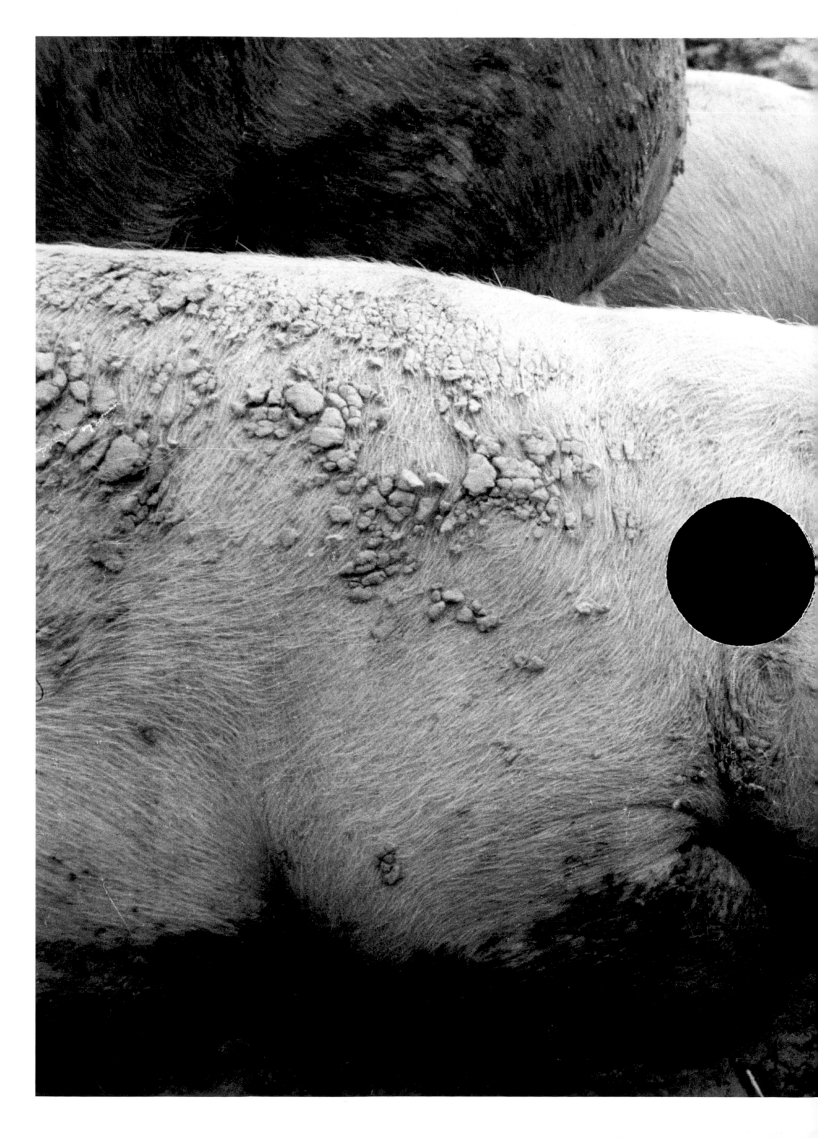

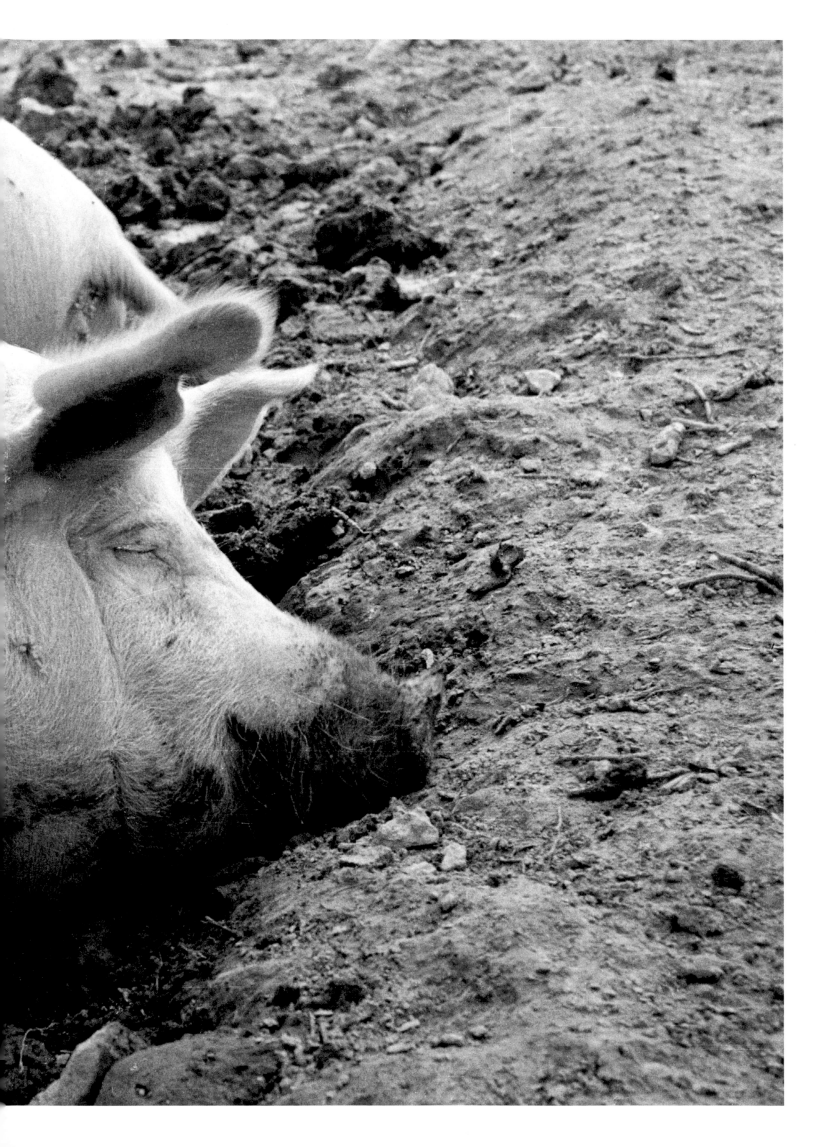

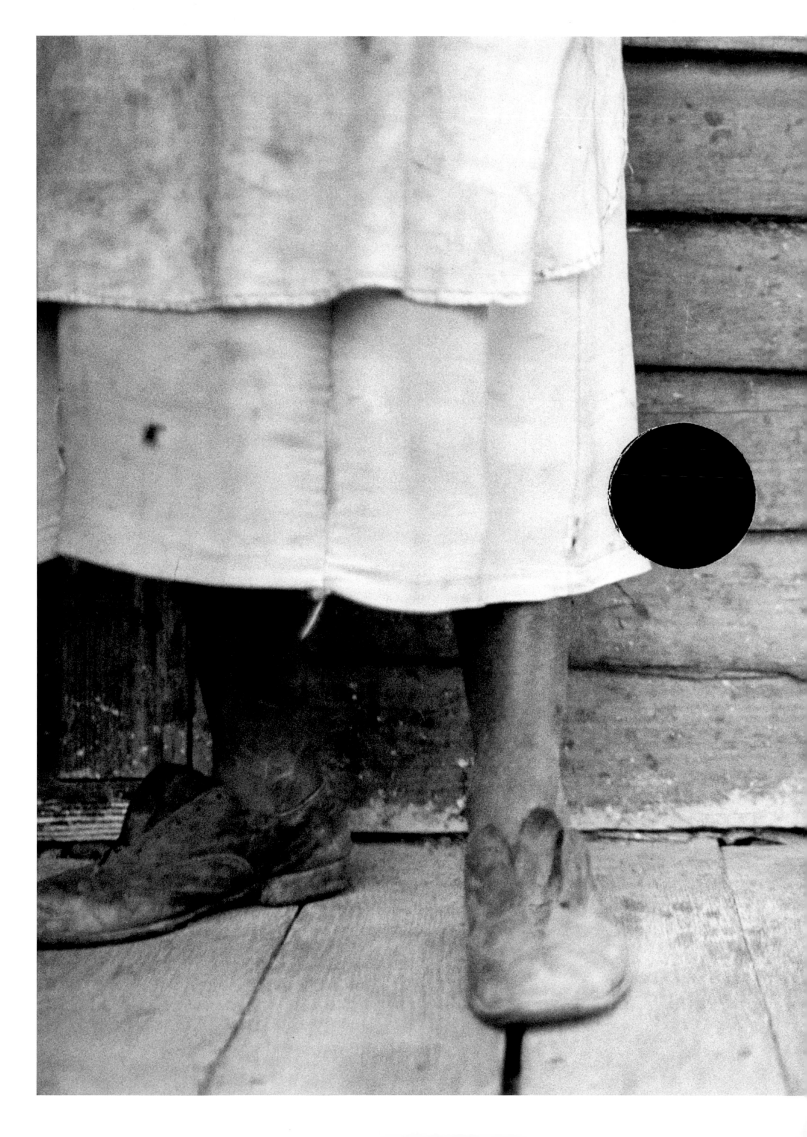

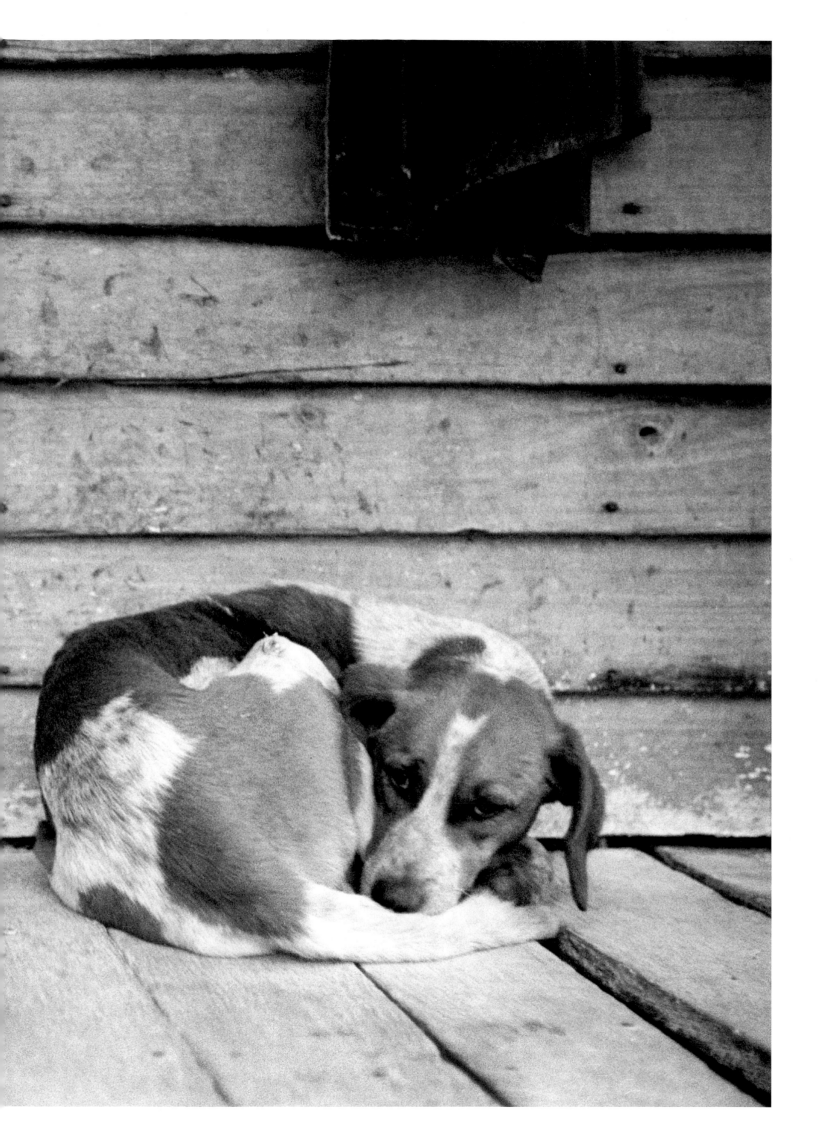

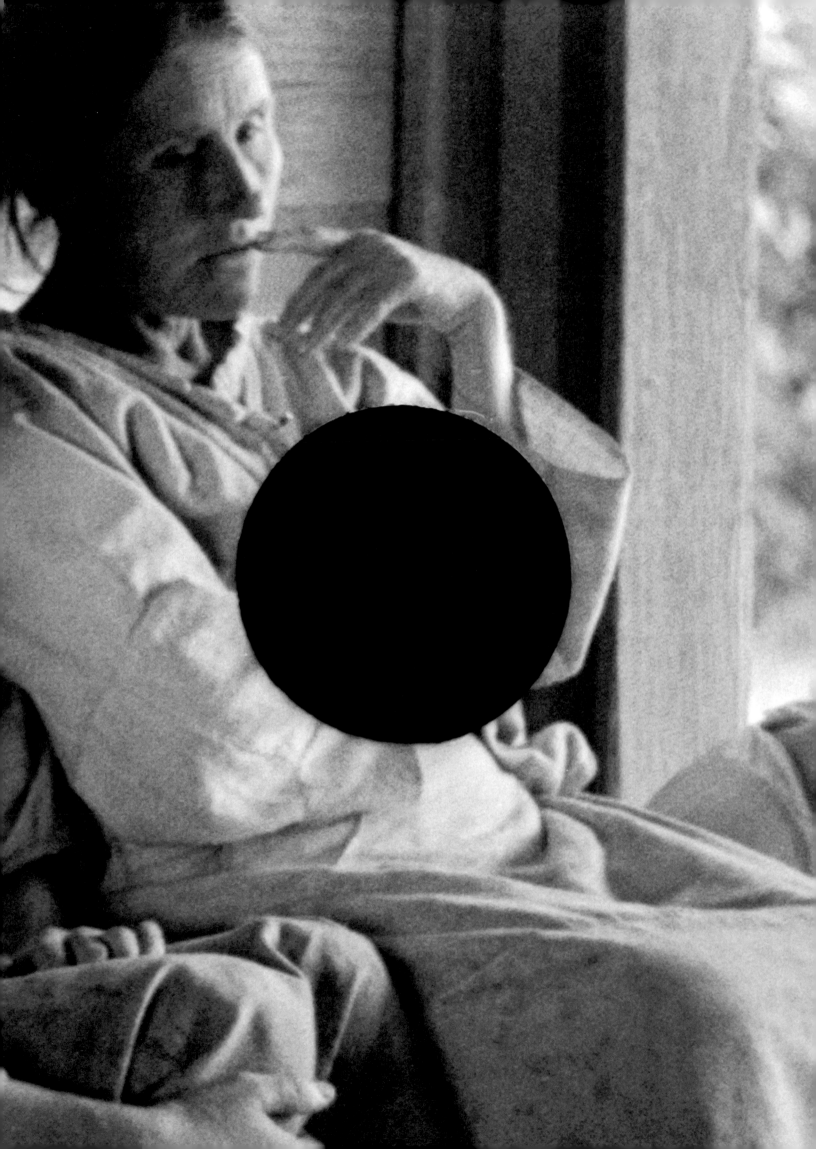

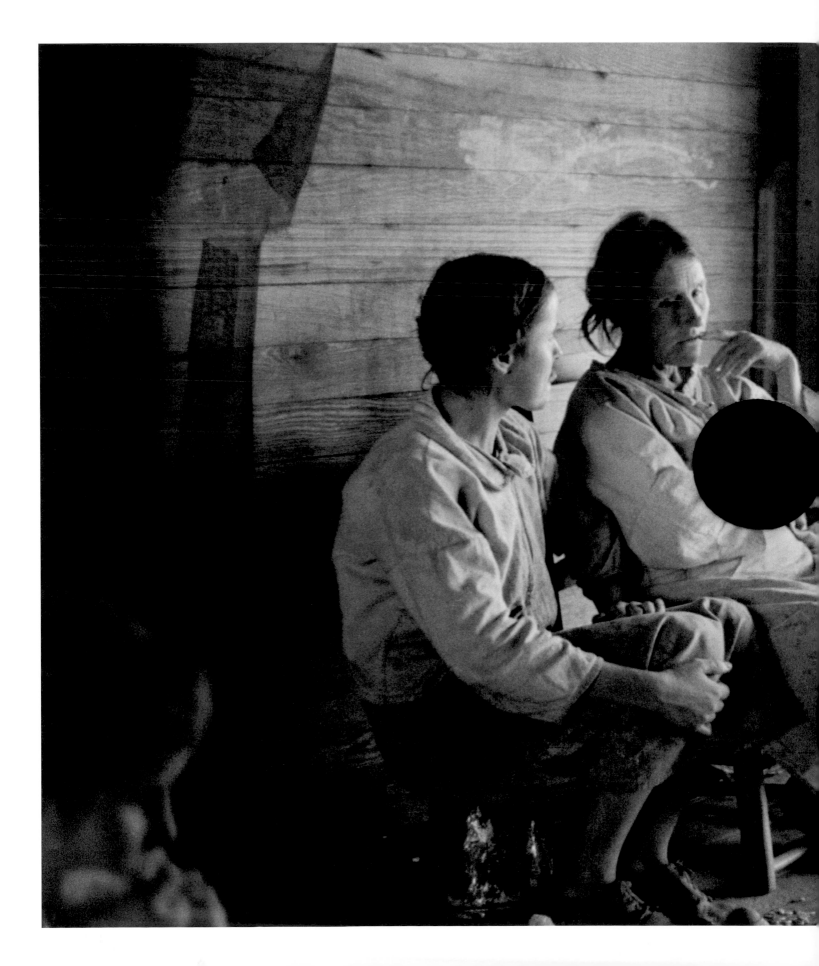

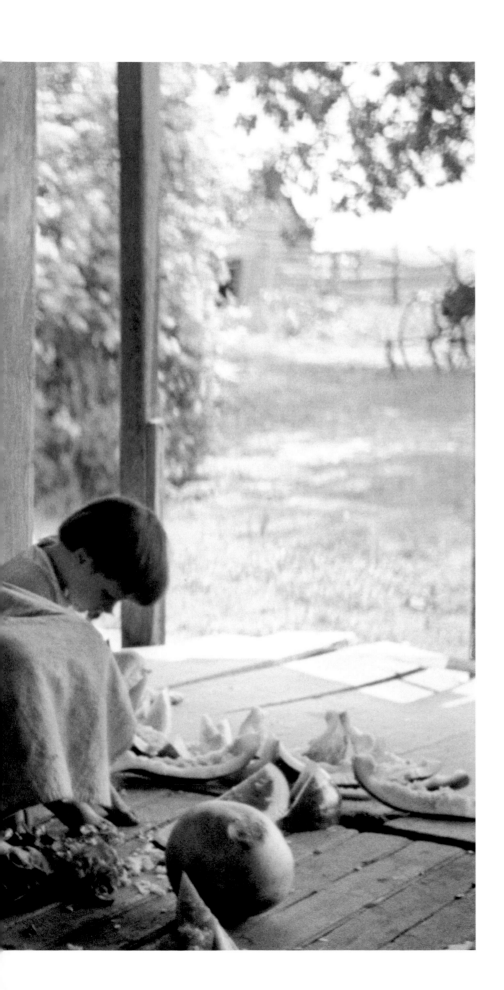

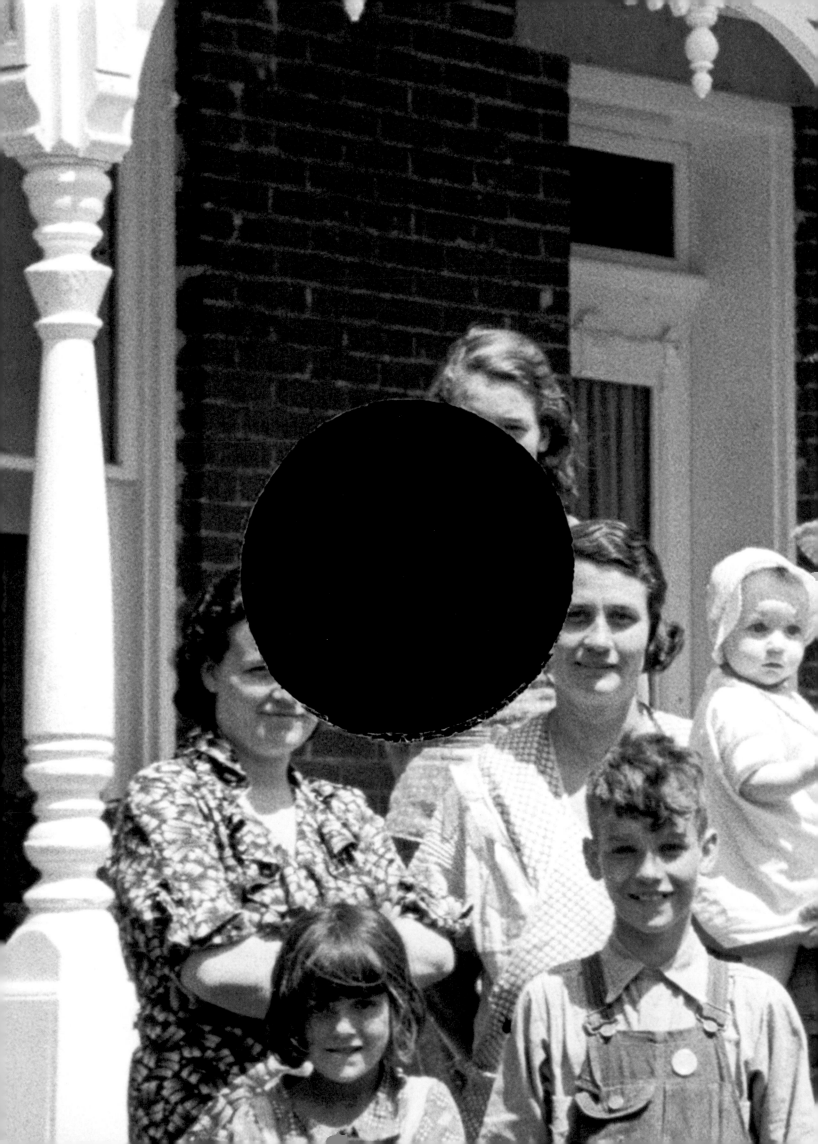

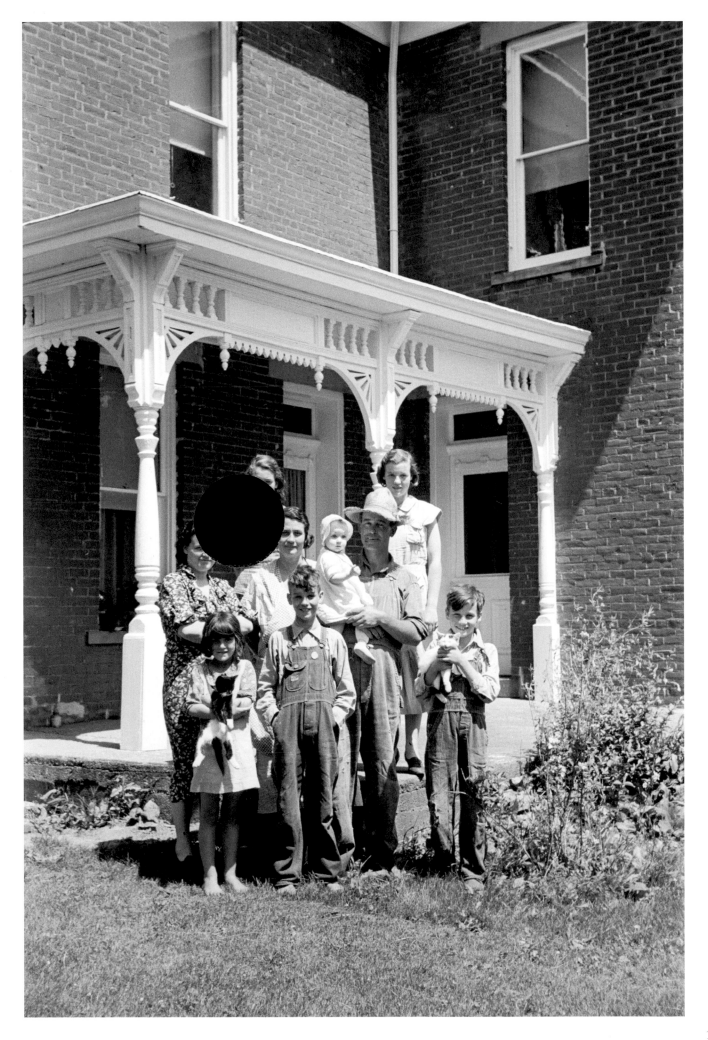

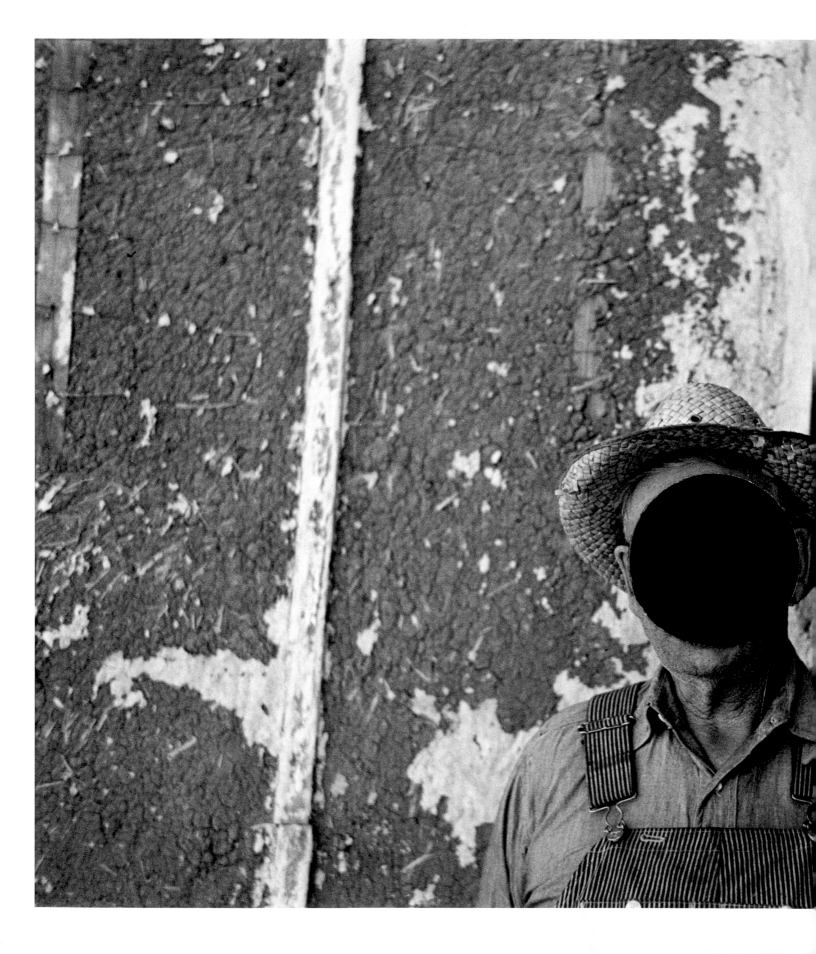

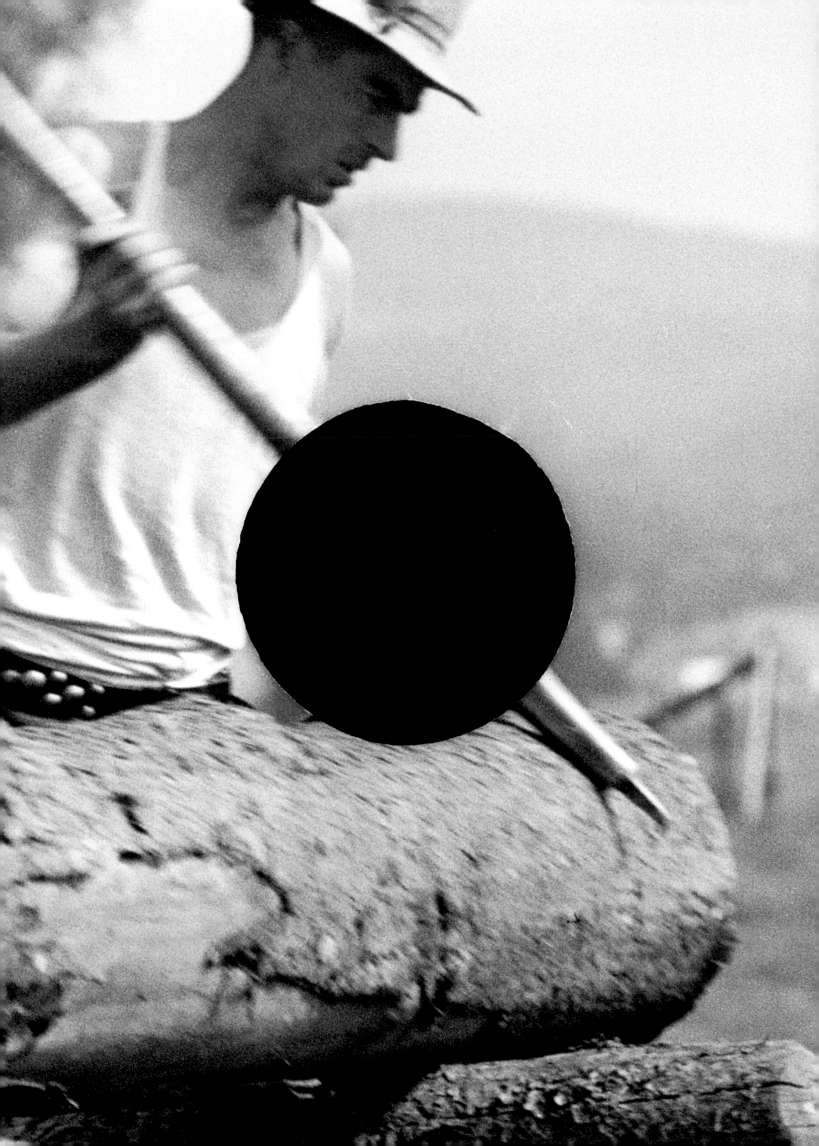

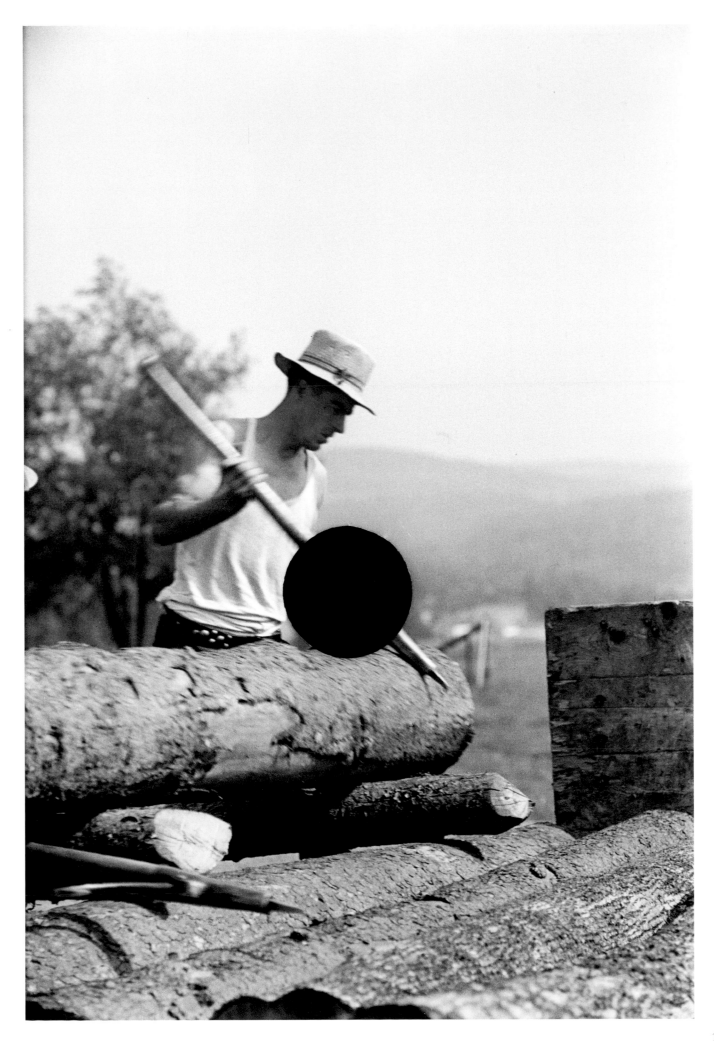

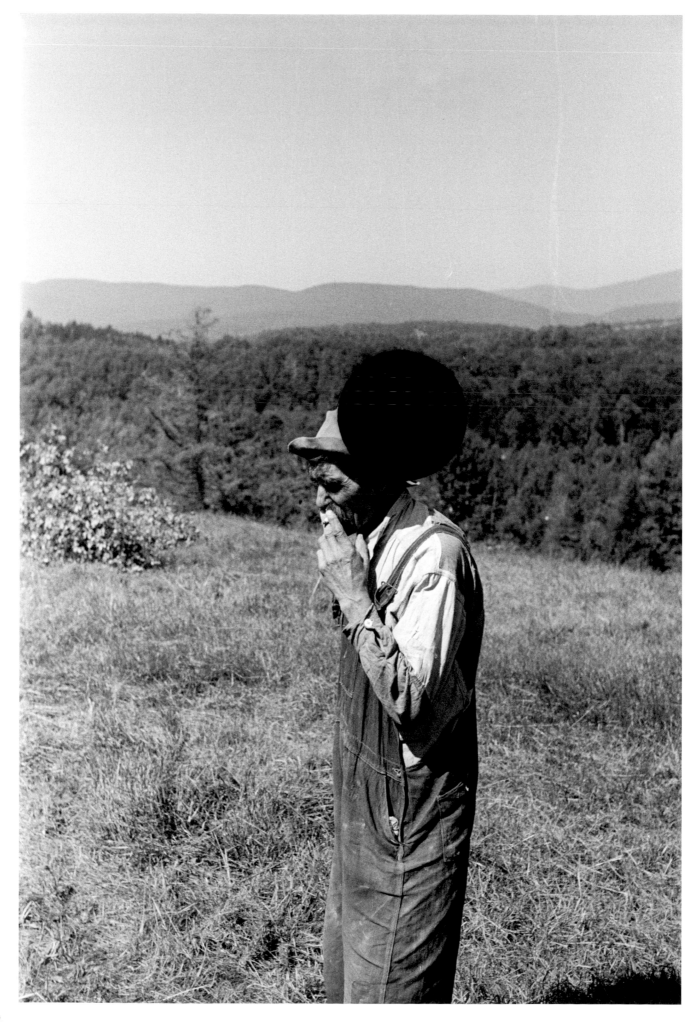

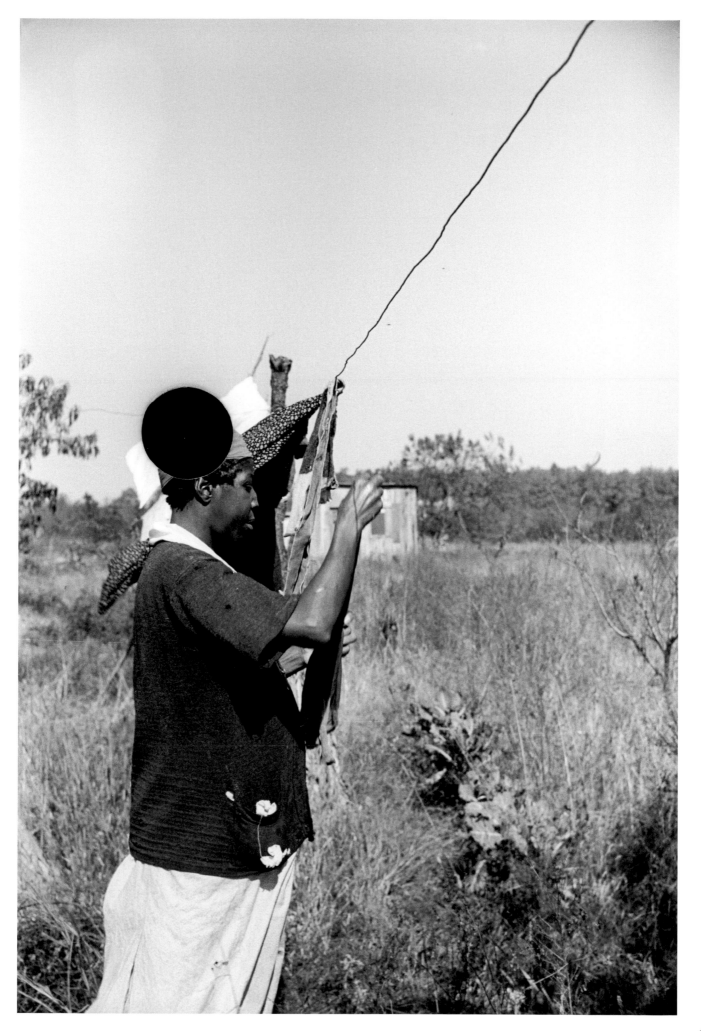

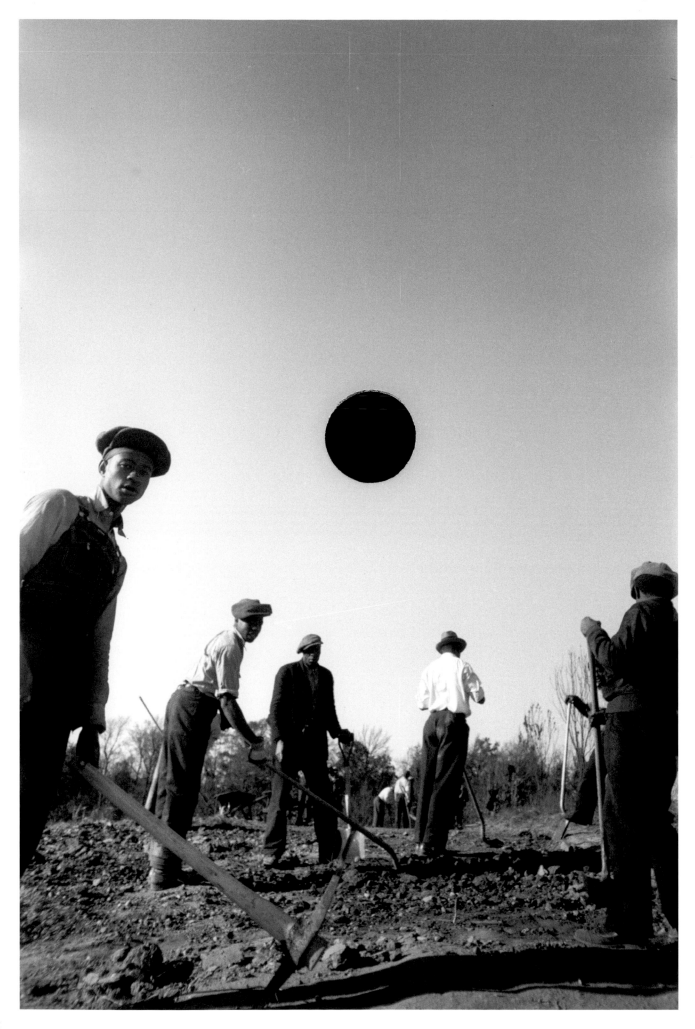

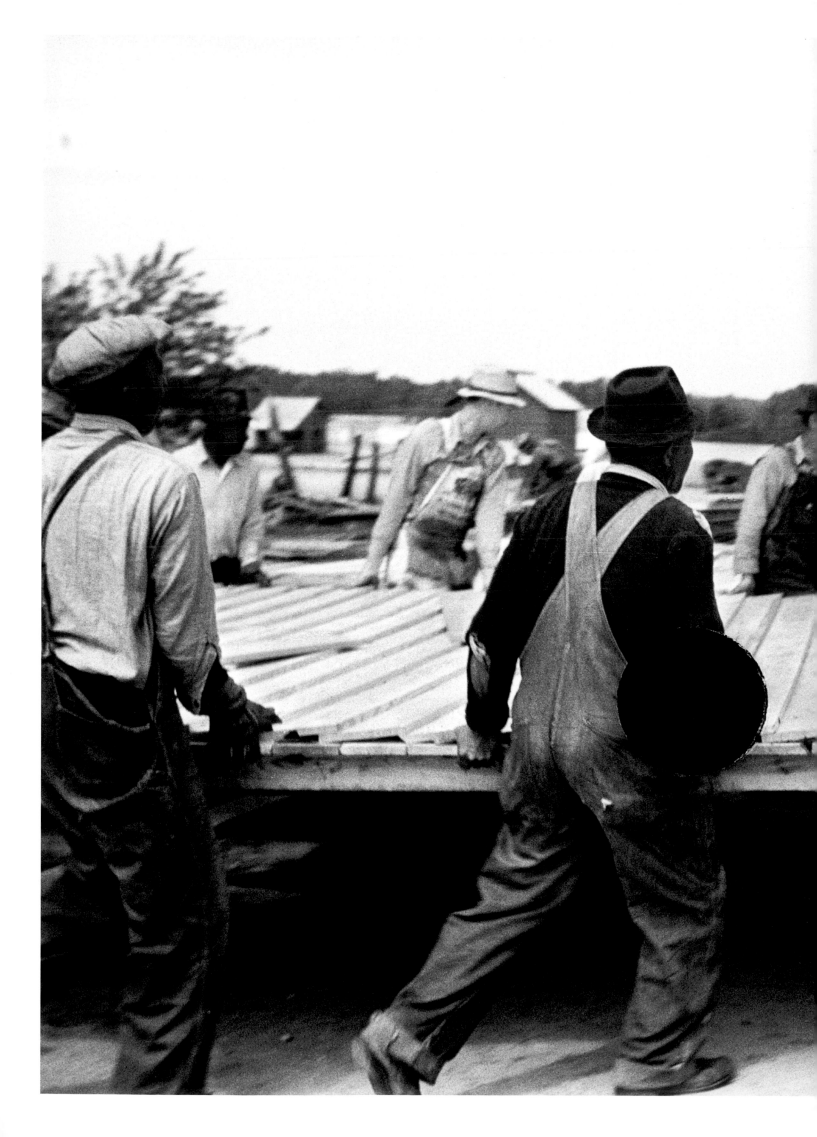

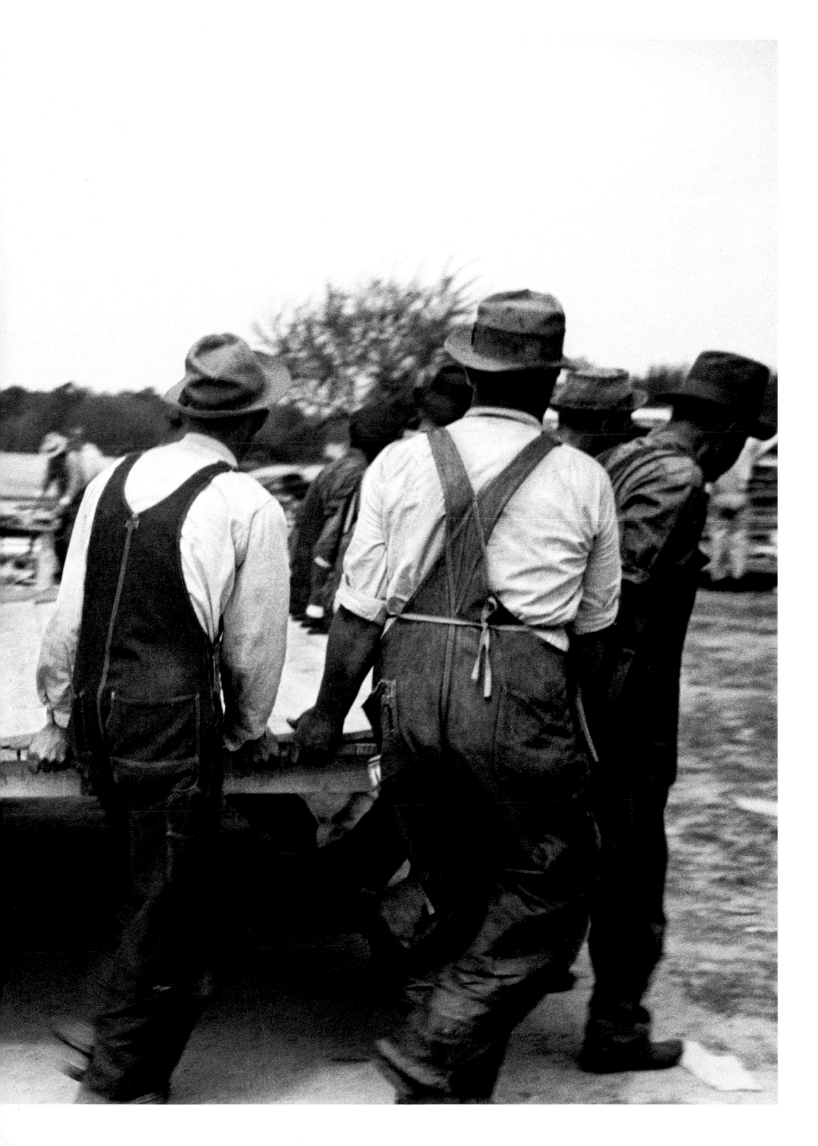

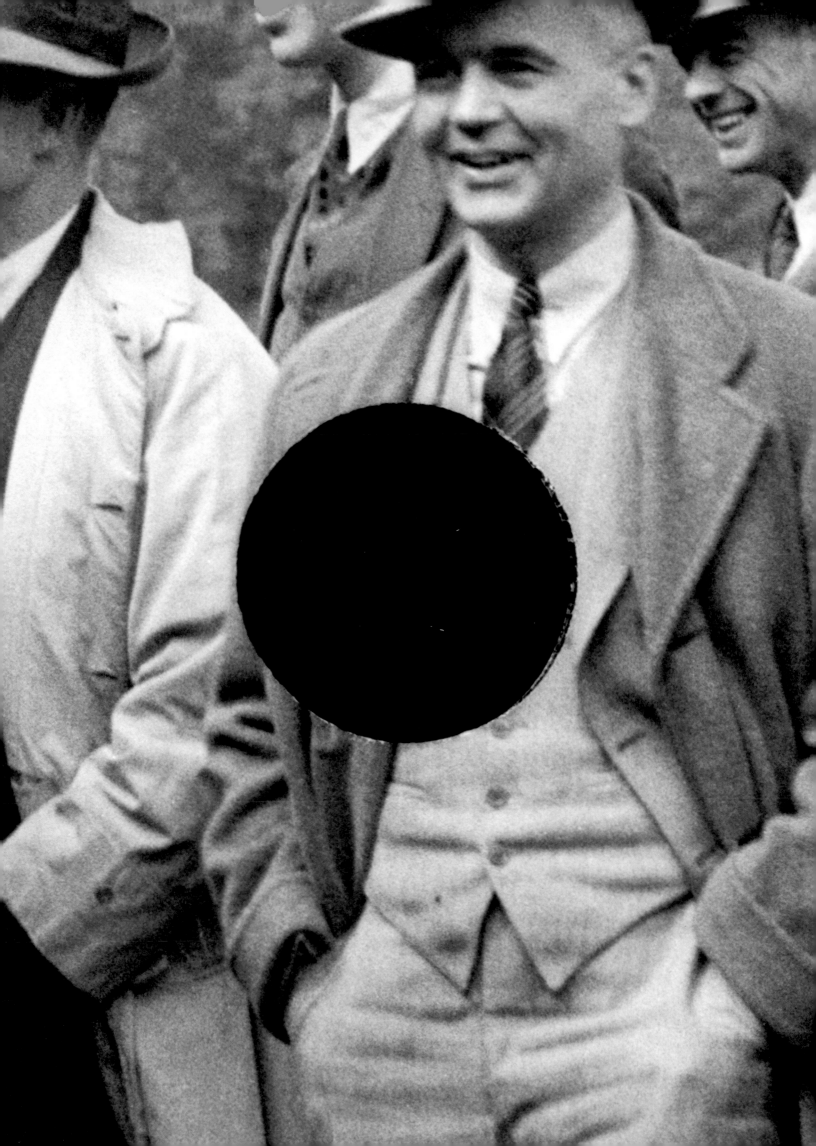

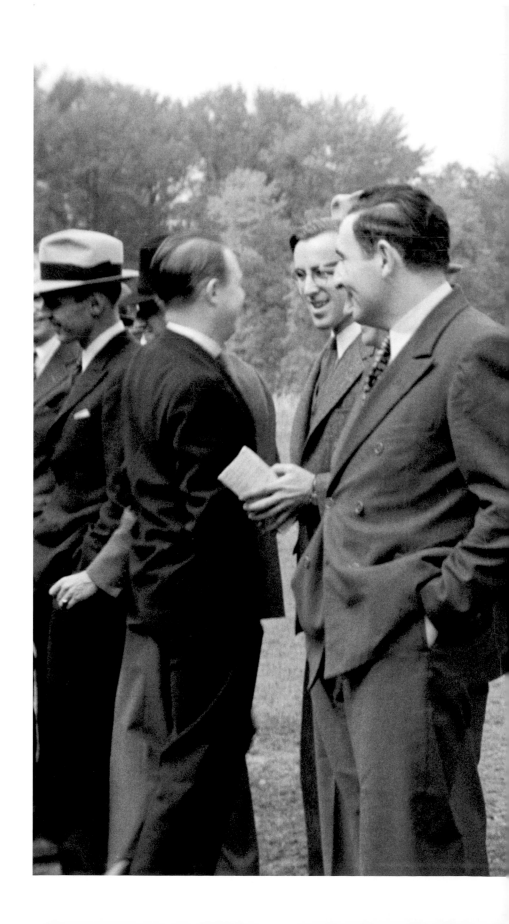

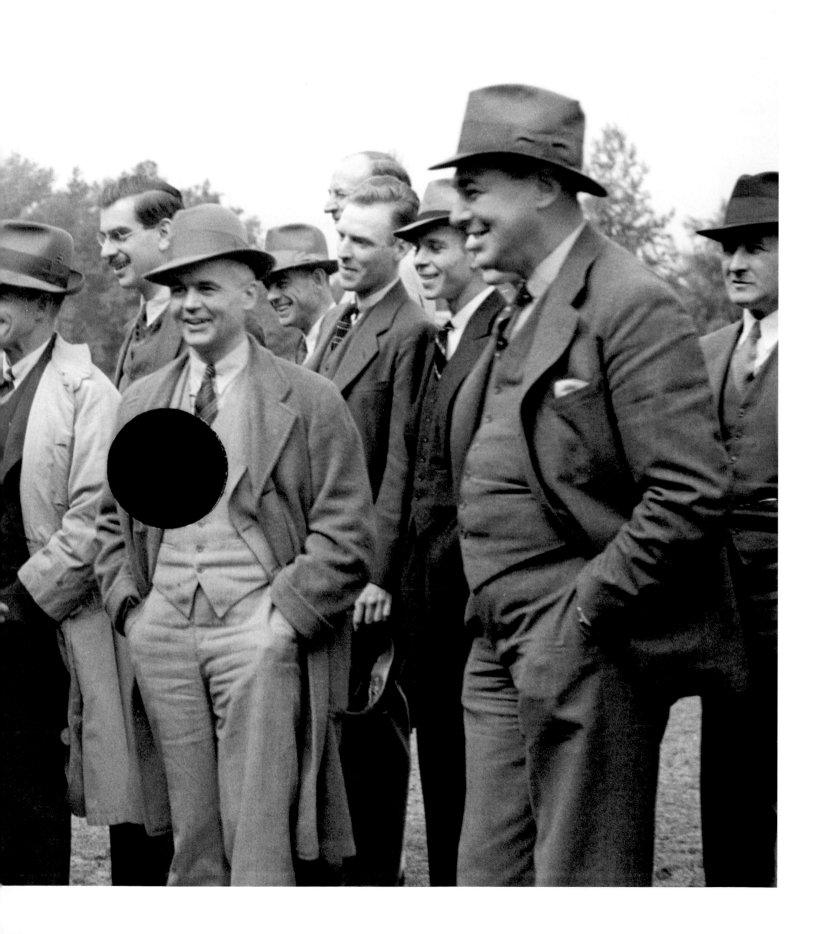

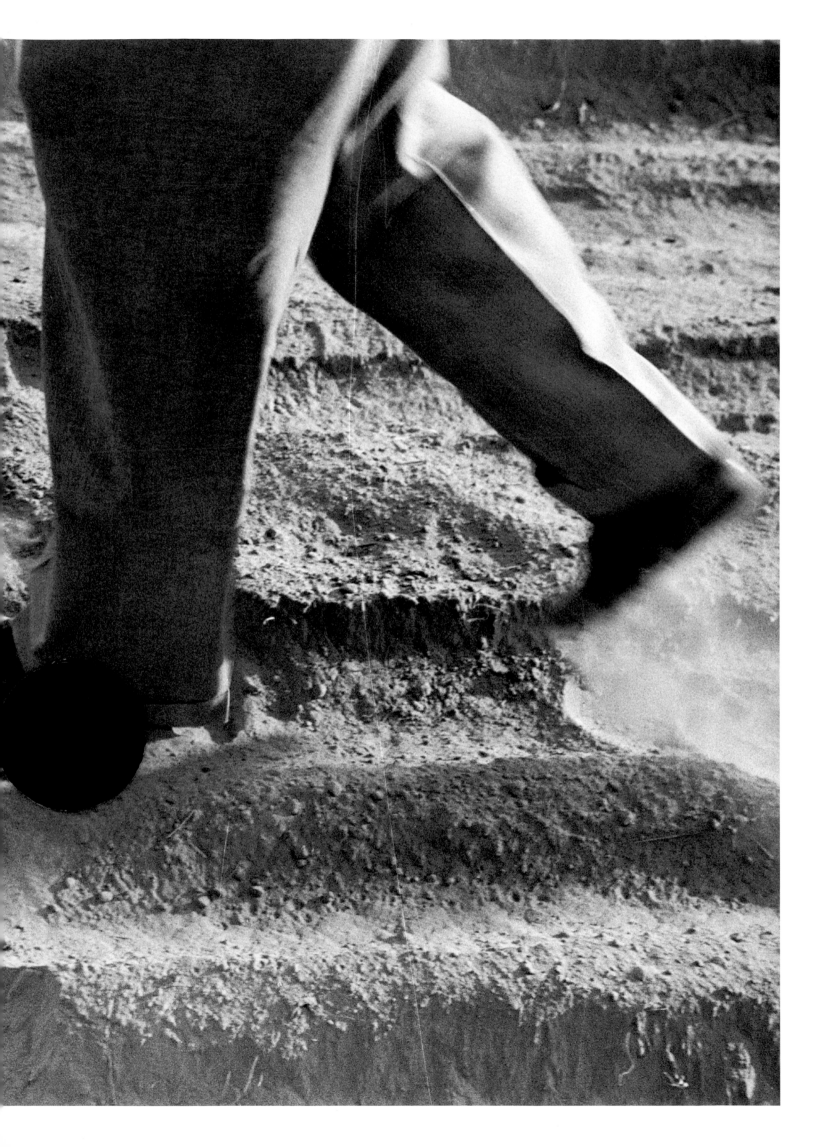

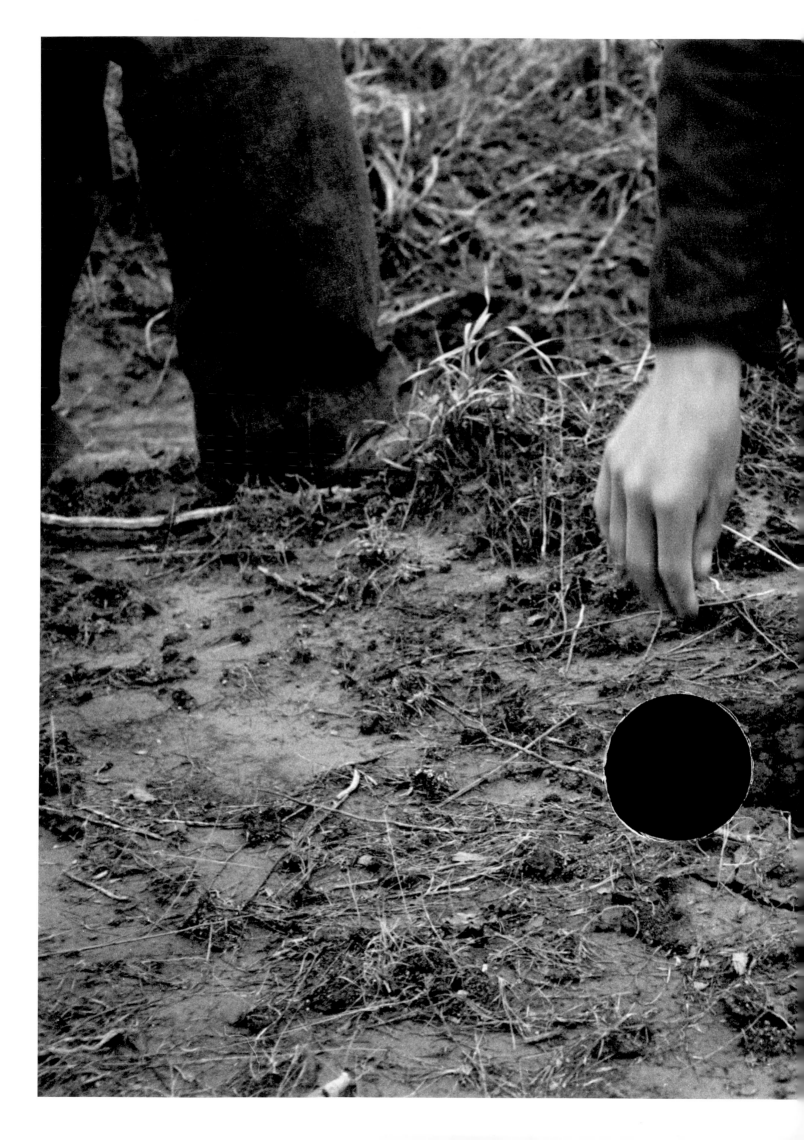

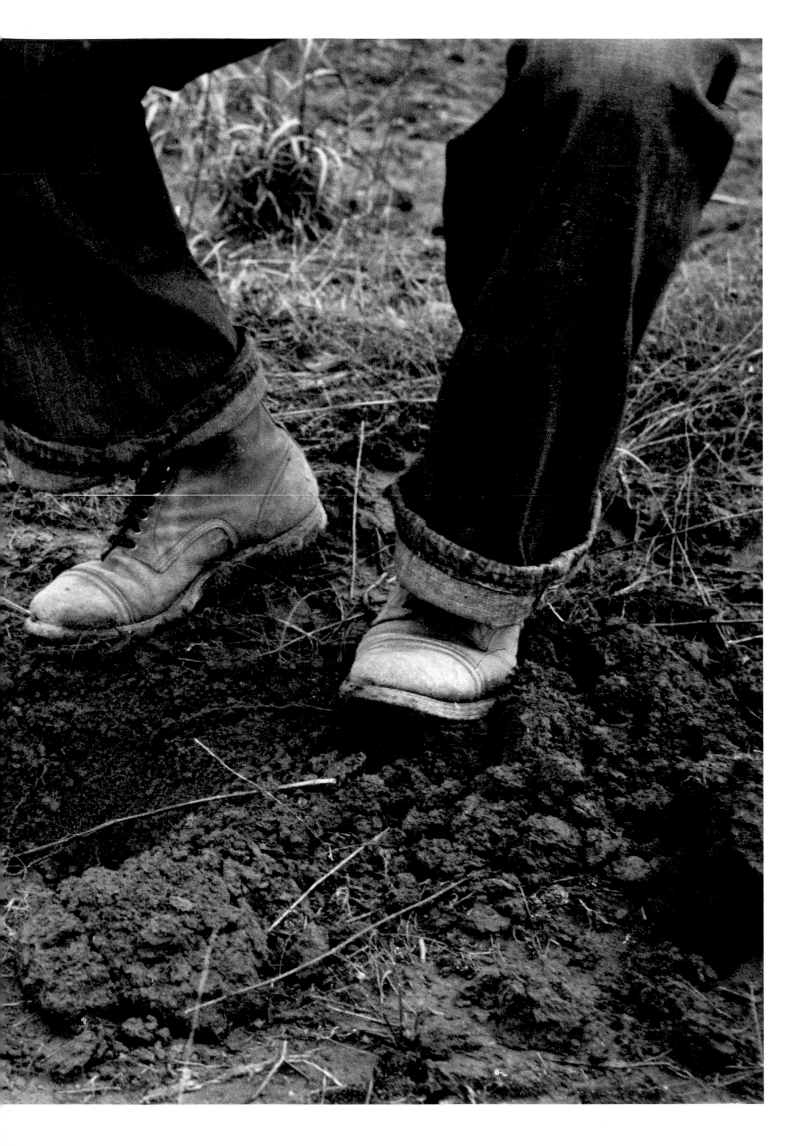

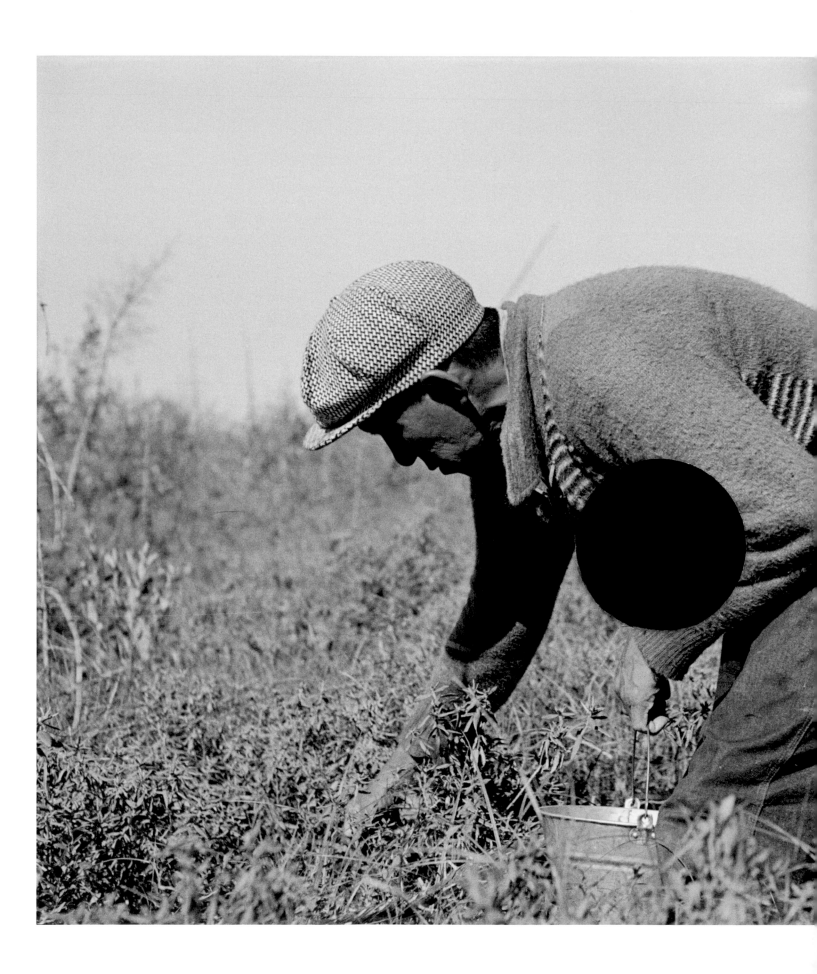

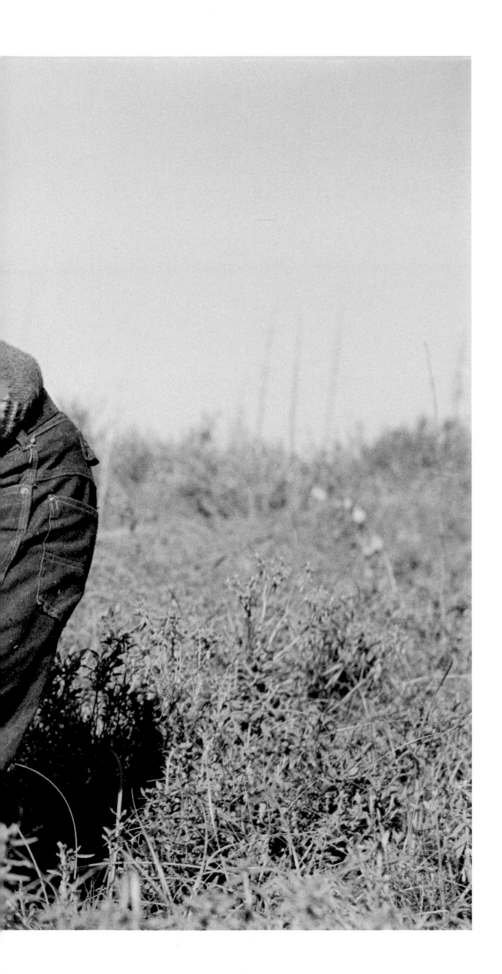

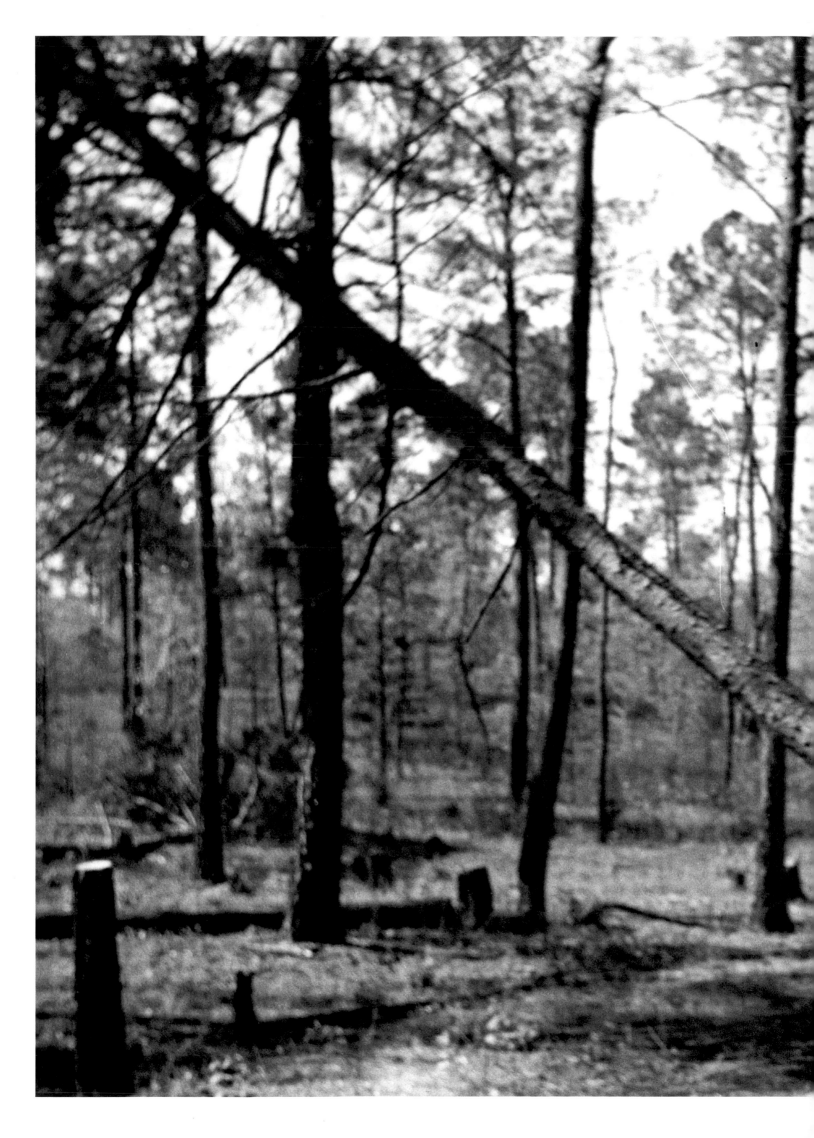

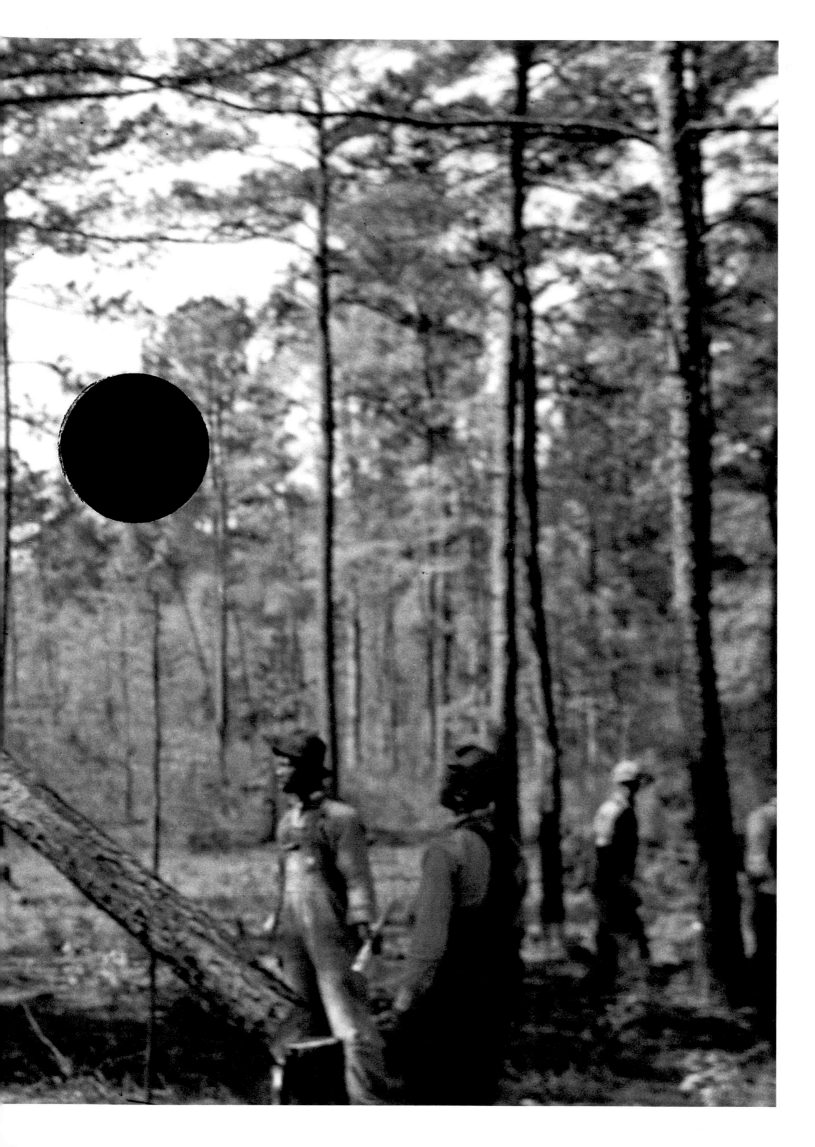

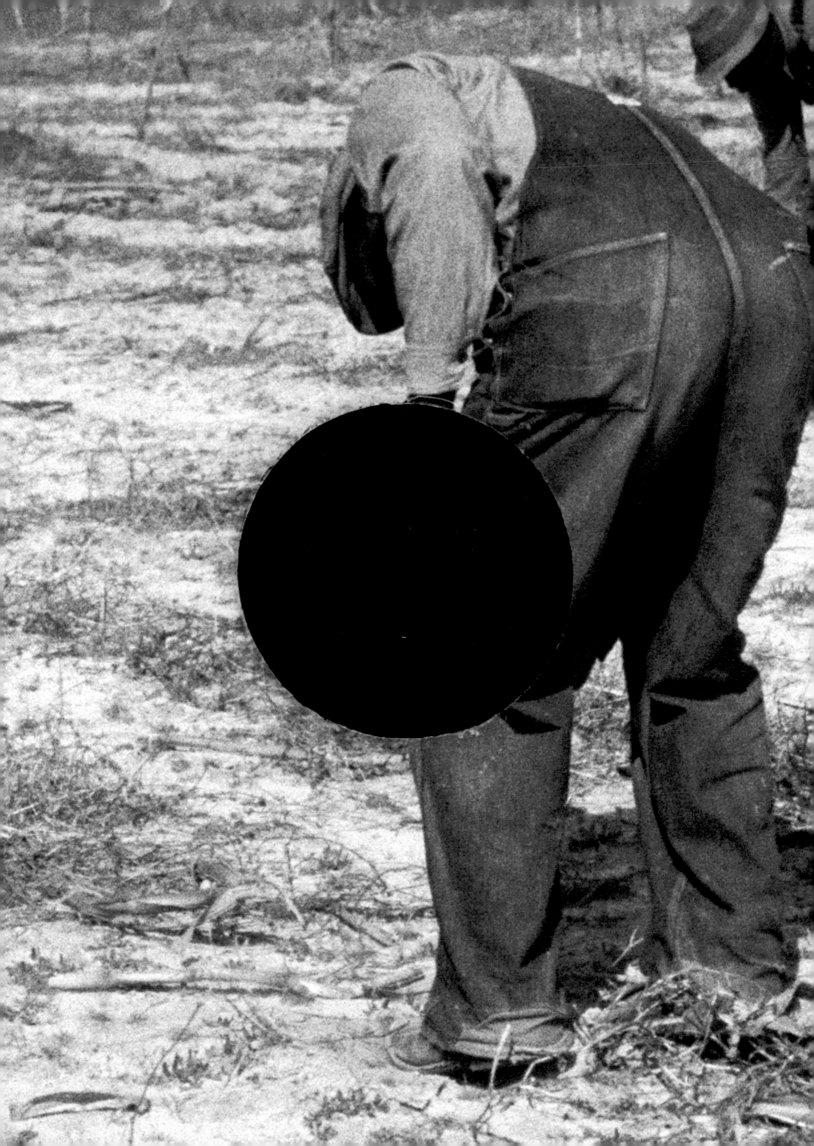

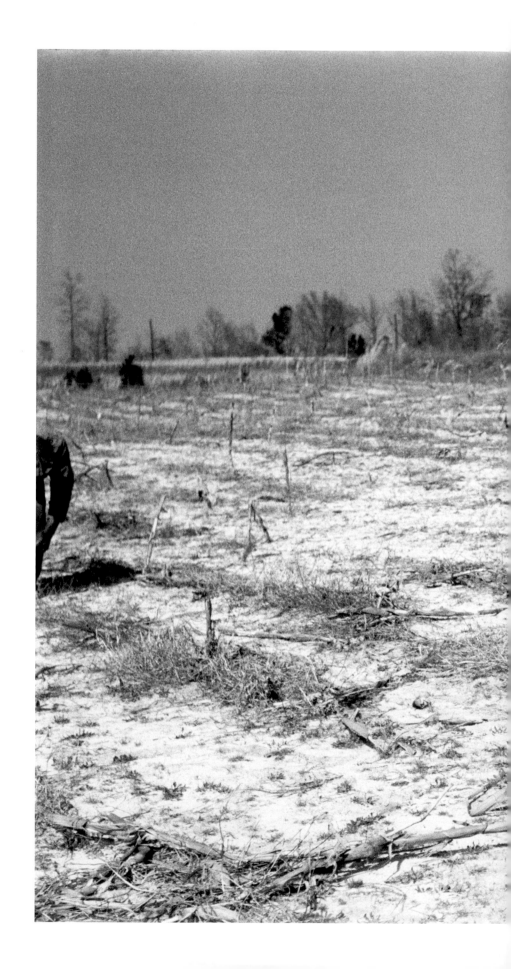

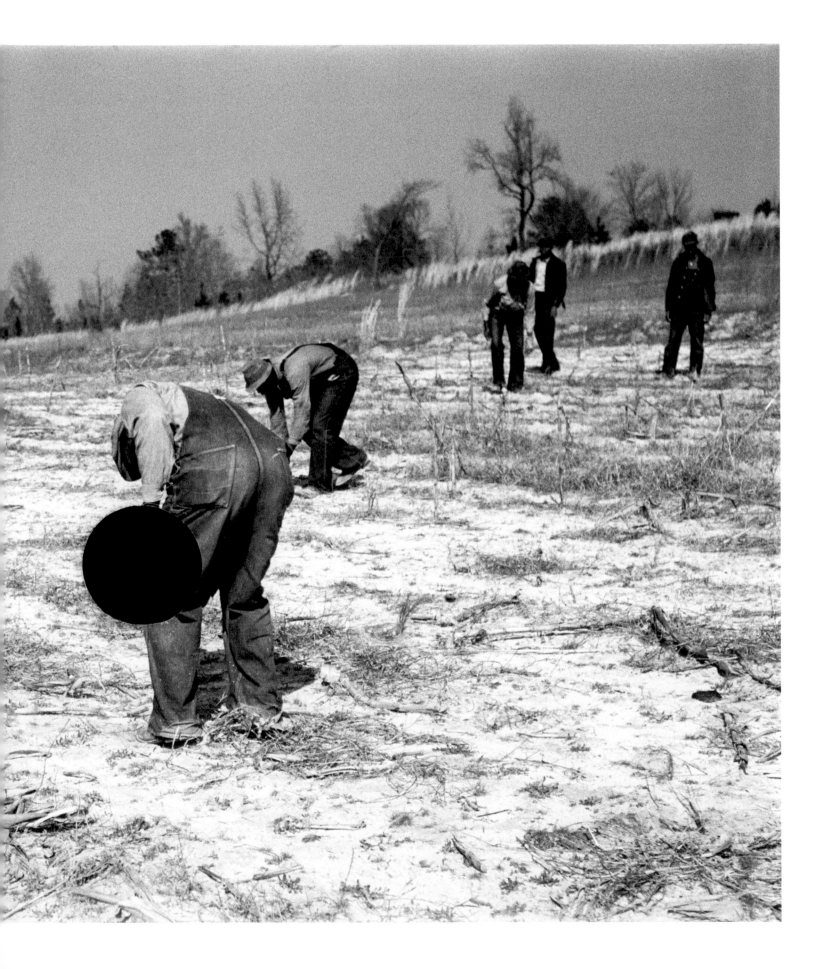

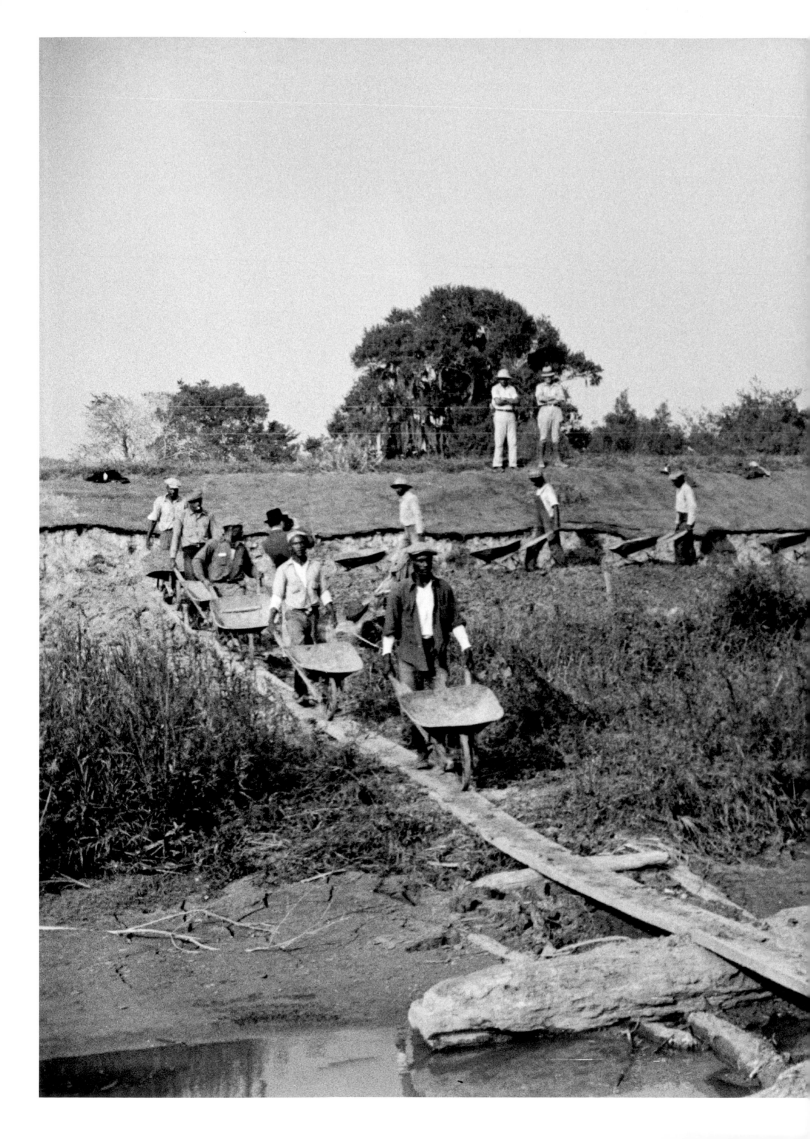

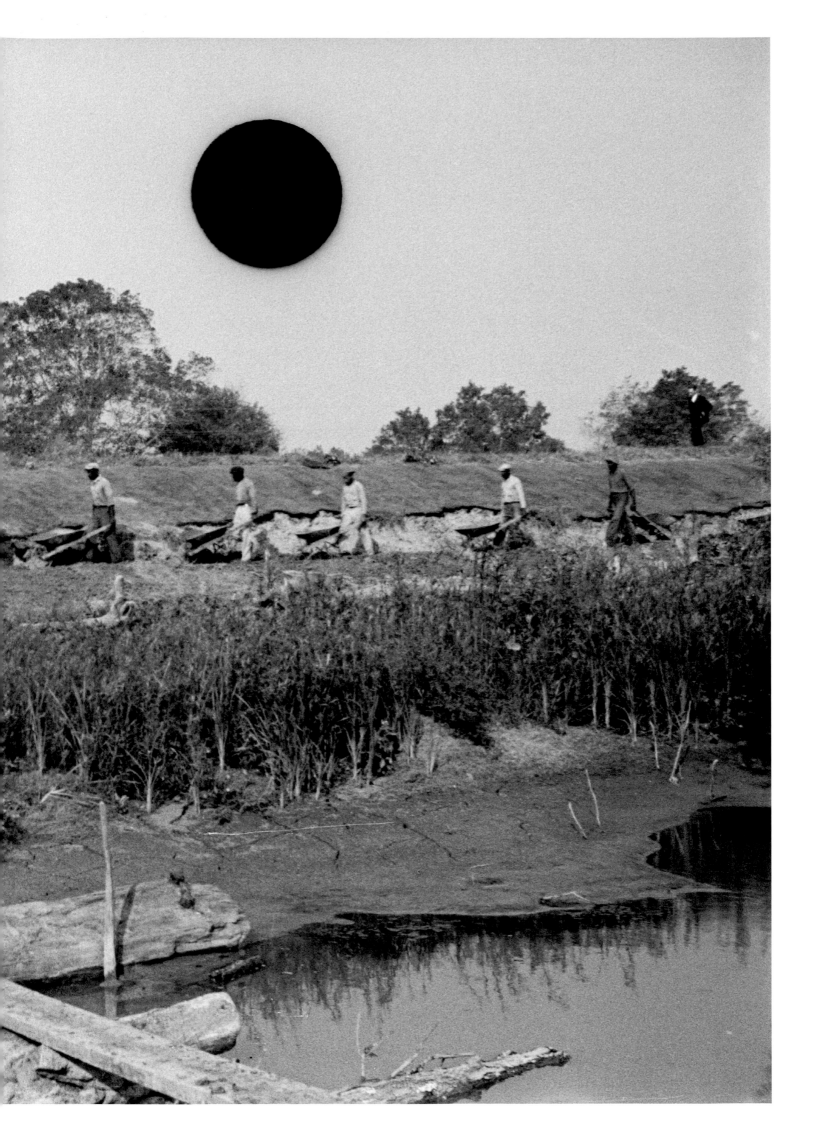

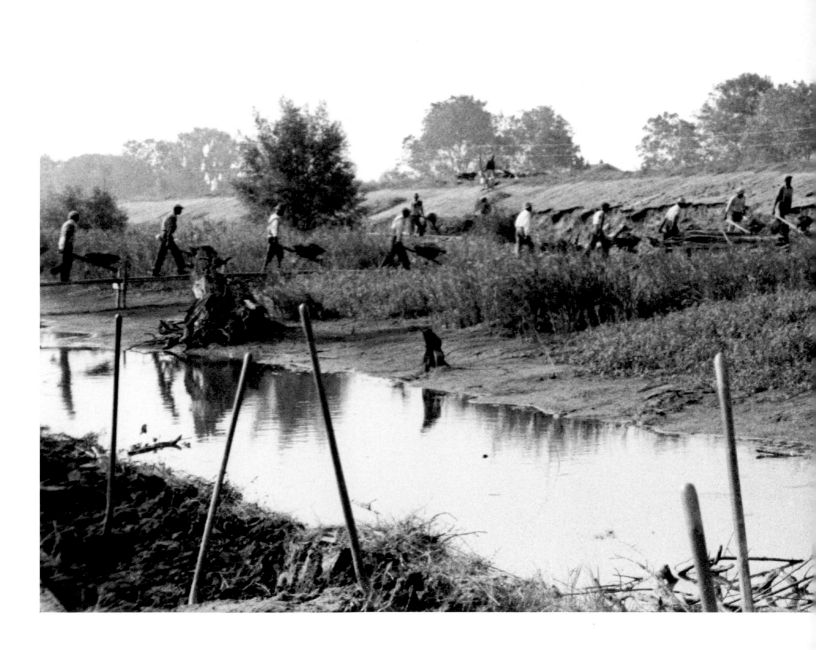

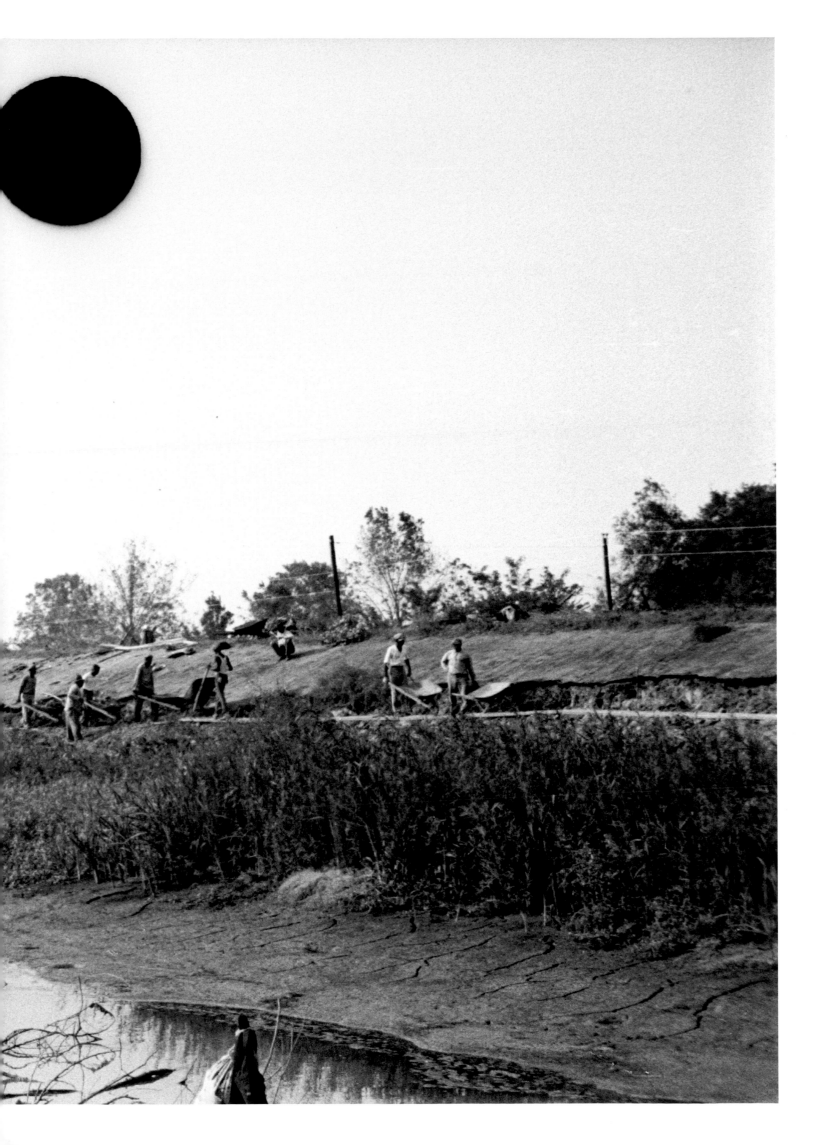

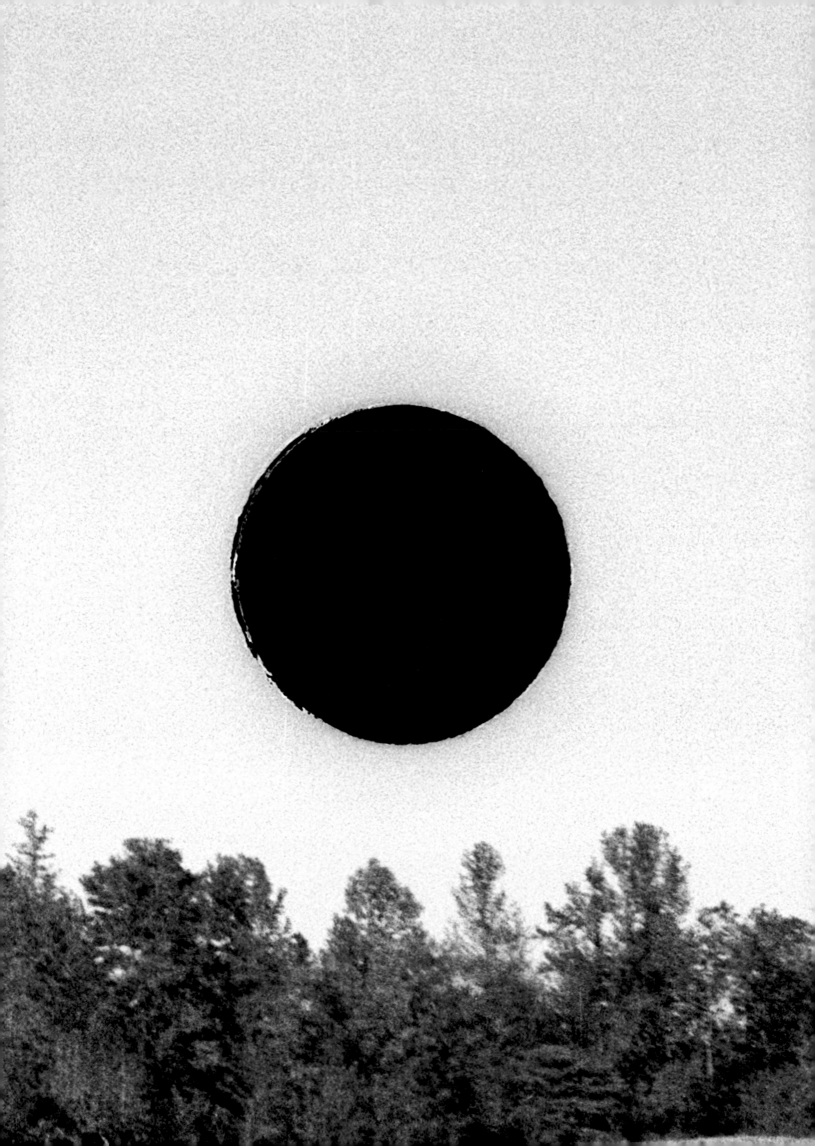

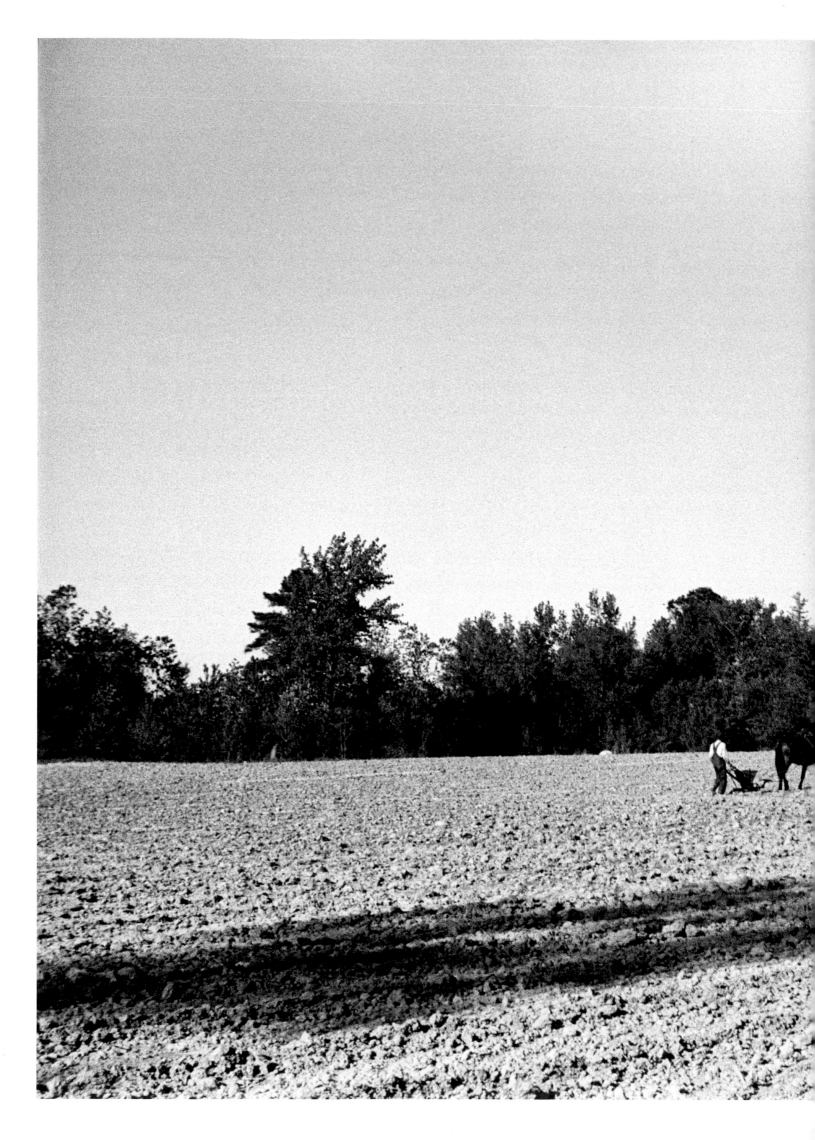

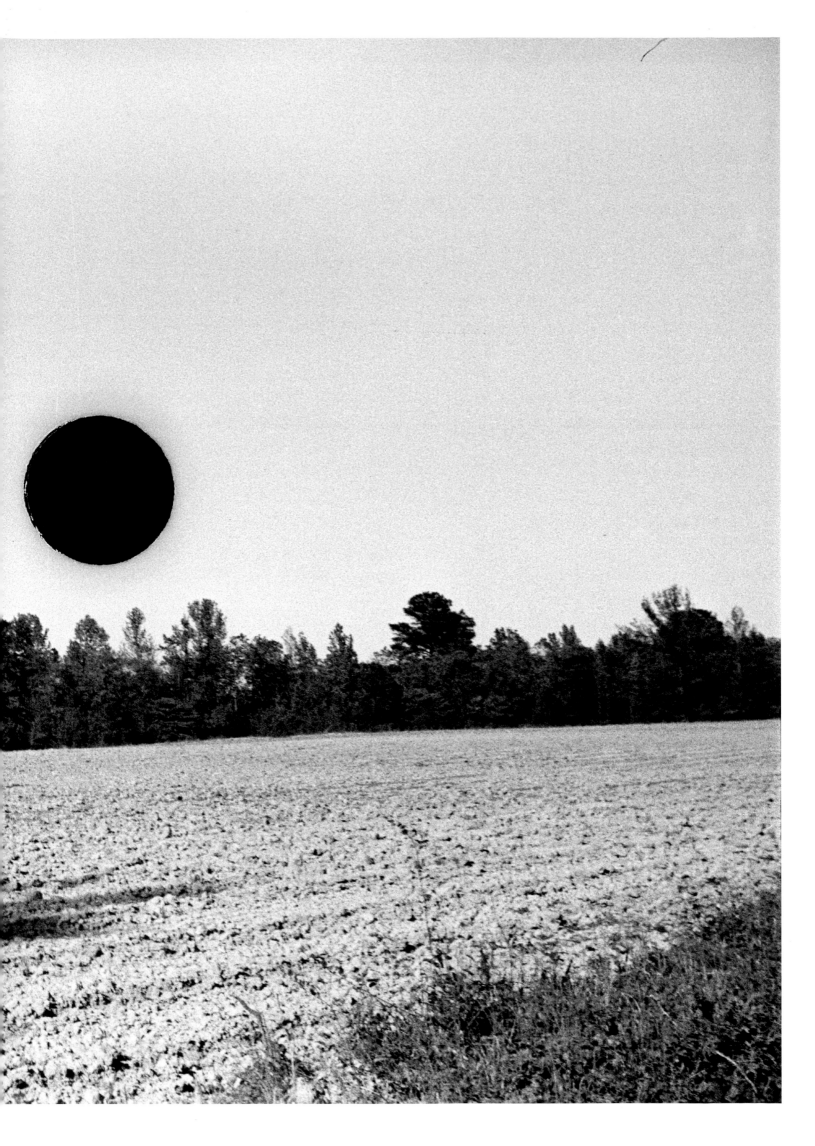

THE HOLE IS A MARK

Since 2009, Bill McDowell has downloaded more than 1,000 files of "killed" negatives from the Library of Congress website. He's made several hundred prints, experimenting with selection and sequencing to get some coherent understanding of the images. In Ground *his edit homes in on a very particular group of photos taken by nine different photographers in the formative years (1935–1939) of the Farm Security Administration project.*

McDowell's selection of images is specific and intentional, as are his juxtapositions and rhythmic layout. His interpretation of this small sliver of the FSA imagery is entirely subjective and, as he writes, "does not represent the scope of the FSA photographic record. It is non-comprehensive in the photographers chosen, the breadth of their subject matter, and the geographic locations in which they worked."

In another statement about Ground, *McDowell writes, "It is certain that [FSA director Roy] Stryker's use of a hole punch was strictly utilitarian; his only goal was to destroy negatives. But in his act of censoring what images were 'suitable' for printing, Stryker unwittingly created a new picture, one that belonged neither to the mission of the photographer [nor to that of] the FSA."*

If Stryker, albeit unintentionally, created new pictures that were collaborations between himself and the photographer, Ground *inserts McDowell into the mix, adding yet another layer of picture-making content to sift through.*

The following conversation between Bill McDowell and DJ Hellerman provides a deeper understanding of McDowell's process, his interest in the killed images, and the larger context for these images' resonance with our particular moment in history.

DJ Hellerman: How did you first discover the killed negatives?

Bill McDowell: I had a very powerful, almost visceral reaction the first time I saw a killed negative printed. It was in a magazine that accompanied a short article on the publication of Michael Lesy's book *Long Time Coming*, published in 2002. I recall the image in the magazine was of a street scene, and it had a perfect black hole deleting part of the photograph. My reaction was something like, "Damn, I wish I had made that." Looking back, it's a little odd, because Lesy's book, while about FSA photography, doesn't include any killed negative images, although he briefly mentions them.

Once I began the project, I did a search to see who else had made published use of the killed negatives and I came across the work of Lisa Oppenheim, Étienne Chambaud, and William E. Jones. Their respective approaches in working with the negatives were different from mine, and it

was good to see broad possibilities in mining the collection.

DJH: *Ground* refers to the agricultural focus of your project and to figure/ground relationships—your interest in formalism. Can you discuss your formal interests in these images and your strategies for layering content into the work?

BM: That's correct; there is a dual meaning to the title. But I'm not sure that the reference to the various figure/ground shifts that occur in these photographs relates to my interest in formalism. Rather, I'm often drawn to photographs (or photographic situations) that have a certain pictorial intensity to them, and I use that as an entry point. And then it becomes a matter of how to work with and against that entry point to engage in more complex and nuanced relationships. So I'm interested in making a photograph that has a formalistic base only as a beginning point.

In *Ground*, I paid attention to the many ways in which the black hole impacted the pictorial dynamics of the respective photographs, and figure/ground was just one of the visual attributes the hole punch affected. The simple presence of the hole joined the images together, and then the specific way it impacted each photograph further created a congruent or dissonant relationship. Not every killed negative has a figure/ground shift. For me it was important to include in the title a reference to the way the selected photographs operate visually, and not just refer to their subject matter.

DJH: How did you come to focus on the agriculture images, and why are you interested in these landscapes?

BM: This project went through multiple iterations as I worked with several hundred photographs downloaded from the Farm Security Administration archive. To help me get a handle on the many photographs, I placed them in different categories: cities, towns, landscapes, portraits, industry, farming, animals, and domestic situations. I experimented with taking photographs from different categories and mixing them, as well as presenting them in distinct, subject matter–delineated sections.

I saw that the landscapes were less specific than the others in their temporality. As I thought more about the linkage between the 1929 and 2008 economic crises, I selected subject matter that related to the most basic needs we share with the past. Food, shelter, and water.

Additionally, my choice to limit the photographs to land and farming was a nod to the origins of the FSA.

DJH: Is *Ground* a curatorial project for you?

BM: Yes. And one that relates pretty closely in its sensibility to other projects in which I was the artist making the photographs. In all of my

photographic work I spend inordinate amounts of time in the editing process, testing relationships between images and layering meaning. What made *Ground* different for me was that because I didn't make the original images, I had a built-in emotional distance to them that aided somewhat in building a structure where they would interact.

DJH: The first image inside the book is particularly aggressive [Mr. Tronson, farmer near Wheelock, ND. 1937 Russell Lee. 8a22121 (detail)]. Can you explain that decision?

BM: When I first began working with the killed negatives, I was disturbed by the images of people whose faces had been excised by the hole punch. In fact, early on that motivated me to digitally repair the hole and show the restored version along with the hole-punched one. But I kept coming back to the feeling that the black-holed images were far more fascinating (visually and emotionally) as they were, rather than when repaired, and that the violation (or violence) embedded in them had the potential to signify so much. In time I thought that the impression of violence, toward people and the land, created by the hole punch was important. Eventually, in my edit, I felt I should lay it all out with the first image to inform the viewer this book is not going to be a romantic journey to the past.

The detail of Mr. Tronson is one of 22 such cropped versions of wider images, all of which appear in the book. The details are cropped in exactly the same way, with each hole being the same size and positioned in the center of the frame. In these images the hole becomes the main subject, and the rest of the frame revolves around it. The inclusion of the details in the book allows for another interaction between photographs, yet one that is still predicated on the presence of the hole.

DJH: Most, if not all, of your other projects have an intense connection with humanity and universal struggles that we all face. Where do you find that human connection within these FSA images and the *Ground* project?

BM: It begins with the pictures. The photographs in *Ground* share so much with my own previous work in being simultaneously abstract and realistic (to steal a phrase from Alan Sekula's description of Anthony Hernandez's photographs). This becomes the basis for constructing a body of work that relates to my desire to share with the world. It's a strange weaving of the personal and the shared, mediated and distilled through dispassionate editing. I use the editing process to distance myself emotionally from the photographs at hand and to overcome the self-indulgence and ego attachment every work begins with. In time, the photographs speak to you. They inform you as to where they belong, if they belong at all.

And yes, pretty universal themes run through my work, and all my projects make use of the poetic document. In *Ashes in the Night*, for example, I

worked (literally) with my father's cremated ashes to make photographs that question our place in the universe. The project began with the intensely personal, but my attempt was to create photographs that extended beyond any emotional relationship I had with my father. A connective thread in all my work is the malleable relationship between the depicted and the signified, played out through a particular sensibility of picture making and presented within a thematic and conceptual framework which, hopefully, triggers a dialogue beyond the simple reading of a photograph.

DJH: Have you ever worked with the actual killed negatives? What is your relationship to the physicality of these images?

BM: All of the images in *Ground* were downloaded from the Library of Congress website. At some point in the project I asked the LOC if I could see the actual negatives and was told they were in storage off site and not available.

In working with a digital file you have a greater ability to alter the appearance of the image. This includes the ease in repairing scratches and blemishes in the original negative. I chose to retouch only what I thought were dust specks, and I intentionally kept the scratches and other blemishes I found. Many of the negatives that were hole-punched had already been damaged in the government photo labs, which is presumably why Stryker killed them. I wanted to retain those marks.

As you enlarge the image, the hole reacts differently than the rest of the negative (even in a digital file). While the subject matter degrades in sharpness as it gets bigger, the hole (which is just air) remains sharp.

DJH: The title of an earlier *Ground* project statement is "The Hole Is a Mark." In some ways the hole allows our contemporary dialogue into the images. But in other ways it empties nostalgia out. How does the hole operate in relationship to the romanticism and sentimentality that can be at play in these images?

BM: The hole is a mark. It may not have been created for that reason, but it is a mark because that's the way I've used it. The hole effectively confounds the photograph's original purpose. Its presence challenges the established tenets of the FSA project that can be discerned in the unpunched photographs. In becoming the dominant pictorial device in each photograph, it shifts the narrative.

I think of these as unsentimental photographs, and as such they work counter to the way many FSA photographs are perceived today. There is nothing romantic about the effects the Great Depression and the Great Recession have had on so many of this country's people and on its land.

DJH: Continuing with this idea of "The Hole Is a Mark," can you explain how it operates as a formal element and as a conceptual element in the images you've selected for *Ground*?

BM: The hole disallows an easy reading. It disturbs and intercedes, but never in the same way. Sometimes it becomes largely a graphic element, while in other pictures it takes on an emotional bearing (as with the opening photograph in the book, the detail of Mr. Tronsen).

It was important to me that the placement of the hole was in all likelihood a chance occurrence; the particular interaction between the black circle and the subject matter it interfaced with wasn't planned. It's critical to me because it says something about the editing process, and about the way that visual language and the practice of making pictures evolves over time. Like latent images, these pictures were made as soon as the hole was punched in the mid to late 1930s. But it took time, and the changes in the ways that we see and use visual language, to recognize the potential of those images.

DJH: These images are available for anyone to download from the Library of Congress website. Can you talk about ideas of authorship, ownership, and propriety as they relate to the images and your project?

BM: These photographs are owned, technically, by the American people. Anyone can download and print them. I like that each photograph in *Ground* is the result of three separate acts of picture making: the original photographer's deliberate compositional and contextual choices, Roy Stryker's hole punch, and my recontextualization. Since one can't assign sole authorship to these photographs, it's possible to view this project as an interactive body of work influenced both by photographic conventions of the 1930s and by those of today.

DJH: What are the political implications of your involvement with the killed negatives?

BM: Well, every photograph is a political reflection, whether it's intended to be or not. Leading up to and following the Great Recession of 2008, I was saddened and angered by the parallels I saw with the Great Depression in terms of the increasing divide between the classes, the shrinking of the middle class, and the disconnect between Congress and the American people.

DJH: In our discussions, you've mentioned that Nathan Lyons has had a significant impact on you as a photographer. Can you discuss the editing, sequencing, and design of the book?

BM: Yes, Nathan Lyons's influence on me, and on so many photographers, artist bookmakers, and curators, is enormous. When I was in graduate

school at Rochester Institute of Technology, I took a class with Nathan at the Visual Studies Workshop, and I spent lots of time at the workshop. In his teaching and his books he was, and still is, concerned with extending the meaning and significance of images through their sequential relationships. You see this sensibility in Walker Evans's *American Photographs* and Robert Frank's *The Americans*. This is where photography shares more with poetry than it does with, say, painting or even cinema. This has been the foundational strategy of my working method ever since.

DJH: After spending such a significant amount of time thinking about and working with these images, what is it that keeps them exciting for you?

BM: It's such a great story. You begin with the largest photo documentary project in the history of the United States (except perhaps NASA's and now Google Map's), which produced so many iconic photographs (with all the issues and complexities inherent with the documentary model).

And then it turns out that the director of the FSA photography division, Roy Stryker, had damaged thousands of negatives with a hole punch to ensure they would never be printed or published. Little is known on why he did this, but it appears it had nothing to do with those negatives being controversial—it was a control thing. But the punched negatives remained in the files, and the collection eventually moved to the Library of Congress, where they became accessible to the public.

In the years since the FSA negatives were defaced, our thinking about photography (as with everything) has changed; authorship and the auteur is questioned, the idea of the neutral image is challenged, and we have the fluid incorporation of the photograph in other media. And with the change in culture, the meaning of that black hole, as a mark, now signifies something that it didn't in the 1930s.

More than anything, what has kept me invested in this work is the idea that the presence of that black hole, in certain photographs and when presented in a certain construct, makes the FSA photographs relevant today. The photographs in *Ground* speak to our contest with different forces: nature, the government, the dynamics between people of different classes and races. They speak to now even as they confer meaning on the past. Damaged and bountiful land; drought, flood, and exodus. Starting over. Repeating the past.

DJ Hellerman is the curator and director of exhibitions at Burlington City Arts, Burlington, Vermont.

ACKNOWLEDGMENTS

I am very grateful to the many people who have contributed to the making of *Ground*.

Thank you to Daylight Books. Michael Itkoff and Taj Forer, for understanding the importance of producing photography books that don't necessarily fit snugly into a market niche. Ursula Damm, for your ability to divine the essence of a book in its design. And to Elizabeth Bell, for your uncanny talent, not only in wordsmithing but also in helping an artist clarify their idiosyncratic relationship to words and pictures.

To the University of Vermont for providing important support, specifically to Richard Galbraith and Dan Harvey in the Office of the Vice President for Research, Antonio Cepeda-Benito, former dean of the College of Arts & Sciences, and Luis Vivanco and David Jenneman of the Humanities Center.

To my colleagues in the Department of Art & Art History at the University of Vermont, who, from the very beginning, encouraged this project.

To Jock Reynolds for your generous and incisive essay, and for a couple of phone calls of encouragement and enthusiasm that helped propel this book to its conclusion.

To Rosanne Cash. After perhaps the 500th playing of *The River & the Thread*, I came to fully appreciate your gift for connecting the past to the present. Your music inspired this book. Only later did I learn your father's boyhood home had been built by the FSA.

To Wendell Berry. When I read *The Current* I am reminded of the promise we make when our hands dig into the soil, and how we draw out the past to plant the future. I am thankful for all your digging.

To DJ Hellerman for first showing work from *Ground*, and for your insightful text and interview. I hope this will be the first of many collaborations.

To Jeffrey Hoone, Shane Lavalette, Walker Blackwell, and John Manion at Light Work. No other arts organization in the world supports photographers so well.

To the Peter S. Reed Foundation for your timely and generous support of this work.

To Jessica McDonald at the Harry Ransom Center, University of Texas at Austin, for your appreciation of *Ground*.

To the staff at the Library of Congress for making the FSA archive so accessible, and especially to Beverly Brannon and Jan Grenci.

To Nathan Lyons, whose teachings are embedded in the structure and sequence of *Ground*.

To Anthony Bannon for your counsel and encouragement, early on and throughout.

To Dornith Doherty, Judy Natal, and John Huddleston, photographer friends who over the years have provided unwavering communion and inspiration.

To Jean-Jacques Guyot for your wisdom.

To Michael Lesy for *Long Time Coming*.

To my students at University of Vermont, Texas A&M University– Commerce, and RIT, who have given me faith in the power of, and the necessity for, the interchange of art.

PLATES

The majority of killed negatives in the Library of Congress files are listed as untitled, uncredited, and undated. In most cases it was a straightforward task to determine who made the photograph and its date and location by searching through nearby captioned images. Whenever possible, I have included the caption from a similar frame of film. The photographers represented in this book are Paul Carter, Walker Evans, Theodor Jung, Russell Lee, Carl Mydans, Arthur Rothstein, Ben Shahn, John Vachon, and Marion Post Wolcott.

Page/Title, locale, date/Photographer/Library of Congress file number

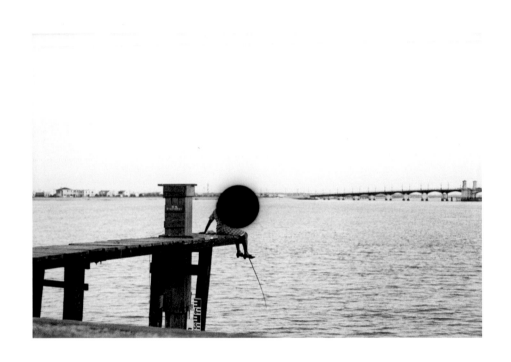